The
Apocalyptic
Vision

The
Apocalyptic
Vision

The Art of Franz Marc

as German Expressionism

by Frederick S. Levine

Icon Editions

Harper & Row, Publishers

New York, Hagerstown, San Francisco, London

FIRST EDITION

Designed by Suzanne Haldane

Library of Congress Cataloging in Publication Data

Levine, Frederick S.
 The apocalyptic vision.

 (Icon editions)
 Bibliography: p.
 Includes index.
 1. Marc, Franz, 1888–1916. 2. Painters—Germany—
Biography. 3. Expressionism (Art)—Germany. I. Title.
ND588.M194L46 1979 759.3 [B] 78-4736
ISBN 0-06-435275-7

79 80 81 82 83 10 9 8 7 6 5 4 3 2 1

To the memory of my grandfather,
Irving Siegelbaum,
and to Miriam,
Michael and Daniel

Acknowledgements

Without the persistent support and encouragement of Lawrence Steefel, Jr., Robert Rosenblum, Donald Gordon, and Angelica Rudenstine, this work would not exist. I should like to thank William S. Bradley for his help in reviewing my translations, Fern Simon for her kindness and good advice, and Diane Symonanis for the quality of her assistance. I wish also to express my gratitude to Cass Canfield, Jr., and Pamela J. Jelley for all of their efforts in bringing forth this book.

Grateful acknowledgment is made for permission to reprint the following.

Lines from "The Knight" from *Rilke, Selected Poems* with English translations and notes by C. F. MacIntyre. Copyright 1940 by C. F. MacIntyre. Reprinted by permission of the University of California Press. An excerpt from *Concerning the Spiritual in Art* translated by Francis Golffing, Michael Harrison, and Ferdinand Ostertag. Reprinted by permission of Wittenborn Art Books, Inc. An excerpt from "Kaspar Hauser Lied" by Georg Trakl translated by Dr. David Luke from *Modern German Poetry: An Anthology with Verse Translations* by Michael Hamburger and Christopher Middleton. Published by Grove Press, Inc. Reprinted by permission of Dr. David Luke. An excerpt from *Modern German Poetry: An Anthology with Verse Translations* by Michael Hamburger and Christopher Middleton. Published by Grove Press, Inc. Excerpts from translations of "Weltende" by Jakob von Hoddis, "Umbra Vitae" by Georg Heym, and "Mond" by Yvan Goll from *Modern German Poetry: An Anthology with Verse Translations* by Michael Hamburger and Christopher Middleton. Published by Grove Press, Inc. An excerpt from *An Anthology of German Poetry from Hölderlin to Rilke* edited by Angel Flores. Reprinted by permission of Peter Smith.

Portions of the Introduction appeared originally as "Expressionism: A Redefinition" in the Morton D. May Collection of German Expressionist Painting (Austin, Texas, 1974). Reprinted by permission of the University Art Museum, the University of Texas at Austin. Portions of Chapter 3 appeared as "The Iconography of Franz Marc's Fate of the Animals" in the June 1976 issue of *Art Bulletin*. Portions of Chapter 4 appeared as "An Example of Apocalyptic Regression in 1913 Expressionism" in the Fall 1976 issue of *Michigan Germanic Studies.*

Contents

Acknowledgments vi

Introduction: The Themes of Expressionism 1

1. Munich and the Formative Years 15

2. The Years of Transition 47

3. The Image of Apocalypse 76

4. Signs in the Sky 104

5. The Apocalypse Realized 138

Conclusion 170

Notes 175

Bibliography 186

List of Illustrations 193

Index 197

Introduction:
The Themes of
Expressionism

1.

THE WORD "Expressionism" is perhaps the most misunderstood and least fruitful term in the entire vocabulary of modern art history. Defined by the dictionary as a "theory or practice in art of seeking to depict not objective reality but the subjective emotions and responses that objects and events arouse in the artist,"[1] the term has been employed by the art historians of this century to cover as limited or as wide a range of art as was deemed necessary. Thus, under the same rubric of "Expressionism," Paul Fechter could place seven German artists, Peter Selz could locate seventy, and Sheldon Cheney could apply the term "to the work of all modern artists from Cézanne and Rousseau to Picasso, Dali and the social realist M. Siporin."[2] Because of the limitations fostered by these wide-ranging and divergent definitions any present discussion of Expressionism as a style or movement in art must begin with a qualification of the term and as clear a statement as possible regarding its application.

In the present study we will draw a clear distinction between the generic meaning of Expressionism, that is, as a type of creative activity that could include anything from primitive art to Goya, from Grünewald to Van Gogh, and the more particular usage of the term as it refers to those developments in modern art occurring within Germany and the German-speaking areas of Europe in the period from about 1880 to 1916. This period of activity has been referred to as

"prewar Expressionism" or simply as "German Expressionism."[3] While we have limited the term "Expressionism" to a specific context, there is the further confusion of attempting to designate or define a common principle or aim that could in some degree apply to Fechter's seven German artists, Selz's seventy, or some equally arbitrary number in between. Indeed, is there any degree of unity, either in terms of style or content, within German Expressionism? Can we properly call it a movement at all?

In actual fact there is no fundamental stylistic conformity to be found within German Expressionism. Rather, the Expressionists sought, as one of their major aims, a negation of the concept of style and a diminution of its importance on the grounds of its "insincerity" and its "dishonesty," especially so in regard to its hindrance of the full expression of "inner reality."[4] Somewhat ironically, this antidoctrinaire attitude toward stylistic value and regimentation is not only one of the major unifying factors in the movement, but one which also clearly sets it apart from the more stylistically cohesive contemporaneous trends occurring in France and Italy. While there is no formal or structural unity to the movement known as German Expressionism there are, nevertheless, certain internal characteristics that all works of this movement tend to share.

On the most rudimentary of levels Expressionism may be viewed as a rejection of both classicism and realism. It is a subjective rather than objective art, not relying for its themes upon the visible world of nature but seeking instead to reveal aspects of a hidden, unobservable world, relating the unconscious or subconscious responses of the artist to his environment. Thus, one common denominator of all Expressionist art is the subordination of forms within nature to personal emotional perceptions; it is an art that seeks to project "emotional needs, psychological pressures, and private obsessions."[5]

On another level, Expressionism is an art of didacticism. The movement was not in any sense concerned with the principle of art-for-art's-sake, but rather its forms were regarded by the artists themselves as vehicles for change, vehicles that would somehow aid in improving the world and the life of man therein. Expressionism was a socially involved art, an art that sought to communicate the depths of its involvement with and its concern for mankind. Emerging from the alienation and isolation suffered by the innovative German artist at the turn of the century, Expressionism sought to reach out beyond

the confines of the individual self and to establish contact with the broad mass of humanity. Indeed, Expressionism reflected an anguished longing for community which, when carried to its extreme, represented an attempt to establish a unified and harmonious relationship between the mortal isolated individual and the eternity and universality of the cosmos.

German Expressionism was an art movement born of intense psychological despair. It was a movement that rejected absolutely the progressive, rational, materialistic outlook of the Wilhelmine society from which it emerged, a movement that, in the end, sought to alter or entirely to replace that society with *something*, indeed *anything*, better.

It is on yet another level, however, that we find the core of Expressionism, its root, its driving energy, indeed its very substance, which, in the final analysis, gives meaning to the works themselves. It is on the thematic level, within the realm of the specific representation of subject matter, that we find the ultimate cohesive force which characterizes and, in effect, gives definition to this movement. The underlying initiative of pre–World War I Expressionism, in both art and literature, is characterized by an overwhelming propensity toward the conscious or unconscious representation of two central themes: the theme of regression and the theme of apocalypse.

The theme of regression is, in this instance, expressed in a movement that seeks to reach far beyond any mere admiration for, or desire to emulate, the arts and social organization of primitive man. Regression, as it appears in Expressionism, should be understood in the sense of profound yearning, a longing to return to the distant echoes of the animal past, a past free of moral restriction and restraint. The ultimate goal of Expressionism was literally to "lose its own mind," to seek an identification with forms of precognitive existence as a manifestation of its collective desire to reenter the world of "unconscious consciousness," the world in which being is not encumbered by the weight of rationality, the world in which all life proceeds on the most primitive, the most instinctual of levels.

The root causes of this apparent and extreme determination are a vital part of this study and, as we shall see in succeeding chapters, the Expressionists were both the inheritors and victims of what was one of the most turbulent and confused periods in their nation's history. In addition to this turmoil, the Expressionists carried with them into

the twentieth century the intellectual legacy of the century that pre-
ceded them, an age in which the nature of man had been redefined.
As a consequence, the Expressionist generation, quite unlike any
generation before it, was compelled into an acute awareness of the
fundamental contradictions inherent in human existence. The Expres-
sionists were to learn from their legacy that man is an animal, but an
animal in possession of a quality that all others lack—awareness,
awareness of oneself, awareness of one's past, awareness of one's ul-
timate future, of the certainty of death. Not only were they to com-
prehend fully the nature of man's smallness and powerlessness in the
immediate present, in the remote and uncaring empire of Wilhelm,
but more important, beyond that, they perceived man's insignificant
nature within the vast infinity of the surrounding universe. The Ex-
pressionists were to realize that man is a part of naure, subject to its
laws and demands, and yet divorced from the unity with that nature
that is the birthright of the merest unthinking instinctually acting
animal. They were to become fully conscious of the terrifying conflict
of being bound to the dictates of this world and yet of being free to
think beyond it; of being a part of nature, and yet of being a freak of
nature; of being "neither here nor there." They were to understand
completely that "human self-awareness has made man a stranger in
the world, separate, lonely and frightened."[6]

The Expressionist generation, born in the late 1870s and early
1880s, was compelled to seek a solution to this dilemma of man en-
tirely through its own sustenance, without the support or counsel of
church or state. "What," asks Erich Fromm, "can man do to cope
with this fright inherent in his existence? What can man do to find a
harmony, to liberate him from the torture of aloneness, and to permit
him to be at home in the world, to find a sense of unity?"[7] The choice
is complex but the options are few: man can either *progress* toward a
more complete realization of his own humanity or he can *regress*
toward a consolidation of unity in his lost animality. Facing the terror
of historical dislocation, social alienation, and philosophical doubt, the
Expressionist artist chose the latter; he sought to return to his origins,
to cast off the shackles of reason and self-awareness and to revert
toward the bonds of unity he saw existing between nature and its in-
stinctual inhabitants.

Aside from the question of whether or not the choice made by the
Expressionists was an appropriate one, it is obvious that one cannot

return to a place where one has never been. After all, it might be argued, man has never been an animal; nor has he ever resided within nature purely by his instincts. This assumption would be incorrect, however, for in all of us there existed a time and a place in which this was the pattern of our lives. In retaining an unconscious identity with the mother during childhood, we maintain an unconscious existence that closely parallels that of the animal. The older we get the more we attain consciousness and thus the more we are detached from the world of instinct. Yet, we never completely lose our desire for this forgotten realm and when grave enough difficulties arise we are consistently lured toward this retreat, this regression to infancy.[8]

Thus, while on a conscious or semiconscious level the Expressionist artists, authors, poets, and playwrights sought a return to animality and a unity of existence within nature, on the deeper, unconscious level, something more intense was at work. As Jung has said, "The road of regression leads back to childhood and finally, in a manner of speaking, into the mother's body."[9] Even more portentous, according to Jung's position, is the understanding that "regression, if left undisturbed, does not stop at the mother but goes back beyond her to the prenatal realm . . . to the immemorial world of archetypal possibilities."[10]

There is one further factor to consider in this longing for regression that was first advanced in 1920 by Sigmund Freud. In *Beyond the Pleasure Principle*, Freud offered the view that all organic instincts are directed toward regression. According to Freud, the ultimate goal of all organic striving is not toward the illusory aims of change and progress, but rather toward a primeval beginning that was abandoned by the living being early in its development, and yet toward which it circuitously but continually seeks to return. In seeking this return to its origins, to the inorganic, Freud concluded that, as the inanimate preceded the animate, death was the goal of all life.[11] The longing for regression, when carried to its ultimate conclusion, represents a longing for death.

In supporting this view, Joost Meerloo has maintained, "When life becomes too bothersome man regresses easily to the state of a primitive being. In his primitive rage man reverts to primitive magic ideas and expects somehow in death to be reunited with mother earth. Death means for him the magic union with what created him."[12] In

speaking of what is perhaps the primary agent in this driving impulse toward oblivion, Meerloo defines its purpose as "a primitive mystical escape into death in order to find a new life, the acceptance of death in order to destroy inner evil and achieve righteousness."[13] The agent to which Meerloo is referring is that of suicide. This consideration leads, as a matter of course, into our next area of investigation and into the corollary theme that characterizes much of Expressionist art: the theme of apocalypse.

The impulse toward suicide and the longing for apocalypse are clearly not unrelated. According to Meerloo, the suicidal urge, like all other human phenomena, has a dualistic explanation. We should already be at least somewhat familiar with the first form, that is, "the regressive, archaic form of suicide, a retreat to pure instinctual life . . . a return to mechanical equanimity."[14] The correlative form may be described as a "progressive and even heroic form of suicide of [a] going beyond the self toward what it conceives of as continual and eternal values."[15] Thus, on the one hand, the suicidal impulse is a clear effort toward the destruction and annihilation of the individual, while, on the other hand, it is the actualization of a crisis, a ritual purification in which the individual transcends himself and returns to the spiritual harmony of the universe.

So far we have seen that the longing for regression, manifested by the Expressionists, can, in its most extreme unconscious intensity, lead toward a suicidal impulse, toward a longing for death. In terms of its ultimate application, this suicidal vision may be considered as both a fulfillment of the longing for regression and as a means of progression, a method that seeks a cleansing, a purification, a preparation for a breakthrough toward a higher or better form of life. Therefore, when the urge toward regression reaches its peak and ultimately manifests itself as the desire for self-destruction, it is at that very juncture that the regressive longing actuates itself in a yearning for apocalypse.

On the conscious or semiconscious level apocalypse was envisioned by the Expressionists to act as a cleansing, a ridding the world of all those institutions and traditions that had hitherto restricted the free play of "animal" instincts. Simultaneously, on the unconscious level, apocalypse acted as the vehicle for regression, the means by which the lost unity with the world of nature could be regained. The Expressionists never envisioned apocalypse solely as an act of wanton

destruction; rather they viewed it as involving the redemptive aspects of death and rebirth, of a purifying cataclysm that would provide a regenerative force for the life that would follow.

The concepts and longings, the desires and yearnings we have been discussing are, indeed, rather dramatic in their intensity. The degree of that intensity was determined in large measure by the critical nature of the cultural climate from which it emerged, and it is toward an understanding of that climate we will now turn.

2.

Toward the closing years of the nineteenth century, all of Europe found itself in the grip of a fever, a fever that kindled an anticipatory outlook regarding the future but which simultaneously exposed a strong sense of discontent with the present. It was a fever born from a shattering of the knowledge of what was, and from an apprehension of what would follow. A century was drawing to a close, but it was a century in which man's place in the world had been decisively altered.

Coupled with the dramatic growth of industrialization and urbanization came significant, indeed remarkable, new investigations into hitherto unexplored areas. The revolutionary discoveries of Freud and Einstein, Röntgen and Planck,[16] added to the feeling of apprehension already felt by Europeans and further shook the increasingly fragile foundations of man's view of his place within nature. With the end of the century there also came the termination of a generation that had seen its rise during the days of the Franco-Prussian War of 1870. It was a generation that had been preponderantly materialistic. That is, it had been especially devoted to, and proud of, material achievements, and its philosophy tended toward the pragmatic, toward conceptions of a mechanistic nature.[17] With the approach of the new century, with the advent of new ideas and the awareness of new voices of criticism, all of what had passed before was now called into question. In his novel *The Man Without Qualities* (1930), Robert Musil described the situation that existed at the turn of the century:

> Nobody knew exactly what was on the way; nobody was able to say whether it was to be a new art, a New Man, a new morality or perhaps a re-shaping of society. . . . But people were standing up on all sides to fight against the old way of life. . . . The Superman was adored and the Subman was adored; one dreamed of ancient castles and shady avenues,

man and woman in the primeval Garden, and the destruction of society. Admittedly these were contradictions and very different battle-cries, but they all breathed the same breath of life.[18]

While this strange mixture of apprehension and anticipation was felt throughout Europe, "nowhere," notes Victor Miesel, "was the reaction more intense than in Germany, where anxiety about the future developed into extremes of utter despair and wild expectation."[19] Indeed, by the 1890s Germany had entered into a full-scale intellectual and spiritual crisis originating, to a large extent, from a deep and general sense of dissatisfaction with the political and material culture of the empire that had been founded only twenty years before. The roots of this crisis emanated from Germany's peculiar position in the course of nineteenth century developments and the beliefs and ideas resulting from this crisis would speak with a voice that would be heard with increasing frequency into the next century as well.[20]

The nature of Germany's intellectual problems which surfaced at the end of the nineteenth century lay in two precipitous factors: first, the search for a German national identity and unity, and second, an industrialization and urbanization whose advance was without parallel anywhere in Europe.

While the Germans' quest for a sense of national unity characterized much of their history during the nineteenth century, the roots of that quest began some six centuries earlier. With the execution of Konradin, last of the Hohenstaufen, in the year 1268, the former great medieval German empire began to collapse into rival political factions. While most of the nations of western Europe were embarking upon a process of consolidation into unified, identifiable national entities, Germany was propelled on quite the opposite path until, at the end of the eighteenth century, Germany had become a provincial backwater composed of some 1800 separate political entities. Serious thought toward the idea of union began to emerge strongly only in the nineteenth century, during and after the Wars of Liberation, which served to remind Germans that they had a national soil, and which caused a rewakening of a national consciousness. After the defeat of Napoleon, the impulse toward the creation of a unified state could have been realized at the Congress of Vienna, but this was not to be the case. Instead, the Germans were presented with a loose Confederation, which aided in the consolidation of some of the terri-

tory, but which nevertheless left autonomy in the hands of the individual states and principalities. The failure of the revolutions of 1848 only added to the frustrations of the nationalists, and resulted in an abandonment of the goal of a political unity that now seemed unattainable. In its place the idealistic nationalists sought a cultural solidarity among the German people that, in looking back toward the nation's roots, vigorously opposed any further efforts at modernization or adaptations to modern life.

When the German Empire was finally proclaimed in 1871, after the defeat of France, it became, literally overnight, the most powerful nation on the continent. Yet, this political unity failed to meet the expectations of most Germans. Discarding the utopian ideals and traditional values that had propelled the movement toward unification, German society grew increasingly prosaic and materialistic. Thus, instead of promoting a feeling of national self-awareness, the new empire represented to many a political union which served merely to foster a belief in bourgeois material pursuits and individual aggrandizement.

Coupled with this disappointment over the actualization of the long-sought-after drama of national unity, many Germans also reacted with horror to the increase in industrialization that was totally transforming the character of traditional German society. Beginning later than most developed Western nations, Germany, as late as 1870, had not yet overtaken France in industrialization. After 1870, however, stimulated by the Franco-Prussian War, the requirements of the army and navy, the growing merchant fleet, the railways, and the increased demand in domestic markets, German industrialization surged forward in unparalleled growth.[21]

At the beginning of the nineteenth century Germany had a population about the same as that of the period of the Thirty Years War. By the turn of the century this population had increased at least threefold. Between 1848 and 1914 the number of persons living in Berlin had increased ten times over, from four hundred thousand to four million, and such was the case in cities throughout the new empire.

A crisis was thus initiated in the German consciousness, a crisis of identity, a crisis emanating from a profound feeling of social dislocation and disorientation. Many Germans honestly saw this new industrial society as something fundamentally un-German, and they began to believe that the true essence of German life was being seriously

undermined.[22] Dissatisfaction with the arrangement represented by the empire was rapidly voiced from many quarters of German society, but most vociferously from those who felt that their ideals had been neglected or even entirely overlooked. These people now came to be considered "outsiders" in an increasingly bourgeois-dominated materialistic culture, and their numbers grew to include anyone whose philosophy differed from that of the prevailing view. They sought an end to their isolation in spiritual terms, in the search for an intimate relationship with a desirable although unattainable myth of the past. In looking inward this group of "outsiders" also looked backward, into the religious and mystical heritage of their nation's past, in an attempt to associate themselves with what they considered to be a vital current of German-ness now in danger at the hands of materialism.

Born of a deep-rooted pessimism and feeling of anguish at what they viewed as the cultural disembodiment of their country, these critics sought nothing less than a spiritual revolution through which the true essence of German life might be restored. Many Germans could thus agree wholeheartedly with the words of Paul de Lagarde, one of the most influential, outspoken, and vehement of the German critics: "All spiritual forces should be set free, all sham stamped out, every organization of idealistic intent allowed and encouraged: if this were done, it would be a joy to be alive. Instead it is a punishment today to have to witness the withering away of our nation."[23] The idea of the spiritual was viewed as a force for salvation, a means by which the disappointing world of the present could be overcome.

The decade of the 1890s in Germany has been described as "one of strife and unrest, when the cultural discontent which previously had been the complaint of a few artists and intellectuals became the faddish lament of the many."[24] It was a decade in which the revolt against modernity, the frontal attack on the very basis of civilization itself, gathered force and momentum, when the voice of the critic was the rule rather than the exception. "Nietzsche, ignored during his creative period, was suddenly read and admired, Ibsen was played and praised, Nordau's *Degeneration* vehemently debated."[25] Throughout Germany, there arose a call to greater freedom, toward self-expression, toward a recognition of the inner spiritual capacity of man.

A new age was beginning to emerge, an age which sought resolution for the doubts and uncertainties that had been fostered by the

recent past. It is in an age such as this, an age seeking definition for itself and a purposeful program for the future, that men "will often gain self-knowledge for the first time from a programmatic book, even a bad book. For the decade of the 1890's . . . such a book, at least for Germany, was (Julius) Langbehn's *Rembrandt als Erzieher*, published in 1890."[26]

What was significant about Langbehn's book was certainly not its scholarly erudition, for the work has precious little to do with either the life of Rembrandt or the study of his art. Rather, the book was celebrated because it corresponded so fully with the moods and anxieties of the decade in which it appeared. It was far more a work of prophecy, a guidebook toward salvation, as it were, than a serious work of scholarship. As such, its impact was simply enormous: "the book became the great literary fad of 1890, not only among the general public but among the academic and artistic elite of Germany,"[27] and surprisingly it was reviewed by them with almost unanimous favor. The influence of Langbehn's work grew steadily until the First World War and its message profoundly affected an entire generation of German youth. Langbehn's philosophy, as expressed in *Rembrandt als Erzieher*, blended a criticism of the present with a longing for the past, a philosophy that mercilessly condemned contemporary culture, and which appealed to the forces of the irrational to take its place.[28] If one theme could be said to have dominated Langbehn's book, it was that the culture of Germany was degenerated and destroyed by scientific rationalism and that its only hope for regeneration lay in the resurgence of art and the elevation to power of great artistic individuals in a new society.[29]

While the work of Langbehn and the newly discovered thought of Friedrich Nietzsche were hailed as rallying cries for all dissaffected Germans throughout the 1890s, it was only toward the turn of the century that the radical views of these thinkers began to find application. With regard to Langbehn, it was only at the approach of the new century that the exaltation of art as a means of salvation began to capture the imagination of students and aspiring artists. For the generation that had been born in the late 1870s and early 1880s, the generation of the Expressionists, art would now concern itself with the highest spiritual aspirations and ideals.

Another, fully related aspect of the cultural crisis that is vital for our purposes here was the revolt by a large segment of German art-

ists and intellectuals against the authoritarianism that paralleled the development of bourgeois-dominated life in the late nineteenth century. For the Expressionists in particular, emerging as they did almost exclusively from middle-class backgrounds, this revolt tended to manifest itself in inter-generational conflict and was directed at those most visible symbols of both authoritarianism and the preservation of the status quo; most notably against the image of the father who, whether actual or projected, "represents the world of moral commandments and prohibitions."[30]

According to Freud, however, a boy tends to develop an ambivalent identification with his father. On the one hand, the boy wishes to occupy his father's position because of genuine admiration and a desire to be like him but, on the other hand, he wishes to displace him, to get him out of the way. This ambivalent attitude toward the father was projected by the Expressionists onto the whole of Wilhelmine society, giving them the desire both to destroy the hated world of their fathers as a means of purification and to raise them to a spiritual plane upon which they would again be worthy of respect and admiration.[31]

As we have seen, the Expressionist generation came to regard their society as somehow life-inhibiting and as spiritually repressive. As their perception of this inhibition and repression increased so did their hostility and with it a greater urge toward destroying not only what they viewed as a stifling and restrictive social milieu but, in both a real and a symbolic sense, destroying themselves as well.[32] On the personal level the Expressionist artist remained isolated from his society, rejected for his innovativeness, misunderstood, or completely ignored. Thus, a persistent feeling of unworthiness is a common motivating factor in the work of Expressionism. The ambivalent Expressionist artist both held the bourgeois in contempt for his philistinism and yet envied and admired his sense of belonging. The Expressionist stood on the outside looking in, wishing to be a part of the center, to feel at home. Yet, an artist's work can often be considered a projection of himself in which, through public acclaim, he can gain approval of his own self.[33]

Finding no approval of this "self" from the public, but aware of his artistic potential, his intellectual perception, and the importance of his mission, the Expressionist artist stood at the crossroads of a pro-

found dilemma, a dilemma that could be resolved only through the choice of a single course. He could either surrender his newly acquired values and accept his given position within the empire he detested, or he could pursue the path to which he felt destiny had called him, to offer a spiritual alternative to a world burdened by excessive materialism. By choosing the latter, the Expressionist artist adopted a position that was in direct conflict with the prevailing values of the established political and social structure, and thus served to alienate him from his own culture.

By projecting his own isolated position onto the whole of mankind, the Expressionist artist sought consolation from his sense of separateness, and through regression, a means that offered spiritual unity and harmony, sought to include himself in the whole of nature and the cosmos. Whether the impulse toward regression is conscious or unconscious it should be clear that the path of regression implies a return to the world of natural instinct and, when carried to its ultimate conclusion, represents a longing for death.

If all creative activity stems from the needs of the individual to cope in a productive manner with his environment, then the creative activity we refer to as German Expressionism sought to do this by destroying both that environment and themselves as well, so that both could be born anew. "The world is so full we are stifling," wrote Franz Marc, "what can we do to be happy but give up everything and run away, draw a line between yesterday and today?"[34]

As with any other artist, Franz Marc's is an art in response to these internal and external crises, an art that acts as a means of coming to terms with a hostile and confusing world. In reacting to these crises, in seeking relief from the pressures of his immediate existential situation, Marc came to understand, along with many of his contemporaries, "that art was concerned with the deepest things, that a true revival could not be a matter of form but had to be a spiritual rebirth."[35]

Seen in this light, the largely formalistic or stylistic analyses of his work that have heretofore preoccupied research on Franz Marc[36] have been helpful in determining the method of his representation, but have given us little indication of what it is he *actually* sought to represent. The fact that the great majority of his works is concerned with the depiction of animal subjects is clearly apparent. But Franz

Marc was not a simple man, nor was he simply a lover of animals. "Truth," he said, "is always on the move. It is always somewhere, but never in the foreground, never on the surface."[37]

> Everything has appearance and essence, shell and kernel, mask and truth. What does it say against the inward determination of things that we touch the shell without reaching the kernel, that we live with appearance instead of perceiving the essence, that the mask of things so blinds us that we cannot find the truth?[38]

By undertaking an analysis of the content of Marc's painting, we can arrive at a truer appraisal of his work, an appraisal in keeping with what Marc himself seems to have meant when he said, "Have we not learned from a thousand years of experience that things cease to speak the more we hold them up to the *visual* mirror of their appearance?" and that the goal of art "is to reveal unearthly life dwelling behind everything, to break the mirror of life so that we may look being (*Sein*) in the face."[39]

This study seeks to "break the mirror," as it were, to "penetrate the surface," and to demonstrate that Marc's work closely parallels what have here been delineated as the central themes of German Expressionism in both art and literature. Its aim is to show that the art of Franz Marc exists as an exemplary visual embodiment of the themes of regression and apocalypse on the collective level of the Expressionist movement, as well as being a personal metaphor for the unconscious needs of the artist himself. By so demonstrating, it should be possible to remove Franz Marc from his current position as a secondary figure within German Expressionism, and to place him in the center of a movement whose urgency of *Sehnsucht*, whose inner longings and desires, whose very expression are so well articulated in his paintings.

1

Munich and the Formative Years

1.

Following the creation of the empire and the explosive advance of industrialization during the 1870s, a new moneyed class began developing in Munich as it had elsewhere within Germany. The taste of this class did not differ to any considerable degree from that of persons in similar situations in Europe and America, that is, it was generally ostentatious, inclined primarily toward displaying wealth and possessions and, if possible, intended to aid in improving one's social position and status. Within this class the word "culture" became quite popular and, indeed, this newly emergent bourgeoisie set about the accumulation of this "culture" with an ever-increasing and rapacious appetite.[1]

For the most part, the paintings the German middle class collected and the artists they patronized were very closely associated with the realist and naturalist stylistic tradition of Munich, a tradition that included the predominant painters of the Munich Academy, Karl von Piloty, Wilhelm von Kaulbach, Arthur von Ramberg, Wilhelm von Diez, and most notably, Franz von Lenbach. It was Lenbach who, from the decade of the seventies until the turn of the century, came close to being a dictator in matters of taste in the Bavarian capital. He was known as the *Malerfürst*, or painter prince of Munich, and his ambition was attested to by the portraits of those he painted—Kaiser Wilhelm I, Kaiser Wilhelm II, Bismarck and Moltke, among others—

and he lived in a style of baronial splendor, owning several large mansions in the city.

During Lenbach's tenure as the "official tastemaker" in Munich, a dangerous split began to develop, for while the pretensions that Lenbach and his circle represented were both fed and echoed by the emergent middle class, these very pretensions represented a debasement of what many viewed as the traditional German values. Only one major figure was able to transcend this gap, and that was Richard Wagner, who came to Munich in the mid-1860s. Even Wagner, however, was subject to the same duplicity, the same "corruption," which came so bitterly under assault as the century closed. Yet, his style, his ostentation, possessed something that other artists of "officialdom" lacked entirely; in a word, substance.

The significance of Wagner's thought during this period will be discussed elsewhere; suffice it to say at present that, on the one hand, Wagner's Bayreuth festivals, with the elaborate stage settings of the operas, the ostentatious garden parties, and of course the princely style of Wagner himself, greatly appealed to the bourgeois's taste for pomp, elegance, and magnificence. On the other hand, Wagner's romantic philosophy, his exaltation of German mythology, his popularization of the *Gesamtkunstwerk*, his concept of salvation and redemption, his realization of the world of the dream, had an immediate and lasting impact upon artists as well as the public, not only in Munich but indeed throughout Germany and throughout Europe as well. The acceptance of Wagner's thought and its application was, in large part, responsible for the dramatic changes that began to affect the Munich art world, in particular, during the last decade of the nineteenth century.

Dissatisfaction with the Lenbach definition of "art" had been developing throughout the 1880s, but it was only, very cautiously, in 1892 that outspoken opposition led to an actual separation from Munich's prevailing academic style. In that year, Franz von Stuck, Fritz von Uhde, Gotthard Kühl, and others severed their relationship with the Munich Academy and formed a wholly independent group under the heading of "Munich Secession." The first exhibition of this "Secession" was held the following year, and while its doors were thrown wide open to such diverse artists as Liebermann, Corinth, Slevogt, Trübner, and Hölzel, the most decisive influences upon this group of "secessionists" (and on Stuck in particular) were the mystical and

mythical paintings of Arnold Böcklin and Hans von Marées.[2] The Secession never made any claims toward group cohesion and its members soon went their separate ways (Franz von Stuck, for example, was appointed a professor at the Munich Academy in 1895, a position in which he would later instruct both Wassily Kandinsky and Paul Klee), but the very act of separation from a rigid stylistic conformity had established a significant precedent as well as providing a liberating effect upon the artistic attitudes of Munich.

The breakthrough made by the Secession was quickly followed by others, most notably, the advent of the Jugendstil. In the closing years of the century, the Jugendstil represented something akin to a revolution in Munich, an idea whose time had arrived. The instrument of the Jugendstil artists was line, and their goal was a purity and beauty of form without need of reference to the visible or objective world. At its root, however, the new movement represented an attempt to spiritualize German art, to take it away from the world of the external and to direct it inward, into the mind and soul of the individual artist. Acting in many ways as a parallel to the ideological concepts that had emerged from the cultural crisis, the Jugendstil helped to give voice to concerns and aspirations that had been incubating for decades, only to emerge fully with the approach of the new century.

As the Jugendstil grew in popularity, several new magazines and journals were founded, initially to provide both an impetus and a sounding board for the movement, but which later achieved significance in other fields of intellectual activity as well. In Munich, two of the most influential of these publications were *Jugend* and *Simplicissimus*. Both weeklies were founded in 1896 and quickly became avant-garde institutions. Indeed, both *Simplicissimus* and *Jugend* acted as the principal organs for the literary avant-garde of Munich, its dramatists, novelists, and poets, as well as its painters and draughtsmen, and in their pages one could keep well abreast of the latest developments in literature.

Among the arts in Munich at this time, avant-garde drama was made available to a much wider audience when, in 1895, Ernst von Wolzhogen founded the Intimes Theater, and it was given even greater opportunity for breadth and scope when Max Reinhardt opened the Kleines Theater seven years later. On these stages one could view the recent works of Ibsen, Chekhov, Zola, Strindberg,

Gorky, and Tolstoy, as well as Strauss's *Salome*, and the newest plays of Gerhart Hauptmann and Frank Wedekind. There was an overwhelming propensity toward the representation of tragedy during this period, but unlike the curative tragedies of Ibsen and Chekhov, the German variety tended toward the fatalistic, focusing obsessively "on mankind's cruelty to man, on his bent toward self-destruction and death."[3] Of the contemporary German dramatists, none had a greater impact upon the future course of Expressionism than Frank Wedekind.

We will consider Wedekind's work in greater detail later on, but it is worth noting here that it had a strong and immediate effect in representing a mode of thought that appeared as a substratum during the nineties, but which would burst forth as a dominant theme after the turn of the century. It was Wedekind's conviction that humanity had become vile, an aberration against nature, corrupt to its very core, a form of life that had so repressed itself that it had completely lost touch with its own subconscious drives and longings. It was a form of life that had become a shell, an opaque imitation of its true being, one that could no longer be justified or maintained.

Similar expressions of discontent, and intimations of death and disaster spread through the works of the Munich poets of the nineties as well. Richard Dehmel spoke of "a well named sorrow/from which flows pure happiness,"[4] and Rainer Maria Rilke, in *Das Buch der Bilder* (*The Book of Pictures*, 1902) saw, in the armor of the knight,

> *Death squatting, brooding and brooding:*
> *When will the sword spring*
> *over the hedge of iron,*
> *that strange and freeing blade,*
> *to fetch me from this place*
> *that has cramped me many a day,*
> *so that I can stretch myself*
> *and sing*
> *and play?*[5]

The most influential Munich poet of the nineties, however, was a curious blend of mystic and high priest, a poet who, in his youth, had studied with Mallarmé in Paris and had carried the tradition of Symbolist poetry back to his native city. His name was Stefan George and his poetry reflects the same moodiness and despair that were so char-

acteristic of this period. George's *Das Jahr der Seele* (1897), for example, is a work enveloped in a mood of quiet melancholy. The poet's year of the soul contains no spring, for George the decisive season is fall; parting, loss, and resignation to fate are his basic motifs. In a later work, *Der Teppich des Lebens* (*The Tapestry of Life*), published in 1899, George presented the reader with the major themes of his art and thought, among them, aesthetic detachment; the establishment of an aristocratic elite antagonistic to modernity and devoted to the ideals of Greece; a new feeling for the *Volk*, for the pulse of the nation and its heritage; the slavish devotion to the leader; and the extolling of the Dionysian, the antirational. Significantly, the last word of George's tapestry is "death."[6]

The figure who dominated the thought of this period was Friedrich Nietzsche. Rescued from obscurity only in the nineties, his works came to touch or influence all of the artists and writers we have so far discussed (and indeed will discuss). It was the Nietzsche of *The Birth of Tragedy*, of *Beyond Good and Evil*, of *The Genealogy of Morals*, of *Zarathustra* who completely enveloped the desires and inclinations of an entire epoch. It was the Nietzsche of the Dionysian, of the antirational, of the vitalistic, the Nietzsche of the "transvaluation of values," the exposer of the "slave revolt in morality," of the emergence and presence of decadence, whose words would be carried as "weapons of truth" by generations of Germans, those seeking to bridge the abyss between past and future, those seeking to overcome the life-inhibiting atmosphere of the diseased and corrupt society they saw smothering them.

It was into this wholly ambiguous world of doubt and uncertainty, this society enveloped by dissatisfaction, dissent, and despair, this city embroiled in intellectual and cultural ferment, that Franz Marc was born on the eighth day of February, 1880.

2.

Franz Marc's father, Wilhelm, was a man "of distinguished stature, of elegant footing and cultivated hands; his bodily constitution was rather delicate, something that in later life his family, to its grief, would notice to an ever more considerable degree."[7] Until his marriage in 1876, Wilhelm Marc had moved in the highest social circles of Munich and had become a competent if not wholly successful

painter of romantic landscapes and interiors. He was a sensitive, introspective figure, "a peculiarly philosophical man," in the recollection of his son.[8] At the age of thirty-seven he married the governess of his sister's children, Sophie Maurice, a woman who, while born in Alsace, was raised in a Calvinist boarding school. A handsome woman, she could be strict and severely moralistic. Indeed, her religious and moral standards were decisive in halting some of the fashionably "decadent" tendencies of her husband's early work. After their marriage these tendencies disappeared. Because his wife felt alien in his social milieu, the young man gradually withdrew from such circles.[9] Despite these contradictions in upbringing, social status, and philosophy, the marriage soon produced two children: Paul, born the following year (1877), and Franz, born three years later.

Little is known of Franz Marc's early years, other than the recollection of his mother that he was a shy, sensitive, quiet, and withdrawn child who, because of his continual seclusiveness, was referred to by the family as "the little philosopher." He began drawing at an early age, probably at the instigation and under the supervision of his father, but any inclination toward a career in art was certainly not considered seriously at this time.

As a young man, Franz, like his brother Paul before him, entered Munich's Luitpold Gymnasium, pursuing a course of study in theology, the field in which he ultimately received his *Abitur* in 1899. Our knowledge of his youthful perceptions is considerably broadened by a correspondence he developed at this time with a man almost twice his age, the Germanic philologist, Dr. August Caselmann. The two first met at Schney, a village near Lichtenfels am Main, where Marc had gone during the summer of 1897 to visit his former pastor and mentor, Otto Schlier. Caselmann, a classmate of Schlier's, remembered,

> it was during the summer holiday of 1897 that I became friendly with the then 17 year old—we walked together. I was continually astonished by his intellectual maturity. He had already read much and grasped with a critical view those problems he had encountered in his readings. Art, literature, religion, those were our themes as we wandered along the lovely banks of the Main. He was unclear about his future occupation . . . the idea of a customary career did not seem to satisfy him, on the contrary, he sought new lands and viewed all the major events of the time critically.[10]

In his letters, Marc spoke of reading Epicurus, and he relayed to Caselmann the idea of reconciling Stoicism with Christianity. He showed particular enthusiasm, at this early age, for the works of Richard Wagner and Thomas Carlyle, and expressed dissatisfaction with the most recent works of Gerhart Hauptmann; but one name is referred to with the reverence of a new discovery. In a letter dated 2 August 1898, Marc wrote,

> I have now placed all other readings aside in favor of Nietzsche. *Zarathustra* is a work of poetry and magnificence of thought almost without equal in its intensity. *Beyond Good and Evil* and *On the Genealogy of Morals* have affected me very deeply. I have read with great attentiveness what Nietzsche has said here. . . . It is becoming very clear to me, what I had only formerly felt and thought in my intimations, presentiments, and instincts. And I have now become one with my Christianity and with Nietzsche. [11]

In addition, we know that Marc was, at this time, deeply interested in the work of the German Romantics, possessing in his library the complete works of both Novalis and E. T. A. Hoffmann, the latter a legacy from Marc's great aunt. [12]

The sensitivity, shyness, and introspection that Marc evidenced as a child seem to have extended well into his eighteenth year. In a letter from August of 1898, he wrote Caselmann that he was spending the summer months at the home of his parents in Pasing, a suburb directly to the west of Munich's city center, and that he had

> little desire to travel. Yet even here I have enough opportunity to pay tribute to my habitual "Wanderlust." I roam all over the neighborhood alone, except for my little dog Trine as faithful companion, seeing cities, people, and countryside. What pleases me is that I can retain it in my memory as well as in my sketchbook. . . . By wandering about attentively one learns very very much and understands what one sees and hears. And, the fact of being alone sets one free to write what one thinks. [13]

It is clear from the Caselmann correspondence that Marc was having a great deal of difficulty in resolving his plans for the future. On the one hand, he showed a decided inclination toward theology, especially in his attempts to reconcile Christianity with the philosophies of Epicurus and Nietzsche. On the other hand, he demonstrated an avid interest in literature and creative writing, and indeed, as seen in the

above letter, a renewed interest in art. Marc seems to have made his choice during the following year when, after receiving his *Abitur* in theology, he decided to enroll in the University of Munich as a student in philology.

Before he was able to attend any classes however, Marc was compelled to serve a year of duty in the military. He spent this year at the field artillery training camp at Lechfeld, where in 1900 he at last made the fateful decision that would alter his life. He related the news to Caselmann: "I have finally found the courage to proceed to my true element and that is art. I am happy you are not in disagreement with my true occupation." [14]

The disagreement about Marc's chosen profession came not from Caselmann, but from closer to home, indeed, from Marc's own father. As the artist's later wife, Maria, recalled: "That he wished to be a painter was no pure joy for his father who saw no special talent in what Franz Marc had occasionally drawn or painted." [15] Nonetheless, the artist had made his decision and, in the spring of 1900, began attending classes at the Munich Academy.

At the turn of the century, with few exceptions, the Munich Academy remained a stronghold of conservative naturalism, of ponderous, heavy-toned landscapes, and of equally severe old-master-like portraits. Marc spent a total of two years at this institution, the first in the drawing classes of Gabriel Hackl, the second in the painting studio of Wilhelm von Diez. While Marc's absorption of naturalism is evident in his earliest paintings, these works nevertheless demonstrate more than a hint of individuality, a depth of insight that already reaches beyond the surface of the canvas and penetrates into the very life of the subject.

This quality of discernment is particularly evident in the two portraits of his parents, both dating from his final period at the Academy in 1902. Stylistically, *Portrait of the Artist's Father* [1] and *Portrait of the Artist's Mother* [2] are fully in keeping with the academic directives of portrait composition, with their concentration on the tonal contrasts between light and dark areas, de-emphasis of the importance of color, and the dedication to as physically accurate a rendering of the sitter as possible. Beyond this however, the artist brings us into contact with the psychology of these individuals, and allows us to "read" the works as portraits of personality.

The physical frailty of the father, for example, is suggested by the

1. *Portrait of the Artist's Father*, 1902, oil.

2. *Portrait of the Artist's Mother*, 1902, oil.

sharp contrast between the apparent limpness of the left arm and hand resting, as with great weight, upon the solidity and firmness of the chair's armrest; the gentle grip on the cigar between the thumb and forefinger of the right hand, which seems so casual and yet so precarious, so full of effort. Our attention is consistently drawn to the area between hands and eyes, between the focus on the physical and the gateway to the spiritual. The eyes of this "peculiarly philosophical man" are directed away from the viewer, away from the composer. Staring downward to the right, the eyes reflect an absorption in thought, an aura of contemplation, of concentration into what is beyond the purely visible. Yet, once again, we cannot help feeling the sense of precariousness, the intimation of portent, the gloominess these eyes project, as though they had been able to forecast the bitter reality that lay ahead.

Although rendered in the same predominant tones of black, gray, and white that characterize the image of the father, Marc's *Portrait of the Artist's Mother* is a sharply divergent work, revealing an altogether different personality. Seated in a less sturdy cane chair, she nevertheless reveals a quality of strength that appears noticeably absent from the portrait of her husband. She is a woman firmly in control, her body bent forward, her hands clasping an open book, presumably the Bible. The light which seems to radiate from the pages themselves is reflected in the strong, sharp features of her face, revealing a communion of spirit, a sense of unity between book and reader, a feeling of mutual reinforcement. There is a definite impression of comfort, of security, rendered in this dialogue between reader and book that extends beyond any simple depiction of domesticity; a quality that is revealed in the absorption of the eyes into the substance of what they are reading. This portrait of the artist's mother is, at its core, an expression of conviction, an image revealing the meaning of the transmission of values which, when received, accepted, and understood, can act to bridge the past, the present, and the future.

This portrait is an image of family as well for, although our attention is naturally focused upon the mother, we can see to the right of her head a portrait of her infant son, the artist, painted by her husband. Their presence is thus with her, even while her concentration may be momentarily directed elsewhere. The underlying feeling of unity, of family, of calm and serenity, in this portrait of the mother thus provides a strong contrast, a persistent alternative to the lonely,

isolated image of resignation that we see in the father. They are the
representations of two distinct and separate personalities, each with a
different bearing, each possessing a different attitude and philosophy
toward life, each containing qualities that were transmitted to their
son but which could never be fully integrated by him.

Even at this early stage of his development, with his means of rep-
resentation only barely adequate in expressing the depth of his feel-
ings, Marc was already engaged in the struggle that would continue
throughout his short life. Perhaps unconsciously, this avid reader of
Nietzsche could already recognize "the tired, pessimistic look, discour-
agement in the face of life's riddle, the icy *no* of the man who loathed
life," [16] in the countenance of his father while, at the same time, har-
boring an intimation of doubt, a lingering, as yet unidentifiable, dis-
satisfaction with the "fatal self-presumption" [17] of his mother's faith.
In the years ahead, Marc would use his art as an instrument to recon-
cile these divergent ideas, to discover a fresh, new faith that would
provide solace from loneliness and answers to "life's riddle," a faith
that would leave behind the dogmatism of the past, a faith that he
would later describe as "a new religion . . . still without a spokesman
and identified by no one." [18] Before he found even a degree of resolu-
tion for these contradictions however, Marc would undergo a long
and often desperate struggle, an extensive period characterized by
disappointment, tragedy, and failure.

In the fall of 1902, the artist accompanied his brother Paul on a
short trip to Italy, but the visit seems to have had little impact on his
method of representation. His landscapes from this period, among
them, *High Mountain Landscape with Shepherd, View of the Staffel
Slopes, Woodland Path in the Snow* [3], are wholly conventional, fully
in keeping with the naturalism of the Academy. Yet, at the same
time, the subject matter of these works reflects a peculiar moodiness,
an oppressiveness, a sense of loneliness conveyed by the minute size
of the figures in relation to their environment. In one, a shepherd is
dominated by the mountain peaks that surround him; in another, a
solitary house is perched broodingly atop a snowy ledge; in a third, a
peasant is seen trudging through a path in the snow, flanked by the
tall pines that tend to diminish his presence.

More decisive in its effect on his stylistic development and on his
state of mind was a trip Marc made the following year, in 1903. This
excursion, made possible by the generosity of a wealthy fellow-

3. *Woodland Path in the Snow*, 1902–3, oil.

student from the Academy, lasted more than six months, and took the two young budding artists to Paris and the Breton coast.[19] This trip represented Marc's first extended departure from his home city, and indeed, away from the influence of his parents. As Alois Schardt has noted, "At his parents' home he lived in a very free intellectual atmosphere, one that in no way withheld the necessities of life. But his father had extremely decided views about the nature of art, with which his son did not always agree. The mother was very strict and she placed no value on a cultured mode of life. . . ."[20] These travels showed Marc a new way of life, filled his mind with new impressions, and assisted his own independence of thought and action.

It was during his stay in Paris that Marc first made contact with the work of the French Impressionists. After viewing an exhibition of works by Manet, Renoir, Monet, Pissarro, and Boudin, at the Galerie Durand-Ruel, he excitedly wrote home: "A huge collection of Impressionists—of crucial significance to me. . . . The only salvation for us young artists."[21] In his diary he noted that this experience had marked "a turning point in my life."[22] Yet, for all of the excitement, all of the new impressions that he had received, all of the fresh discoveries he had made during his stay in France, the young artist produced few original works. After more than six months abroad, Marc returned home to Munich with three India-ink drawings, one watercolor sketch, and one oil study. What was lacking in quantity, however, was made up for not so much in terms of quality (for the works are generally pedestrian in execution), as in the new avenues of exploration which they represent.

One of the drawings, *Café Chantant II* [4], has been described as "Parisian in both subject matter and in the freshness with which it is conceived and treated."[23] Indeed, it does possess some of the qualities of an unstudied Impressionist sketch, with its quick rendering of a boulevard scene in Paris, captured during the summer of 1903. Even in the poorly executed watercolor sketch *Dancing Breton Fishermen* Marc's brush shows a sense of vitality, a feeling for rapid movement that had been totally absent from his previous compositions. Further, in the oil study entitled *Children in a Boat,* painted at the Breton coast, the young artist demonstrates a new concern for the effects of light and atmosphere upon an outdoor composition, and while the color scheme still remains somewhat somber and muted, there is, nevertheless, a new freedom of application, a loosening of

4. *Café Chantant II*, 1903, India ink.

brushstroke, that is far advanced from his works of only a year before. This life-fulfilling period of joy and satisfaction, of exploration and discovery, would unfortunately be an all-too-brief interlude, for almost immediately upon his return to Munich, Marc would fall victim to a melancholic depression of such severity that its effects would remain with him for as long as he lived.

3.

When Franz Marc returned from France in the fall of 1903, he was approaching twenty-four years of age. For almost four years he had been deeply committed to his vocation as an artist, having earlier proclaimed and then abandoned careers in both theology and philology. Yet his development as an artist was slow, painfully slow: after four years of work he had completed no more than a total of twenty oil paintings (including oil studies). He had not yet found a style or mode of working within which he could feel comfortable, nor had he

been able to resolve the internal doubts and conflicts upon the surface of his paintings, as he may earlier have imagined he could. Art, he felt, was his instrument, his means of expression, his true voice, and yet until now that instrument appeared terribly blunt, leading him nowhere, expressing little, resolving nothing. By nature introspective, shy, and lonely, Marc was now further obsessed by the idea of failure, the dread of disappointing not only himself but even more importantly those he loved, those whose judgment would be tantamount to a determination of his own self-worth. During the later months of 1903 that judgment was rendered almost totally in terms of negatives.

As we have seen, the artist's father had been opposed to his son's vocation from the very start—not, as one might expect, due to the difficulties in earning a living, but even more injuriously, because he felt that his son lacked talent. Nothing that Marc accomplished in the intervening years in any way altered that initial judgment. When the young artist returned home from his half-year abroad armed with the scantiest visible evidence of his artistic inspiration, his reception must have been memorable. "For his father and his family," according to Schardt, this meager production "was completely incomprehensible."[24]

A year and a half later, on the occasion of his son's twenty-fifth birthday, the elder Marc expressed his position in the clearest of terms: "In the year 1905 the father delivered an affectionate yet painful judgment upon his son. As he turned 25 on the eighth of February, the father said to the son, half in bitterness, half in jest, 'Thus 25 years! So far at least you have accomplished *that!*' "[25] While this was indeed more of an accomplishment than the father might have imagined, such a statement could only add to Marc's already intense feeling of worthlessness. Even more damaging to the psyche of the young artist was the knowledge that this statement represented the judgment of a man critically ill, a man with only two years to live.

In 1892 Wilhelm Marc was stricken by an unknown but progressively crippling and incurable disease. Some of the effects of this illness are apparent in the 1902 portrait; the weakness in the hands, for example, and the despairing quality of the eyes. By 1906 the condition of the elder Marc had deteriorated sharply, indeed, to the point of total paralysis. All that remained for the family was the inexpressible hope that death would come soon and extinguish the suffer-

ing. This it finally did in the spring of 1907. Thus, for fifteen years, from the age of twelve to the age of twenty-seven, Franz Marc, a sensitive impressionable youth in search of an answer to the riddle of life, was compelled to witness the pathetic tragedy of his father's gradual decline toward death. The physical deterioration of his father was an experience that overwhelmed him, an ordeal so painful that its effect tended to shatter whatever faith Marc still retained in the "truth" of physical being. During this period, the young artist began to retreat further and further away from what he now viewed as a cruel and merciless and horrifying reality.

Unable to understand the reasons for his own failings, lacking encouragement and direction in his work, and incapable of fully comprehending the burdens inflicted upon him by the daily confirmation of disease and mortality and the frailty of life, the already introverted Marc tended to withdraw even further from the world, further into himself. Yet, this effort to escape into the self merely served to compound his agony, to increase his frustration, and to magnify his desperate feeling of loneliness. Ironically, the depth and severity of his depression also had an inhibiting effect on his productivity, tending to limit his output still further, to diminish his initiative. As we have said, Marc's depression was extremely long-lived, and while it fluctuated from mild to severe reactions, the most intense period of despondency seems to have occurred between his return from France in 1903 and the death of his father in 1907. Indeed, the almost constant disorientation that the artist was experiencing at this time invariably found its way into his work—compositions which, without significant exception, now begin to reveal a marked disposition toward the projection of moods of extreme melancholy. This state of mind is made strikingly apparent in the artist's *Self-Portrait* [5], painted early in 1904.

As in the portraits of his parents, Marc's power of discernment, his keen critical eye, is still very much in evidence. Here, however, he had turned this faculty upon himself and has attained a result that can best be described as haunting. Beyond the appearance of self-assurance or relaxation suggested by his deceptively casual posture, the face of the artist betrays a mood of ghostly despair. Within that face, the dark sunken world-weary eyes cast an aura of such pervasive dread that no other element in the painting is able to diminish the fear, indeed the terror that they project. The eyes are the deter-

5. *Self Portrait*, 1904, tempera.

minant focus of this image, touching, influencing, and affecting all that is mirrored within them, all that the artist sees in himself. The rest is merely affect, compensation; the tousled hair, the loosely tied cravat, the exaggerated gesture of placing the hand on the hip, the carefree almost cavalier swerve of the coat, all are desperate attempts by Marc to project the image of a self-assured, self-confident, self-reliant artist.

By assuming this demeanor, by donning these accouterments, Marc self-consciously sought to temper the reality of his own situation, sought to compensate for the gnawing persistent belief in his own failure. In this portrait the artist tried to present himself as a success. To allay his own feelings of self-deprecation, he attempted to convey the impression of self-worth; to ease his all-enveloping fears he longed to view himself as a figure in firm control. Yet, in the end, all of these attempts at self-assertion were countered by the brutal candor of his own vision, by those haunting, fearful eyes, and the dreadful unspeakable portent they contain. With his sense of failure now further compounded, his fears intensified, Marc destroyed the painting—only a photograph of it remains.

Desperately in need of warmth and reinforcement and human understanding, Marc entered into a brief relationship at this time with "a spirited, artistically talented" young woman named Annette von Eckardt. According to Schardt, "she was able to understand him and to adapt herself to the idiosyncracies of his personality," and by so doing, "provide him with an inner security which he could not give to himself." [26] Indeed, Marc's remaining sketches of her, all dating from the end of 1904, show her to be an attractive, sensitive-appearing individual, with large, deep-set eyes that reveal more than a hint of empathy and compassion. It was at her instigation that Marc began work on a series of illustrations to moody sentimental poems—illustrations that he was never quite able to complete, but which nevertheless reveal that his literary interests were, at this time, directed toward the somber, the melancholy, and the erotic. [27]

By the middle of 1905, after a long period of inactivity, Marc left Munich and spent the entire summer walking, sketching and painting in the Bavarian Alps, west of Kochel am See. It was here that he first showed an interest in representing animals within nature, and in his sketchbook he recorded several studies of sheep, concentrating mostly on their facial detail and on the interrelationships of the herd.

According to Maria Marc, however, this summer's activity "remained merely experimental without any determined goal."[28] This is equally true of the two small landscape studies which he also executed on his wanderings through the mountains.

While they are merely oil sketches, both *Mist among Fir Trees* and *Small Mountain Study* [6] nevertheless show a much freer, more open style than is evident in any previous works of the artist. The fir trees in both paintings are rendered quickly, as are the grasses of the mountain slopes, the agitated brushstrokes now more fully engaged in the suggestion of form rather than in its actualization. The color is still rather muted (as indeed it would remain for many more years), tending toward the deep dark greens of the grasses and the silver-gray of the misty skies. Yet, it is these very tones that combine to give these two works such a peculiarly chilling effect, an ominous air that is reinforced in the first study by the progressive, relentless movement of the fog down the mountainside, a force which seemingly disintegrates the trees it touches; in the second, by what for Marc is an unusually harsh, emotionally agitated brushstroke that composes not only the mountain slope but the sky as well. Both works tend to project an atmosphere of unsettledness, of anxious disquiet that would become even more apparent in the months ahead.

When Marc returned to Munich from the mountains in the fall of 1905, he reentered a world that would soon provide him with new vistas and old torments. In the late summer he had met Marie Schnür, a painter and illustrator for the magazine *Jugend*, and through this friendship Marc was introduced to several other members of the Jugendstil movement. He became especially interested in a group of artists known as "Scholle" (Soil), which was composed of a number of *Jugend* illustrators who sought to initiate a new style of art by infusing decorative Jugendstil motifs into somewhat more traditional naturalistic landscapes.[29] Marc's association with this group seems to have had a beneficial (though not immediately recognizable) effect on the development of his style. By 1906 his forms are generally more flattened in appearance, tending toward sharper, more defined areas of color and showing less dependence on the representation of three-dimensional reality.

It was during this period, in October of 1905, that he met the French animal painter Jean Bloé Niestlé, a man who was to remain his life-long friend and with whom Marc had much in common emo-

6. *Small Mountain Study*, 1905, oil.

tionally. In a letter to Fräulein Schnür, dated October 20, 1905, Marc described Niestlé as "a retiring young-blooded French animal illustrator of such genial melancholy that it pains one to see his drawings. . . . He is very poor and almost unknown; one of those poor one-sided geniuses, most of whom die young from melancholia, those to whom nature had imparted a frail sick body. He had not been able to work from spring until August."[30]

Marc and Niestlé also shared an interest in the representation of animals, and Marc was deeply impressed by his new friend's keen ability, as he put it, to "design a large, nearly endless, animal study . . . in which he painted hundreds of birds (swarming in flight). One can almost hear the chirping and the rustling of the wings. And none the same as the other! Every animal has its own expression!"[31] While Marc had shown some interest in the illustration of animals prior to his meeting with Niestlé, the Frenchman provided him with an entirely new focus in the direction of empathy with the animal and its representation as an object of expression. Marc would have cause to test these new ideas in the very near future.

In the winter of 1905 Marc's relationship with Annette von Eckardt suddenly ended, and the feeling of deep melancholic despair again

7. *The Dead Sparrow*, 1905, oil.

swept over the artist with a renewed intensity. The most immediate tangible results of the artist's frame of mind can be seen in his works from this period, works whose very titles reveal the depths of his gloom: *Snow-Covered Branches*, *The Fiddler of Death*, and *The Dead Sparrow*. Of these three, *The Dead Sparrow* is perhaps Marc's most depressing work to date, yet it is his finest in terms of quality.

The Dead Sparrow [7] is an unusually small painting (measuring only about 5 x 7 inches), painted on wood, and rendered in the most muted of tones, with a color scale ranging from gray to white. Again, the brushstrokes are highly agitated and, while the paint is quickly applied, the monumentality of the small form it depicts is overpowering. There is no ambiguity about the bird's condition, nor is there anything to distract us from the disquieting stillness of its presence. The small creature is stretched out upon its back, its wings folded in toward the body, its head limp, its claws grasping the air, almost imploring, as if its struggle to remain alive had been intense. There is an expression of futility about this struggle, about this small animal which, when alive, could consistently transcend its earthly element, an object of simple grace toward which man could look with envy.

Now it is another image of death, an image which reflects the mood of the artist who painted it. There is more than mere pity expressed here, more than regret or disappointment at the frailty of life, for Marc exposed much of his own self in this painting, much of his own unutterable sorrow, many of his inexpressible fears, and perhaps many of his own subconscious longings as well.

This same quality of both empathy and projection is even more strongly in evidence in Marc's portrait of his friend Niestlé [8], painted in the winter of 1906. Here we see the rather frail-looking artist that Marc had earlier described as melancholic in disposition, with a small bird (possibly a sparrow) resting on his right hand and being caressed by his left. Indeed, birds completely surround him; one rests on his shoulder, one perches on his hat, another is ready to alight on his hand, while two others fly toward him from the distance. There is a deep thoughtful expression in the artist's eyes as he studies the small animal perched upon his fingers. Something approaching an unspoken communication or communion of spirits is revealed in this tender action, something that reaches beyond simple pathos. This *Portrait of Niestlé* is a sensitive, moody work, one that Klaus Lankheit has accurately described as a "document of the melancholic spiritual condition of Marc himself." [32] Further, the portrait represents a sense of longing to be what man is not, a definite expression of envy for these creatures who can never experience the torments of despair, the ravages of doubt or the bitter disappointment of failure, creatures unburdened with the knowledge of their fate. As deeply touching as it is, this portrait and the nature of its content would prove decisive for Marc in the years ahead.

In an effort to soothe his brother's abject despair, Paul Marc invited the troubled young artist to accompany him on a journey to Salonika and Mount Athos in the spring of 1906. As in Paris, three years earlier, Marc seems to have internalized what he saw, for once again his production was meager; no more than two or three sketches of Mount Athos, drawings of crickets and elephants and one watercolor of his brother atop a mule. When he returned to his native land however, the artist's depression was as deep as ever. Spending the summer once again in Kochel, Marc spoke of his state of mind in a letter to his friend Marie Schnür,

> Oh why has destiny closed this art to me! I have heard it in the songs: it can become deadly for me. I resign myself to it completely.

8. *Niestle with Birds (Portrait of the Painter Jean Bloe Niestle)*, 1906, charcoal.

One must be by nature poetic and creative in order to be redeemed through poetry. . . . I can no longer endure the idea of living in painting without painting myself, from dawn until dusk! It must free me . . . from my fear; I so often experience a sense-deluding fear of simply being in this world. One must create gods to whom one can pray. . . . Others have their gods, they carry their religion within themselves, I know it. From their endless longing, they enter into a joyful heaven—I need something else, something completely different, and yet I can only grope towards it.[33]

During this summer Marc attempted to relate the human figure to a natural setting in a series of oil sketches entitled *Two Women on a Mountain*. Though wholly unsuccessful in terms of their composition, the works of this series demonstrate a heightened awareness of the potential of color as an expressive medium.

In the winter of 1906, his father's condition took a decided turn for the worse. The day after Christmas of that year he wrote to Marie Schnür, now his fiancée, from his parents' home in Pasing:

I have begun to paint Papa. I hope it will be good. It is a difficult half-light full of rose-grey and green tones. In any case it is a resemblance—a *profile*. Everything is concentrated in the weary view of emptiness. I am afraid Mama will find it somewhat gruesome, but this weary wait for death is something horrible.[34]

In the portraits of his father, *Father on the Sick Bed I* and *Father on the Sick Bed II* [9], there is indeed a "weary view of emptiness" apparent, a painful recognition of the inescapable presence of death. The old man, his hair and beard now white, his cheeks shrunken, stares upward with mournful eyes as if asking for release from the condition that torments him. There is no hope expressed in these works, only the fateful certainty of a dying man, a sense of futility at halting the inevitable, an aura of sadness acknowledged by his despairing son in lines of poetry written at this same time:

And down go my days like boats,
in which, mute, my dead life sits.
I stand on the shore waving and calling
But my life does not respond.
My own life sails quietly by.[35]

9. *Father on the Sickbed II*, 1907, oil.

In April of 1907 several events occurred that radically altered the nature and course of Marc's life. In rapid succession, during this fateful month, his father died, he was married to Marie Schnür, and on the evening of his wedding, "alone, without his wife, and tormented by a terrifying depression,"[36] Marc fled to Paris. He would return from the trip a changed man.

4.

It should be clear from what we have seen that Marc was not suffering from a simple case of "the blues" or from a "longing for love" but rather from something far more serious. Indeed, in psychological terms Marc's affliction may be referred to as a severe "depressive reaction."

While the symptomology of this type of depression is varied and complex, it may be initiated by, among other things, the death of a close relation, by disappointment in love, or by feelings of guilt relating to one's sense of failure.[37] The depression itself is realized when the individual either overreacts to the onset of such stresses or finds himself lacking in the resiliency needed to cope with the emergent

situation. What follows is a tendency toward dejection and despair, coupled with anxiety, apprehension, and a diminishing of initiative.[38]

This accurately reflects the condition of the artist we have been describing, the artist who spoke of "an anxiety that numbs my senses," and who, before his flight to Paris in 1907, said, "I am nervous and depressed. When I relax my hermit-like habits I feel lonelier than ever.[39]

An additional stress on Marc's state of mind was the decline of his father's health which acted in its own way to compound his already prevalent feelings of failure. Both the fear of his own failure and the fear of his father's judgment upon him as failure created a natural responsive hostility in the artist, a hostility which was directed toward himself, but also, and perhaps more significantly, toward his father as well. This latter hostility would have the most damaging of consequences.

From at least one direction, Marc's depression had its roots in his own feeling of insufficiency, compounded by his fear of failure in the eyes of others. This fear manifested itself in hostility directed at the loved ones, and especially toward the father, a hostility that resulted eventually in guilt, which in itself caused a repetition of this process on an even more intensified level of self-condemnation. Depression is a complex process, however, involving a considerable number of changes within the individual, among them, changes in mood, sadness, loneliness, a negative self-concept, and a desire to punish oneself or to regress, a longing to hide, escape, or die.[40]

Marc experienced all of these emotions, but the final one was to be the most long-lasting, acted out upon a number of different levels, yet consistently expressive of the same basic desire—to regress, "to hide, escape, or die." Thus, while many years later, the artist could recall this period in his life as a time of "grievous melancholy, when the stupid Self stood directly in the center of all feelings,"[41] he could also remember that "at that time death avoided me, not I it."[42]

Marc's escape to Paris in 1907 was thus, in a very real sense, a flight from a reality that had become too painful to bear. This attitude was expressed quite clearly in one of his letters home, when he said: "Oh if only life were like our dreams. Life is a parody, a devilish paraphrase, behind which stands the truth—our dreams. I firmly believe that this is so. Art is nothing more than the expression of our dreams, the more we resign ourselves to it, the closer we come to the inner

truth of things, our dream life, the true life."[43] It was also in Paris that the artist found the means to sustain himself, to submerge his anxieties into a larger whole, to project his loneliness into a greater unity, to give expression to his dream.

There, upon viewing several of the late works of Van Gogh and Gauguin, Marc wrote that his "wavering anxiety-ridden spirit found peace at last in these marvelous paintings." He marveled at the Van Goghs adding, "Van Gogh is for me the most authentic, the greatest, the most poignant painter I know. To paint a bit of the most ordinary nature, putting all one's faith and longings into it—that is the supreme achievement."[44]

After his return from France, Marc spent the summer of 1907 at Indersdorf, north of Dachau, attempting to give visual confirmation to his new discoveries or, as he said, "to paint only the simplest things [for] only in them are the symbolism, the pathos, and the mystery of life to be found. Everything else distracts, diminishes, and depresses me."[45] His work during this summer is, however, completely derivative, showing an understanding of Van Gogh's style but grasping none of the emotional connotations of his use of color. Thus, in a painting such as *Wheat Shocks* (1907), the impasto is thick, the brushstrokes convincingly applied and sharply defined, but the whole is totally lacking in conviction, in any sense of unity between artist and subject. This remoteness is further reinforced by the overall pastel coolness of the composition and by the artist's insistence upon rendering shadows in terms of brown and gray.

In seeking "the pathos and mystery of life," Marc traveled in September to Swinemünde, a town on the Baltic coast northwest of Stettin, and there painted a small picture that reflected the truth of his dreams. *Rider at the Sea* [10] is a dreamy, meditative painting made even more so by the nature of its subject, a nude figure riding bareback upon a dark horse before a sea of indeterminant scale. Marc has here returned to that agitated, emotionally charged brushstroke that we saw two years earlier in *Small Mountain Study*, but here the rhythmic, melodious swirling of the paint exists as an entirely convincing expression of the constant motion of the water. Indeed, the sea is the true body of the painting; the horse and its rider appear almost minuscule before the surging of the waves, and yet they are neither lost nor diminished. There is an aura of mystery at work in this

10. *Rider at the Sea*, 1907, oil.

painting, a feeling of unity existing between man and animal and the forces of the natural world.

It is the kind of unity that Karl Joël expressed in his *Seele und Welt*, published five years after Marc's painting, but almost eerily exact in describing its substance:

> I lie on the seashore, the sparkling flood blue-shimmering in my dreamy eyes; light breezes flutter in the distance; the thud of the waves, . . . beats thrillingly and drowsily upon the shore—or upon the ear? I cannot tell. The far and the near become blurred into one; outside and inside merge . . .
>
> . . . (M)y soul floats out of me as a blue waste of waters. Outside and inside are one. The whole symphony of sensations fades away into one tone . . . ; the world expires in the soul and the soul dissolves in the world . . .
>
> . . . (O)ur life a short pilgrimage, the interval between emergence from original sadness and sinking back into it! Blue shimmers the infinite sea, where the jelly-fish dreams of that primeval existence to which our thoughts still filter down through aeons of memory. For every experience entails a change and a guarantee of life's unity.[46]

Here at Swinemünde, Marc first came to realize the joyous meaning of organic unity, of the harmony among all living things. Like

Joël, he found that it could only be fully experienced in a moment of total suspension, in a loosening of the opposition of consciousness, in a state of dreamy intoxication.

The longing to partake in this unity led Marc toward an intensive investigation into the nature of those living beings which experience it daily, the animals. After spending several weeks in Berlin during the fall of 1907, visiting the zoo daily and making countless sketches of the animals there, Marc returned to Munich and from this period until 1910, in order to earn money, conducted lessons on animal anatomy in his studio.

Generally speaking, Marc's entire artistic preoccupation, from the winter of 1907 to the winter of 1910, was spent in attempting to give visual expression to what he would now refer to as "the organic rhythm of nature." He made his position quite clear to Reinhard Piper, in a letter written December 8, 1908, when he said,

> I am attempting to enhance my sensibility for the organic rhythm that I feel is in all things; and I am trying to feel pantheistically the rapture of the flow of "blood" in nature, in the trees, in the animals, in the air.
> . . . I can see no more successful means toward an "animalization" of art, as I like to call it, than the painting of animals. That is why I have taken it up.[47]

Thus, whether in the pastures of Lenggries (1908) or in the mountains of Sindelsdorf (1909), whether in *Large Lenggries Horse Picture* (1908), *Large Deer Drawing* (1908), *Mother Horse and Foal* (1909), *Foals in the Pasture* (1909), *Large Landscape* (1909), *Deer in the Reeds* (1909), or *Forest Interior with Deer* (1909), Marc sought to compose an image of organic rhythm between animal and nature, one that bound them to a unity existing beyond man's conscious comprehension.

For Marc, this visual expression of unity was achieved primarily through the rendition of line and structure. For example, in *Large Deer Drawing* [11], we see two deer pictured solely in browns and whites, the contours of their bodies rendered separately and yet, through the rhythm of their forms, these deer are joined together in a large arabesque which, in itself, becomes the binding harmonic force of the work. In the *Large Landscape* [12], four horses are again bound together through the linear rendition of their bodies, and in this case

11. *Large Deer Drawing I*, 1908, chalk and tempera.

12. *Large Landscape I*, 1909, oil.

the very landscape itself is distorted in order to conform to the contour of the animals' forms. We find this lucidity in each of these paintings, paintings in which the artist has given expression to his belief in a "flow" within nature that courses and vibrates and pulsates among all living things.

Within the sense of unity enunciated by these works we also find a harmonic order of things, an order that extends beyond the compositional or technical propensities of line and contour. Each of these animals appears safe, secure, at home within its environment and free from threat. This is not a "nature red in tooth and claw," but a nature of serenity, a paradise of peace and tranquility, of innocence and the free play of instinct, a world which, in the final analysis, represents a projection of the artist's own need for escape, his own longings, his own desire for inclusion within the rhythm of the universe.

By the summer of 1909 Marc had moved to Sindelsdorf, there sharing a cottage in the mountains with his friend Niestlé. A year earlier he had obtained a divorce from his first wife and was now seeing and corresponding regularly with Maria Franck, whom he would marry in 1911. In his artistic development, however, two events occurred late in 1909 and early in 1910 that have such far-reaching import that they properly belong to another chapter: his introduction to the group of artists who referred to themselves as the Neue Künstlervereinigung München and his meeting with the painter August Macke.

The Years of Transition

1.

B Y D E C E M B E R of 1909, Franz Marc had fully attained a compositional means of depicting the unified, harmonious nature of which he longed to be part. The artist's forms had become more and more simplified, departing even further from the strict naturalism of his earlier years. His sense of line was now more subtle, more rhythmic, less purely descriptive in terms of defining individual shapes, and more evocative of a larger unity existing between form and environment, between animal and landscape. The only major quality his work now lacked was a more comprehensive feeling and understanding of color as an independent means of expression, a means which could provide a new sense of force, of vitality and conviction to the works themselves.

Marc's search for this expressive color was greatly facilitated by his introduction to the works of Kandinsky and his Russian friends in the Neue Künstlervereinigung. Marc attended the opening of the first exhibition of the Neue Künstlervereinigung München (NKVM) at the Thannhauser Gallery in Munich on the first of December, 1909. According to his later wife, Maria, this exhibition provided him with

the greatest impulse. . . . It was as if strong, until now restrained, powers were recovered, powers which, suddenly, through this incentive would become free in him. Through the experience of Kandinsky's pic-

tures his eyes were opened and he soon knew the reason why his works had not arrived at an effect of complete unity. He wrote at that time: "Everything stood before me on an organic basis, everything but color." [1]

A month after his visit to the NKVM exhibition, Marc received another major impetus toward discovering the possibilities of expressive color in the person of a man who would become his closest friend. On the sixth of January, 1910, the artist met August Macke for the first time. Convivial and easygoing, Macke's personality must also have appealed strongly to Marc, for after the younger man was killed in action at Champagne in 1915, Marc wrote, in a letter home to his wife Maria, that "August's death has meant an irreplaceable void in my life. It was not his art that shone so strongly across to me—as it was the man himself. He was my 'recovery' in those years. If he was there, one had a 'holiday.'" [2]

The relationship with Macke was beneficial in yet another way for, in February, at the instigation of his new friend, Marc was introduced to the generous collector of modern art Bernhard Koehler. Koehler bought several of Marc's works immediately, and after the summer of 1910 he became the regular and predominant financial supporter of an artist who, only a few months before, could not afford the price of a trolley-car fare.

This increasingly optimistic picture of the artist's life was brightened even further when, in February of 1910, Marc held his first major one-man exhibition at the Brackl Gallery in Munich. The show, lasting the month and containing forty-three of his best works from the years 1907 to 1910, was, in the eyes of local critics, considered quite a success. Yet, these rather conservative critics were, in fact, viewing the termination of one long stage in the development of the artist's work, and had no inkling of the steps he would be taking in the near future. In this sense, the show was a true retrospective of Marc's evolution in form over a three-year period. Once his exploration into color began, these reviewers would no longer demonstrate such unqualified approval.

In the same month, February, 1910, Marc saw his first Matisses in an exhibition in Munich of the early work of the French artist, and the influence of this exhibition combined with all the other varying stimuli on the artist's palette was indeed immediate. We can see his

13. *Nude with Cat*, 1910, oil.

new interest in color expression in a work entitled *Nude with Cat* [13], painted during the early spring of this same year.

In *Nude with Cat* the effects of Matisse's work, particularly his paintings from the Fauvist period around 1905, are everywhere in evidence—from the apparently harsh though fluid application of paint to the bold and expressive experiments with complementary color. In Marc's painting we see a large, fleshy, roughly drawn nude figure seated upon a green cushion while bending forward to feed a small yellow cat. The animal is held firmly in the left hand of the figure

while with her right hand she offers it a saucer filled with milk. The mass and boldness of the nude are in striking contrast to the fragility of the cat, and while Marc had perhaps offered us a statement on the immensity and power of humans in the face of nature's fragile creatures, it is the explosive power of the color that consistently draws our attention.

The entire work is composed almost solely of primary colors, representing a significant departure from Marc's more naturalistic, more representational color scheme of the previous years. The hair of the nude figure is composed of a bright fluid red, heightened even further in intensity by the green shading and deep red highlights of her face and skin; the work is further illuminated by the contrast of the blue-violet cloth against the red outline of the body. There is a heatedness, a feeling of warmth, a sensation of radiation emitted by the colors which, through their own expressive functions, add a sense of tenderness, of compassion to the work that the forms themselves only enhance.

Yet, for all of the progress he was making, Marc seemed to be working at cross-purpose during this period (until 1911), trying to accomplish too much in too short a time, failing to recognize his own limitations. While he was beginning to make advances in the use of color, he was also attempting, during the summer of 1910, to compose huge, monumental images of horses in the landscape of Lenggries. Here, however, he seems to have forgotten all that he had learned, adding the color to the image rather than expressing it as a function of the unity of the composition. Each of these large-scale attempts (three during the summer of 1910 alone) ended in a failure so pronounced that the artist acted out the depths of his frustration and disappointment by tearing the huge canvases with his palette knife.[3]

By the fall of 1910 he began working more slowly, more deliberately, seeking a basis, a foundation for his explorations into the expressive potential of pure color and the organic unity of nature. In investigating the effects of expressive color he composed several large studies (among others, *Burning Bush* and *Springing Horses*) in a pointillist style, which he apparently also adapted from Matisse's work of 1904 rather than by direct contact with the works of Seurat or Signac. "Here," according to Schardt, "he began to understand that unbroken color can be employed in little mosaic-like fragments."[4] In attempting to develop a more cohesive and consistent statement regarding

14. *Nude Lying Among Flowers,* 1910, oil.

the harmony and rhythm of nature, Marc was greatly stimulated by viewing the paintings of Gauguin that were exhibited in Munich in August of 1910. A whole series of Gauguin-like nudes in the landscape appeared from the artist's brush during the late fall and winter of 1910, the most significant among them entitled *Bathing Women, Two Nudes in Red,* and *Nude Lying among Flowers.* Of the three, *Nude Lying among Flowers* [14] shows the most complete understanding of Gauguin in terms of its heightened palette, its broad flat application of color, and its expression of a symbolic content that would serve Marc consistently in the years ahead.

In the midst of a dreamy, restless, rolling landscape, a young nude girl is seen reclining in a prone position. The front of her body is in conformity with the contours of the earth, while her feet linger in a stream that runs gently through the foreground of the painting. The head of the girl is nestled in her arms, her eyes are closed, she is asleep and seemingly at one with the nature that surrounds her. Whether her position is actual (i.e., physically within the landscape) or simply the visual evocation of a dream state, we cannot help being reminded of Marc's statement of three years earlier that "art is . . .

the expression of our dreams," and that "the dream life is our true life." Here that dream life becomes a symbolic actualization of that "blessed state of sleep before birth and after death . . . when there is as yet no opposition to disturb the peaceful flow of slumbering life."[5]

Indeed, the symbolic forms of earthly unity and regeneration are at work throughout this painting. In the position of the young girl's body in relation to the earth, for example, we are able to view an almost magical correspondence, a mystical communion not unknown to primitive cultures.[6]

This type of contact with the "material" earth has a regenerative effect, something akin to rebirth, or in the realm of the religious sacraments, an immersion into water or baptism.[7] When we look at the Marc painting there we can notice that the young girl's feet are indeed at rest in the languid stream that runs through the left foreground. In Marc's painting we are also witnessing a rest, a purification which will precede a rebirth, and this idea of purification, of a cleansing as a preparation for a higher existence, would become an increasingly potent force both in Marc's thought and in his art.

While this concept of purification would take years to find its most complete fruition, Marc had already come a long way toward the expression of what he felt to be the "rhythmic, organic" basis of nature. In the last weeks of 1910 and the early months of 1911, he began to perceive in his own work a more complete understanding of the unity the ethnologist Mircea Eliade later described as "the magic, sympathetic bond between the earth and the organic forms it has engendered."[8] He began to see the realization of these beliefs, began to notice in his own paintings that earth and object are bonded together in a living union. Once again Marc returned to the theme of the horse in the landscape as his vehicle to express this unity.

With *Horse in Landscape* of late 1910 and *Red Horses* of early 1911, the artist at last achieved a successful realization of a quest that had lasted more than five years. These paintings represent a success both in the rendering of a harmonious conceptualization of object and environment and in the free, emotionally expressive application of color.

The landscape of *Horse in Landscape* [15] represents a further refinement of the lush, dreamy vegetation of *Nude Lying among Flowers*. In this painting, the entire background appears as a billowing imaginary cloud, a flowing yellow meadowland of the mind, spot-

15. *Horse in the Landscape*, 1910, oil.

ted with what appear to be formless green and blue areas which serve
to denote the location of hills and water. The work is a mass of con-
stant motion, constant fluidity. It is never still, but rather appears to
fluctuate before our eyes in a dynamic rhythmic pattern, in the midst
of which we find a striking, powerfully constructed horse composed in
swirling tones of deep red and violet. Rendered in tones of blue so
deep they border on black, the forms which constitute the mane and
tail of the animal seem almost as if they were totally independent of
the brilliant red body. The neck of the horse is swung to the right,
the tail to the left, and these curves serve to intensify the flowing
rhythm possessed by the entire work.

On the second of February, 1911, Marc wrote to his future wife
that he was now at work on

> a large picture with three horses in the landscape, completely colored
> from one corner to the other. The horses are drawn in a triangle. The
> colors are difficult to describe. The landscape is pure cinnabar, nearly
> pure cadmium and cobalt blue, deep green and carmine red, the horses
> yellow-brown to violet. The landscape is modelled very strongly; com-

16. *The Red Horses*, 1911, oil.

plete passages, e.g., a bush, in purest blue. The forms are all exceed-
ingly strong and clear, within which the color is fully sustained.[9]

The image to which Marc was referring, and which he completed a
short time later was *Red Horses* [16].

Here, in a landscape with gentle rolling hills topped by green and
blue shrubbery, far more sharply defined than the earlier *Horse in
Landscape*, Marc has placed the three red horses of the title. As the
artist said, they are arranged in a triangle which is used to emphasize
the unity among them and the harmony in which they exist. The
center horse, violet in color, is the same animal we saw earlier in
Horse in Landscape, only now his position is reversed, with his long
neck twisted sharply to the left. This horse is flanked on the left by a
deep-red prancing animal, while to its right we see a bright red-
orange horse grazing in the meadow. The curves that constitute the
animals' forms are wholly compatible; the downward sweep of the
mane on the grazing horse, for example, is harmoniously countered
by the upward moving mane of the center horse, as well as by the
curving neck of the animal to its far left. These forms, as well as the
curving rumps of the animals themselves, are echoed further in the
curving hills of the landscape. While Peter Selz, for one, is quite cor-

rect in viewing this work as "lacking some of the direct freshness of the earlier painting (*Horse in Landscape*),"[10] it nonetheless provided the artist with the compositional means he would later employ on such powerfully expressive works as *Small Blue Horses* and *Large Blue Horses* of 1911, *Small Yellow Horses* of 1912, and ultimately *The Tower of Blue Horses* of 1913.

These works were not the first examples of Marc's fascination with the horse, nor were they to be his last. Indeed, the horse appears, in the whole of Marc's work, at least three times more frequently than any other animal he represented. This fact assumes further significance when we realize that these animals function in Marc's work as intermediaries, symbols both of the artist's desires and of the viewer's participation in the harmony and unity which they project.

Because of its very lack of consciousness, its instinctual action, "the animal has always symbolized the psychic sphere in man which lies hidden in the darkness of the body's instinctual life."[11] One may say with some degree of certainty that Marc felt it his goal, saw it his mission, to liberate this instinctual life, to bring it from the darkness into the light and, by representing it as the harmonious essence of nature which binds all things, to project it as an alternative mode of being. The animal he primarily chose for this task, the horse, was the creature which, more than any other, exists "as a symbol of the animal component in man."[12] D. H. Lawrence clearly understood this function of the horse when he wrote:

How the horse dominated the mind
of the early races, . . .
You were a lord if you had a horse. . . .
 He is a dominant
symbol: he gives us lordship: he links us, . . .
 with the ruddy glowing Almighty of potence:
he is the beginning even of our godhead in the flesh. And as a symbol he
roams the dark underworld meadows of the soul. . . .
 . . . Within
the last fifty years man has lost the horse. Now man is . . .
 lost to life and power. . . . The Horse, . . .
 The symbol of surging potency and power of movement, of
action in man.[13]

For Franz Marc as well, the horse was a symbol of something he was not but which he longed to be, an ecstatic symbol of the life

force, a potent surging being at one with the rhythm of the universe. By 1911, the expression and representation of the animal symbol had become firmly fixed in the artist's mind, and the nude studies which were prevalent in his work of the preceding year began to disappear from his oeuvre. [14]

2.

During this same period (1910–1911) several further developments added impetus to Marc's artistic progress. In September of 1910 he attended the second NKVM exhibition, held once again at Thannhauser's Moderne Gallerie in Munich. In addition to the works of the regular members of the group, Kandinsky, Jawlensky, Werefkin, Kubin, Münter, Kanoldt, Erbslöh, and Le Fauconnier, Cubist works by Picasso and Braque, and the Fauvist paintings of Derain, Vlaminck, Rouault, and Van Dongen were displayed.

The reaction by the Munich public to this exhibition was one of "derisive opposition." [15]

Kandinsky remembered:

> The press loosed a total rage against the exhibition, the public laughed, threatened, spat upon the pictures. . . . For us, as exhibitors, the public reaction was incomprehensible. We stood with both feet implanted in the spirit of the awakening art and lived in this spirit with soul and body. We merely wondered how, in the "art city" of Munich, with the exception of Tschudi, [16] no words of sympathy were directed toward us. And then one day came the word. Thannhauser showed us a letter from a Munich painter, as yet unknown to us, who congratulated us on our exhibition and proclaimed his enthusiasm in the most expressive of words. This painter was a "true Bavarian," Franz Marc. [17]

Indeed, Marc was so outraged at the reception given this exhibition that he answered the critics in print, praising the works for their "complete spiritualization and their dematerialized inwardness of perception," [18] while asking, "Has the imagination become so philistinized today, so constipated, as to have broken down completely?" [19] Welcomed immediately into the *vereinigung*, Marc joined the group formally in January of 1911.

Formerly a shy, introspective, melancholic personality, Marc was now taking bold and decisive steps to influence the direction of his art

and his life. Acting now, rather than merely being acted upon, stirred with new confidence by the successful realization of works completed during the winter, the artist began to venture forth beyond his preoccupation with color application and toward the expression of a theory regarding the principles and effects of color. He expressed these new concepts in a letter to his friend August Macke in December of 1910:

Blue is the *male* principle, severe and spiritual. Yellow is the *female* principle, gentle, cheerful and sensual. Red is *matter*, brutal and heavy, the color that has to come into conflict with, and succumb to the other two. For instance, if you mix blue—so serious, so spiritual—with red, you intensify the red to the point of unbearable sadness, and the comfort of yellow, the color complementary to violet, becomes *indispensable* (woman as comfort-giver, not as lover!).

If you mix red and yellow to obtain orange, you endow the passive and female yellow with a (turbulent), sensual power, so that the cool spiritual blue once again becomes the indispensable male principle; a blue automatically falls into place next to the orange; these colors are in love with each other. Blue and orange—this is the color harmony of celebration.

Now, if you mix blue and yellow to obtain green, you awaken red—matter, the earth—to life; but here, when I paint I always feel a difference. With green you never quite still the brutality and materiality of red, as was the case with the previous color harmonies (just recall how red and green are used in the industrial arts!). Green always requires the aid of blue (the sky) and yellow (the sun) to *reduce matter to silence*.[20]

It was also at this time that the artist began to further his already existing concern with the concepts of purification and regeneration. He commented upon this, as well as his new, more forceful, frame of mind in a letter written to Macke the following month, in January of 1911, following his return from Berlin:

I spent a lot of time in the Museum of Ethnology in order to study the art of the "primitives" (a word Koehler and most other critics like to use when they talk about our work). . . . It seems obvious to me that we should look for *rebirth* in the cold dawn of that kind of artistic intelligence and not in cultures like the Japanese or the Italian Renaissance which have already passed through a thousand years of development. In one short winter I've become a completely different person. I believe I am really coming to understand, little by little, what it means to be an artist. . . . We will have to renounce absolutely almost everything

which was precious and indispensable to us as good Central Europeans; our ideas and ideals will have to wear hairshirts; we will have to feed them grasshoppers and wild honey, not history—we must, in order for all of us to escape our tired European lack of taste.[21]

Both of these themes, the newly formulated principles of color and the wish to regenerate a tired civilization, become increasingly more pronounced in Marc's compositions from 1911 and after. We can see their early manifestation in a work like *Blue Horse I* [17], painted in the winter of 1911.

The image of the landscape in *Blue Horse I* is far more idealized than in any of Marc's previous works. Here, the hills are rendered as if they were separate entities, each possessing a color of its own, and whether it be red, violet, blue, or green, each of these hills is linked together by the yellow mist that floods the valleys. This yellow mist also serves as a backdrop for the appearance of the young blue horse. The animal, rendered solely in tones of blue, is seen facing us, his neck curved to the left, all four legs firmly implanted on the mountaintop upon which he stands. Yet, the forms of the animal seem almost weightless, somewhat antigravitational, as if the horse were hovering above the spot on which it appears to be standing. The rendering of this impression appears to have been intentional on the part of the artist, for he has placed the blue fore and hind legs of the horse upon an area composed solely of shades of deep red and violet, which causes a visual disturbance among the contrasting colors that has the effect of pushing the animal upward. In this area, as well as in his use of blue for the coloring of the horse ("the male principle—severe and spiritual"), we can see the actual application of Marc's color symbolism.[22]

Beyond the color of the animal represented, however, there also seems to be an emphasis on the idea of spiritual elevation demonstrated in this work. For example, the animal's youth, its smooth unblemished skin, speaks of a freshness, an innocence, something akin to the "new, cold dawn," that Marc had spoken of in his letter to Macke. *Blue Horse I* is also an image of security, of harmony, an animal assertive both in its stance and demeanor, and thus quite possibly a projection of the artist's new confidence in his own abilities and the certainty of his direction. *Blue Horse I* along with about twenty-five other images from this period (among them *Red Horses,*

17. *Blue Horse I*, 1911, oil.

Blue Horse II, Nude Lying among Flowers, and *Weasels Playing*) were included in the artist's second one-man exhibition, held at the Thannhauser Gallery in May of 1911.

The tone of harmony, security, and serenity evident in such a painting as *Blue Horse I* continued in Marc's work throughout 1911, and appears in such diverse images of that year as *Blue-Black Fox, The Steer, Cat behind a Tree, Deer in the Woods I,* and *Stags in the Woods,* all painted after Marc's marriage to Maria and their trip to England in July. Perhaps his most refined and successful work of this period is *The Yellow Cow* [18] completed after his return to Sindelsdorf.

In *The Yellow Cow* the total image is not only one of complete security, harmony, and comfort, but one of spiritual exaltation as well. Once again the image of an animal appears to transcend its earthly realm, and this concept of transcendence and spiritualization is given further credence when we observe Marc's use of color in terms of its symbolic value. True to his statement of 1910, the earth of *The Yellow Cow* is rendered predominantly in tones of red (matter) and green, which serves in Marc's words, "to awaken matter to life." Within this "living" landscape we also notice a small herd composed of three cows. Seen in the background, to the left of the yellow cow, and rendered in tones of red which almost exactly parallel the colors he had employed earlier in *Red Horses,* each of the animals complements the other in a unified and harmonious manner. The most vital symbolism is, of course, that reserved for the cow of the title. Its dominant possession of yellow signifies its "female principle, gentle, cheerful and sensual," but because of the manifest use of red and blue contrasts in the landscape, the yellow also serves an an image of harmony, peace, and comfort ("female as comfort-giver"). Further, the blue spots on the animal's flank and hindquarter illustrate its "spirituality," a sense of elevation that is reinforced by the same deep blueness that is reflected in the "cosmic" mountains of the background. Indeed, the entire work is a riot of color, brighter and more luminous than Marc had ever achieved before, a sense of color so strong that it demands the entire painting sing out with the cow, and affects the viewer as a chorus engaged in a melody of sensuality, a blissful tune of spiritual ecstasy. This quality of joy and elevation is evident in every stroke of the brush, and indeed in the hand and mind of the artist himself.

18. *The Yellow Cow*, 1911, oil.

More than twenty years after the artist's death, Kandinsky remembered Marc at this time as

living in a farmhouse in Sindelsdorf (upper Bavaria, between Murnau and Kochel). We soon became acquainted with him personally and found that his outward appearance corresponded perfectly with the inner man; he was a tall, broad-shouldered man with a powerful gait, a head that was full of character and an unusual face with features that revealed a rare combination of strength, acuity, and tenderness. In Munich he seemed too tall, his gait too long. He gave the impression that the city was too small for him, that it restricted him. The countryside matched his free nature and I always took a particular delight in seeing him stroll through meadows, fields and woods with a stick in his hand and a rucksack on his back. The naturalness of his manner corresponded marvelously to those natural surroundings, and nature herself seemed to be pleased with him. This organic bond between him and nature was reflected too in his relationship with his dog Russi, a large white sheep dog which in manner, strength of character, and mildness of disposition constituted an exact four-legged copy of his master. The Marc-Russi rela-

tionship was just one example of Marc's profound organic relationship with the entire animal world. In his pictures, however, the animals are so closely merged with the landscape that in spite of their "expressiveness," their Marc-like characteristics, they nevertheless always remain simply an organic part of the whole. At that time particularly there were very few people who had any awareness of the whole, and even fewer who experienced this whole in the deepest part of their being, and who were qualified for such an experience.[23]

It was during this same period that the already existing friendship between Marc and Kandinsky was drawn even closer by the course and pressure of external events.

3.

By the late spring and early summer of 1911 the NKVM had become riddled with internal dissension, and two opposing groups, of sharply divergent outlook, began to develop within the organization. Kandinsky had long regarded some members of the group as "uninteresting, not because their work was too 'objective' for his taste, but because he felt that it was, on the one hand, too 'decorative' and, on the other, not independent enough."[24] The conservative faction, led by Kanoldt and Erbslöh, had earlier mustered enough strength to force Kandinsky's resignation as chairman of the group in January. He was replaced by Erbslöh, whose succession served only to increase the disagreement substantially. By August of 1911 the situation had become so critical that, as Marc wrote to Macke, on the tenth of the month:

> Kandinsky and I clearly foresee that the next jury, late in the fall, will cause a horrible controversy and now or the following time a split, i.e., an exit of one or the other party. The question is which one will remain. We do not want to abandon the Association, but incapable members will have to get out.[25]

Marc was quite accurate in his assessment, for on the second of December, 1911, one of Kandinsky's works was rejected by the conservative jury,[26] and Kandinsky, Marc, Münter, and Kubin promptly resigned from the association. A few days later Marc wrote to his brother,

The dice have been cast. Kandinsky and I have left the association. . . .
Now we have to fight further! The editorship of *Der Blaue Reiter* will
now be the starting point for new exhibitions. I think it is well this way.
We will seek to be the center of the new movement. As for the Associa-
tion—it can now take over the role of the *Scholle*.[27]

Indeed, the idea for *Der Blaue Reiter* had been in operation for
many months before the actual split of the NKVM. In June of 1911,
six months before the break-up Kandinsky had written to Marc,

> Now! I have a new plan. Piper must manage the publication and we both
> . . . will be the editors. A type of almanac (yearly) with reproductions
> and articles and chronicles, i.e., reports of exhibitions, criticism, only
> stemming from the artists themselves. The book must reflect the entire
> year, and be a link to the past and a beam toward the future. . . . There
> we will show an Egyptian work next to a little Zek, a Chinese near a
> Rousseau, a folk-drawing next to a Picasso and so on, again and again!
> The book can be called "The Chain" or something else. . . . Don't speak
> about this unless it will directly profit us to do so. In such cases, "discre-
> tion" is very important.[28]

Later that summer Marc and Kandinsky "spent whole days, eve-
nings and sometimes even half the night discussing what action to
take."[29] Kandinsky recalled that "the name 'Blue Rider' came to us
around the coffee table in Marc's house at Sindelsdorf; we both loved
blue, Marc horses, and I riders. So the name came by itself. And
made Maria Marc's fabulous coffee taste even better."[30] They soon
decided to act decisively on two fronts: first, to prepare an exhibition
to counter that of the association, and second, to make preparations
for the publication of an almanac that both Kandinsky and Marc
regarded as necessary "in order to achieve complete freedom for the
realization of the embodied idea."[31]

So complete had these artists' preparations been that the first exhi-
bition of *Der Blaue Reiter* was able to open at the Thannhauser Gal-
lery on the eighteenth of December, 1911, little more than two
weeks after the schism that split the NKVM.[32] Organized by Marc
and Kandinsky, it included works by, among others, Albert Bloch,
David and Vladimir Burliuk, Heinrich Campendonck, Kandinsky,
Macke, Gabriele Münter, Niestlé, the composer Arnold Schönberg,
Henri Rousseau, and Robert Delaunay, The show ran through Jan-

uary of 1912, and Marc exhibited two works, *The Yellow Cow* and *Deer in the Woods I.*

Even before this initial exhibition closed, however, plans were already under way both for a succeeding exhibition and for the almanac which was promised in the catalogue. The second exhibition of *Der Blaue Reiter* was again so well organized that it was opened on the twelfth of February, 1912, less than a month after the first show closed. This time it was not held at Thannhauser's but at the Hans Goltz Gallery in Munich. Although it was limited to include only prints, drawings, and watercolors, it nevertheless was able to exhibit more than three hundred works, five of them by Marc.

Kandinsky later recalled that "Marc brought a big selection of works from Berlin—thus establishing the "bridge" (*Brücke*) between the Berlin *Brücke* artists and Munich, where they were so far unknown."[33] Indeed, works by Nolde, Kirchner, Heckel, Mueller, and Pechstein constituted almost half the number exhibited.

Like the first, "this exhibition was noteworthy in that it brought together artists of several nationalities and of several movements,"[34] among them Expressionists, Fauvists, Cubists, Rayonists, and Supremacists. The exhibition was soon overshadowed later that year with the publication of the long anticipated *Blaue Reiter Almanach*, which became available in May of 1912.

The popularity of this more than two-hundred-page *almanach*, dedicated to Hugo von Tschudi, and acting as "a declaration of the artistic ideas of the young expressionist painters and musicians,"[35] was both immediate and overwhelming. Shortly after publication, the 1,500 copies of the first edition were completely sold out, and plans were immediately undertaken for a second edition (which did not appear, however, until 1914). The book contained more than 140 illustrations selected by the editors, Marc and Kandinsky; these were so diverse as to include: Bavarian glass paintings, Bavarian and Russian votive figures, medieval art (manuscript illuminations, woodcuts, Gothic sculpture, late medieval painting, ivories, tapestries, mosaics), Chinese popular paintings and masks, Japanese ink drawings and woodcuts, Egyptian shadow-play figures, African masks, a Benin bronze, pre-Columbian sculpture and textiles, Malayan and Easter Island sculpture, and children's drawings.

Among the contemporary German artists selected for inclusion were the *Blaue Reiter* veterans Kandinsky, Marc, Arp, Bloch, Cam-

pendonck, Klee, Kubin, Macke, and Münter, while the Brücke artists depicted were Heckel, Kirchner, Mueller, Pechstein, and Nolde. Contemporary French painting was represented by Matisse, Picasso, Delaunay, Le Fauconnier, and Girieud, while Cézanne, Gauguin, Van Gogh, and Rousseau were chosen as pivotal sources of influence. Of past masters, only a woodcut by Hans Baldung-Grien and a painting by El Greco found their way into *Der Blaue Reiter*.

Of perhaps greater significance were the articles themselves, most of them written by artists and musicians close to the movement. Kandinsky's contributions included his seminal article "Über die Formfrage" ("On the Question of Form"), as well as an essay on stage composition (Über Bühnen Komposition") and an original play, "Der Gelbe Klang" ("The Yellow Sound"). Among the other contributions were those by David Burliuk writing on the new movements in Russia, Roger Allard on contemporary French painting, an essay on Delaunay's style by Erwin von Busse, August Macke's theoretical "Masken" ("Masks"), and articles on modern music by Schönberg, Thomas von Hartmann, N. Kulbin, and Leonard Sabanejew. The three introductory articles were written by Franz Marc, "and since they were the lead articles they can be read as a virtual manifesto of the movement."[36]

In the first of these articles, "Geistige Güter" ("Spiritual Goods"), the artist set the tone for what was to follow. "It is worthy of note," Marc said,

> that our attitude toward spiritual values is completely different from our attitude toward material values. For example, when someone conquers a new colony for his country, the whole nation hails him enthusiastically. . . . But if it occurs to someone to present his country with a purely spiritual good, it is almost always rejected with scorn and indignation. The gift is looked upon with suspicion, and every effort is made to obliterate it. Were it still allowed the giver would be burned at the stake, even today.[37]

In the second article, "Die Wilden Deutschlands" ("Germany's Savages"), Marc praised the works of the Brücke, the Neue Sezession, and the old "Neue Vereinigung," in memorable words that echo much of the course of his own development and which express many of his own longings and desires.

One came to understand that art was concerned with the deepest things, that a true revival could not be a matter of form but had to be a spiritual rebirth. *Mysticism* awoke in their souls and with it the primeval elements of art. . . . They had a different goal: to create symbols for their age, symbols for the altar of a new spiritual religion.[38]

The third of the articles, "Zwei Bilder" ("Two Pictures"), was ostensibly a comparison between a popular illustration from *Grimm's Fairy Tales* of 1832 and Kandinsky's *Lyrical* of 1911, but served further to illuminate Marc's ideas on "style," and the meaning of "serious art."

Since then [the middle of the nineteenth century], what serious art there is, has been made by individuals;[39] these have nothing to do with style. . . . On the contrary, these works were made in defiance of their times. They are stubborn fiery signs of a new age and they are appearing everywhere. This book shall be their focus until the dawn comes. . . .[40]

Marc also spoke of the inherent honesty of these works, their integrity and truth guaranteed by their "inner life. . . . In art everything created by a truth-loving spirit without any regard for conventional external effects will be honest for all times."[41] The artist then went on to view these works, which of course included his own, as somehow signaling the emergence of a new age. This "search for the new age" was to be the predominant note of Marc's work for what remained of his life.

4.

The furious activity of late 1911 and early 1912 had a considerable effect on Marc's work. In style, his paintings of 1912 clearly show the influence of the two *Blaue Reiter* exhibitions as well as the Futurist show which the artist saw at the Sturm Gallery in Berlin in April. In content, these works demonstrate a new and disturbing sense of restlessness, of tension, of imminence and anticipation. These qualities are evidenced in a work like *The Tiger* [19], painted in March of 1912.

In the midst of a landscape composed almost entirely of cubic forms rendered in bright luminous tones of red, green, violet, and orange, the animal of the title, a beast of tremendous power and size, is seen perched upon a rock. This is not, by any means, the kind of dreamy,

19. *Tiger*, 1912, oil.

transcendent image that we saw in *Blue Horse I* or *The Yellow Cow*, but rather the picture of a killer. Disturbed from its sleep, its head risen, its stark yellow eyes fixed upon its intended victim, this tiger, composed solely in tones of yellow and black, is ready to discharge the kinetic force of its massive and muscular bulk. The image of this animal is made to seem even more powerful by the block-like construction of the forms that determine its body. The entire work is filled with tension, with a sense of apprehension, with a presentiment

20. *Two Cats, Blue and Yellow*, 1912, oil.

of quick and sudden death. In this painting the feeling of security, of harmony and comfort that Marc had projected in his works of only a few months before, is now entirely absent. *The Tiger* is not by any means an isolated image. Even in a seemingly innocent work like *Two Cats, Blue and Yellow* [20], painted later that year, the same sense of aggression, of imminence, is repeated, albeit on a less ominous scale.

In *Two Cats,* the two animals of the title are engaged in separate and distinct activities. The blue cat, which dominates the center of the painting, is seen cleaning its left hind leg and, in the process, displaying the surprising power of its small body. From the stylized concentric muscular force imbedded in its right fore and hind quarters, the elongated tail of this cat leads us in a rhythmic curve to the large front paws of the animal, now exaggerated in size and scale. The yellow cat to the right, a Siamese, is coiled, its eyes fixed upon a target, a green ball standing motionless upon a violet strip. This target is, however, at best ambiguous, for beneath the violet area we

can see a small red animal, its tail indicating that it is most probably a mouse. What is at first glance an apparently frivolous domestic scene of a cat playing can, in the very next instant, become an image of violence, a scene involving the drama of a life and death struggle, a view into that "bloodied nature" Marc had so studiously avoided in the past. While a formal or structural harmony remains obvious, this work, as well as *The Tiger*, nevertheless represents a distinct break from the contextual unity, the "placidity" of the earlier works of this same year.

While both of these paintings are stylistically indebted to the Cubist influences that Marc had acquired from the *Blaue Reiter* exhibitions, they owe much of their inspiration to one French painter in particular, Robert Delaunay. Delaunay had exhibited several of his Orphic "windows" at the first *Blaue Reiter* show in 1911, and his use of bright color and interpenetrating cubic forms had a most profound effect on Marc. This influence would not reach its fullest fruition in Marc's work until 1913, several months after he, Macke, and Klee had visited Delaunay in his Paris studio (October 1912).[42] For the present, however, both *Tiger* and *Two Cats* are evidence of the use of intense primary color and the rhythmic effect of intersecting geometric forms that Marc had learned from the French artist during the previous year, and which he only now attempted to employ on large-scale compositions.

The other major stylistic influence that captured Marc in 1912 was that of the Futurists, whose work he had seen at the Berlin Sturm Gallery exhibition in April, and whose lines of force and transparent planes of color found almost immediate expression in his work. Representative of this new influence are works from the summer and fall of 1912, paintings like *Deer in a Monastery Garden* and *In the Rain*. For all of the evidence and understanding of current developments seen in these works, there is, nevertheless, a sense of unsettledness, of insecurity dominating the tone of their content.

In the Rain [21], for example, is a moody image, a picture of the artist, his wife, and his dog caught outdoors in the midst of a rainstorm. While such an event could produce an explosion of forces in the work of a Romantic artist such as Turner, in Marc the rain serves merely to provide an additional focus upon the already prevalent descending pull of the painting. This gloomy tone is reinforced by the downcast expressions on the faces and eyes of the participants who

21. *In the Rain*, 1912, oil.

are being acted upon by a nature they can neither alter nor influence, a nature that grows all around them, and yet a nature sustained by the same rain that appears to give the humans (but curiously not the dog) such discomfort.

Deer in a Monastery Garden [22] is a far different image. In the midst of a dark green landscape which is pierced by numerous intersecting diagonals of color, a young fawn lies submerged in the foliage. While the moon, visible in the upper-left-hand corner, illuminates the scene below, the origin of the rays which penetrate the garden remains a mystery. The disturbance caused by these rays is so intense that the animal appears to be stricken with terror, and indeed, its ears are pinned back in fear, its head is pulled upward and forward by the mysterious forces that control the scene. Here, once again, in an environment the artist would earlier have rendered as secure and harmonious, tension and discord now reign. This contrast in tone is made even more evident in the contrast between two almost struc-

22. *Deer in a Monastery Garden*, 1912, oil.

turally identical compositions painted just one year apart: *Deer in the Woods I* of 1911 and *Deer in the Woods II*, painted in 1912.

In the earlier of these two paintings, *Deer in the Woods I* [23], we see a young deer curled up in a sleeping position against a hillock which is located in the midst of a hollow set deep in the woods. The eyes of the animal, rendered simply as black slits, appear to be closed, thus indicating that the deer is safely asleep. The ground of the hollow, bounded by tall trees on both sides, appears to be soft and smooth, a very comfortable and secure spot for a defenseless creature to spend the night. The spruce branches that cut through the picture tend only to add to the coziness, the sense of warmth, that is not disturbed by the tree stump and stick that are seen in the immediate foreground. From the top of the scene a soft, fluffy, ribbon-like substance makes a gentle, lazy descent toward the forest floor below.

In the later image, *Deer in the Woods II* [24], we can notice that

23. *Deer in the Woods I*, 1911, oil.

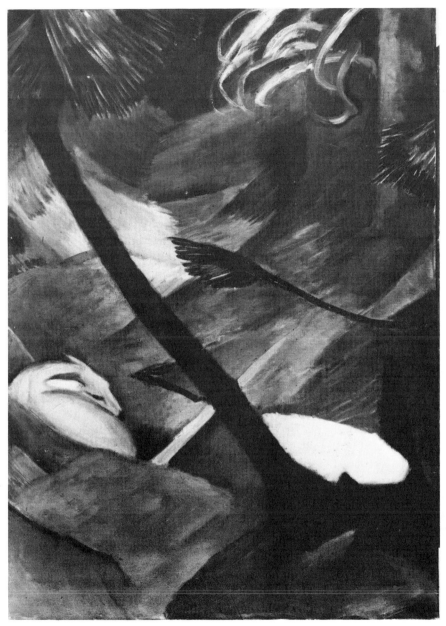

24. *Deer in the Woods II*, 1912, oil.

the position of the animal within its surroundings remains the same; yet, the scene itself is now filled with a new sense of disquiet. The deer appears less comfortable than before, its head is pushed farther into its body which is itself much less exposed than in the earlier image, and now drawn tightly in against the green hillock. The eyes of the animal now appear slightly open and seemingly more apprehensive, while its ears are drawn farther back against its head in an attitude suggestive of fear or presentiment. The forest floor has, in this painting, become embroiled in unseen forces, forces that are pushing and pulling at one another, and this feeling of discord is heightened still further by Marc's use of strongly contrasting tones of red, blue, and green. To increase the tension even more, the artist has added a sharply inclined spruce tree into the foreground, its leftward diagonal angle so severe as seemingly to slice the painting in two. While this tree appears secure at its base, the precariousness of its slant nevertheless produces an image of threat, an unrelievable stress that acts to dominate the entire work. Even the gentle ribbon-like substance that falls from above is now rendered in very rapid linear strokes, its descent seemingly more accelerated, more ominous.

Several months later Marc continued this theme of threat in a work that further reveals his growing sense of discord, his apparent loss of harmony and security. The work needs no description; its title reveals its theme—*Fear of the Hare.*

While Marc was engaged on these paintings the precarious European peace which had lasted since 1871 was fast drawing to a close. By 1911 the international situation had become perilous. Recurrent crises in Morocco in 1905 and again in 1911 had not only cost each of the participants (Germany, England, and France) a good measure of their prestige, but had also served to fan residual antagonisms that were increasing in intensity. From October 8, 1912, to May 30, 1913, the Balkan states fought a victorious war against Turkey (the First Balkan War) and dismembered the rapidly fading Ottoman Empire. Discord among the victors, however, regarding the distribution of captured territory led, within a month, to the outbreak of the Second Balkan War (June 29 to August 10, 1913). While Serbia was once again the major political beneficiary, the true victor was the pervasive sense of apprehension that now swept the continent. These events pushed Europe to the brink of war several times during the period

1911–1913, and it was clearly understood by all that if war came, it would be far different from any previous war, far more destructive, far more costly in material and lives. Although the people of Europe regarded the approach of war as almost inevitable and often talked foolishly and irresponsibly about it, they nevertheless feared its coming and were terribly shaken when it finally arrived. Never before had a truly catastrophic conflict seemed more probable than in the years immediately preceding 1914.[43]

Considering the course of these events and the thematic tone of his images, we should not be surprised that in January of 1912, in a subscription prospectus for future editions of *Der Blaue Reiter Almanach*, Franz Marc wrote: "Art today proceeds along paths which our fathers never imagined possible; one stands before the new work as in a dream and hears the apocalyptic riders in the air; one feels an artistic tension over the whole of Europe."[44] For Marc, "the new age" was close at hand, and in his works painted during the following year the artist sought to bring it even closer. These works are so powerful in their imagery, so important stylistically and thematically, that they demand discussion in chapters of their own.

The Image of
Apocalypse

1.

O N T H E T W E N T Y - S E C O N D of May, 1913, Franz Marc wrote a letter to his closest friend, August Macke, in which we find the following words: "I have, at the present time, painted nothing but utterly divergent pictures; you are about to learn the titles. They reveal nothing but perhaps they will amuse you."[1] Marc then proceeded to name six paintings he had recently completed: *The Tower of Blue Horses; The First Animals; The Poor Land Tirol; The Trees Show Their Rings, The Animals Their Veins* (known today as *Fate of the Animals*); *The World Cow;* and *Wolves* (subtitled *Balkan War*). He had little more than a year left in which to paint. Volunteering for service at the outbreak of war in August of 1914, Marc served the German Army on the western front for one year and seven months. On the fourth of March, 1916, Marc led a reconnaissance patrol around the French town of Braquis, about twenty kilometers east of Verdun. He did not return from this patrol alive.

Thus, while the titles of these paintings may have amused Macke, Marc was quite erroneous in assuming that they would "reveal nothing." On the contrary, these titles tell us much about the thematic concerns with which the artist was preoccupied in this, the last full year of his artistic endeavors. The titles indicate visions of doom (*The Poor Land Tirol*), or of imminent catastrophe (*Wolves—Balkan War*). Two of the titles indicate visions of genesis or rebirth (*The First*

Animals, The World Cow). One of the titles mentioned by Marc, however, stands apart from the others, not only in its verbal ambiguity, but in the very power of visual imagery suggested by the words themselves.

As we have learned from the previously cited Marc-Macke correspondence, *Fate of the Animals* was completed sometime prior to May 22, 1913, and was originally entitled, *The Trees Show Their Rings, The Animals Their Veins*. On the reverse side of the canvas, Marc had written the inscription "And All Being Is Flaming Suffering," which was designed apparently as the work's subtitle.

Sometime prior to the fall of 1913, Marc, acting upon a suggestion by Paul Klee, changed the title of the painting to *Fate of the Animals*, the title by which it was listed in the catalogue at its first exhibition— the First German Herbstsalon held in Berlin in the fall of 1913. While serving at the front in the early spring of 1915, Marc received a postcard from his friend and patron Bernhard Koehler. On the front of the card was a reproduction of Marc's painting and its effect on the artist was both immediate and profound. In a letter dated March 17, 1915, Marc answered Koehler:

Yesterday I received your Herbstsalon postcard with the reproduction of *Fate of the Animals* on it. I was startled and astonished by its immediate effect on me. I saw it as an utterly strange work, a premonition of war that had something shocking about it. It is such a curious picture, as if created in a trance.[2]

On the same day Marc addressed a letter to his wife Maria:

Koehler wrote me today on a Sturm[3] postcard with my *Fate of the Animals* on it. At first glance I was completely shaken. It is like a premonition of this war, horrible and gripping; I can hardly believe that I painted it! . . . It is artistically logical to paint such pictures *before* wars, not as dumb reminiscences afterward, for then, we must paint constructive pictures indicative of the future, not memories as is now the case. I have only such thoughts in my mind. I sometimes wondered about that. Now I know why it must be so. But these old pictures from the Herbstsalon will undergo a resurrection someday.[4]

The paintings would, indeed, undergo a resurrection, but Marc would not be alive to see it.

In November of 1916, seven months after the death of Franz Marc, a memorial exhibition for the fallen artist was assembled at the

Sturm Gallery in Berlin. At the end of November the exhibition was scheduled to move to the Artists Association of Wiesbaden, but the night before the transfer was to take place a fire broke out in the Sturm Gallery's storage area. One painting, the three-fourths of it that was untouched by the flames, at any rate, did not make the trip to Wiesbaden.[5] Somewhat ironically, *Fate of the Animals*, the one painting of Marc in which the theme of destruction was so explicit, the canvas on which he had written "And All Being Is Flaming Suffering," was itself partially consumed by fire.

The immense task of restoration was immediately undertaken by Paul Klee, who, with the help of Marc's widow and the artist's preliminary sketches, was able to resurrect the structure of the original work. In an interview with Klee, a few months before that artist's death in 1940, Georg Schmidt was told:

> He [Klee] intentionally restored only the vitally important linear structure of inter-penetrating diagonals with any degree of accuracy. He did not even attempt to duplicate the inimitable transparent colors of Marc. [Klee believed] that above all, the extent of the flame's progress must remain evident. Then one would be compelled to observe that the picture had, itself, undergone and overcome a catastrophe.[6]

Klee was true to his word. Indeed, the restoration of the damaged right-hand section of the canvas is clear and unmistakable; the dark, somber, brownish tones of Klee's brush contrasting strongly with the bright, radiant, vital tones of Marc's. As a result, although the linear structure remains intact, much of the continuity and the dynamism of Marc's color scheme is gone from this, one of the most vital sections of the entire work.

A few years after the burning and the restoration, *Fate of the Animals* was purchased by Max Sauerlandt for the Moritzburg Museum in Halle,[7] where it remained until 1936 when the Nazis confiscated it as a "degenerate work of art." The whereabouts of the painting was unknown for the next three years, until May of 1939, when Georg Schmidt traveled to Berlin and, in the Schönhausen Palace, "discovered a huge stack of pictures, containing among others, Kokoschka's *Tempest*, Corinth's *Ecce Homo*, and Marc's *Fate of the Animals*."[8] The painting was again being prepared for transport, this time to the Galerie Fischer in Lucerne, Switzerland, where on June 30, 1939, along with 125 other works confiscated from German mu-

seums, it was sold at auction. The work was purchased at this auction by the Basel Kunstmuseum, where it has remained ever since.

The richness, the power, and the subtlety of *Fate of the Animals* can be appreciated on at least three different levels. It exists, certainly, as an entity in itself, a work displaying the technical proficiency and virtuosity of the artist, with its transparent, almost fluorescent, vividness of color, its perfection of balance and structure. It exists most surely as a statement of the concerns and aspirations of this individual artist, as a painting with a readable message, with a meaning that indeed transcends the sum of its component parts; the painting acts as a vehicle for the communication of ideas. *Fate of the Animals* is also a work of its time, a work that not only holds a vital and significant position within the context of Marc's output, but which further represents at least one aspect of the collective concerns of the society of artists within which he lived and worked.

2.

On the most rudimentary level, *Fate of the Animals* [25] is an image of a world in the process of being torn asunder. In the midst of an apparently mythical forest, fires rain down from the heavens, the stumps of what had been standing trees jut out from the burning underbrush, animals shriek in terror, run to escape the inescapable, or timidly submit to their deaths. The vision of destruction and doom presented in this work is both powerful and pervasive, yet at no time does the artist surrender his control to the chaos he depicts. Despite all the frenzy, all the apparent confusion rendered in *Fate of the Animals*, the composition nevertheless remains one of strict order, even balance, and overall unity.

The structural foundation of the painting is a network of interpenetrating and intersecting diagonals, which serve a variety of purposes. First, the diagonals impose a strict compositional order onto a scene that could otherwise easily dissolve into one of utter confusion. Thus, each of the figures within the composition assumes either a diagonal posture (deer, lower right), a position in conformity with an existing diagonal (horses, upper left), or is intersected by a diagonal (blue deer, center). Secondly, these lines serve to provide an atmosphere of unremitting tension, a tension further emphasized by both the

25. *Fate of the Animals*, 1913, oil.

nearly total absence of horizontals or verticals, and the utilization of a color scheme (green on red, red on blue) designed to produce the maximum intensity of tonal contrasts. Finally, and perhaps most significantly, the diagonals play an essential role in the narrative of the composition, a function toward which we will now turn our attention.

The narrative, the drama, indeed, the tragedy of *Fate of the Animals*, has its origin in the upper left-hand corner of the painting. There, we notice three sharp, jagged, triangular forms moving, with what appears to be an intense velocity, in a diagonal direction downward across the dark blue of the night sky. The rich, red, glowing presence of these forms gives them the appearance of some type of cosmic or supernatural flame, an observation reinforced by both the almost incandescent prism of light embedded in the lower of the three forms, and by the absence of any specific earthly origin. At this point in the drama only one of these three intense spearheads of heavenly fire has successfully reached its target. With a more subdued impact than might be expected, the uppermost flame propels it-

self into one of the massive diagonal forms that occupy the entire right-hand portion of the canvas. A chain reaction is thus set in motion as these huge forms, themselves, are ignited and explode, shooting further diagonal sparks and flames up into the air and down upon the earth. One of these downward-moving right-left diagonals has ignited the underbrush beneath the springing green horse on the left, setting the animal on fire and sending stylized, cubistic flames soaring high into the air. Another diagonal pierces and almost envelops the neck of the blue deer in the center of the canvas and then streaks on toward its next victims, the wild boars at the lower left. Yet another diagonal, growing in brilliance and dimension, is propelled behind the diagonally inclined tree in the center, behind the blue deer, striking the earth at an indeterminant point beneath the frame of the canvas. Thus, the conflagration is begun; its effect is catastrophic.

Beginning again in the upper left-hand section of the painting we see two green horses reacting to the terror which is about to engulf them. The larger of the two horses, the one farther to the left, its long neck twisted to the right of the picture, its mane ablaze, shrieks in what must be its final moments of agony. Immediately to its right, a second green horse, its neck turned abruptly toward the left, attempts to escape the flames but is instead being consumed in them. It is the only animal in the entire painting which, according to the original title (*The Trees Show Their Rings, The Animals Their Veins*), actually does "show its veins." As its flank and underbelly glow in a radiant white triangle, the insides of the fleeing animal become visible.

The motif of the fleeing horse has a long tradition in Marc's work, one that preoccupied him until his death. As early as 1910, in two ink sketches entitled *Springing Horses* and *Two Springing Horses*, we can see the prototype of the animal which appears in *Fate of the Animals*, with its forelegs raised and bent in toward the body, its hind legs propelling it forward and upward. By 1912, in the painting entitled *Springing Horse* [26], the body of the animal has become more stylized. Rendered in modified cubistic forms, angular (almost triangular) shapes now define the surface of its flank, while its head and neck are turned sharply toward the viewer. In its posture and rendering, the *Springing Horse* of 1912 is fully comparable to the horrified, leaping creature of *Fate of the Animals*. In two other sketches, *Horses and Panther* from 1912, and *Horses Fleeing in Great Agitation* [27], com-

26. *Springing Horse*, 1912, oil.

27. *Horses Fleeing in Great Agitation*, 1915, pen and ink.

pleted at the front in 1915, we are again presented with scenes of horses leaping, attempting to escape from an apparently desperate situation, their mouths again open and shrieking in terror, their necks again abruptly turned to one side. Perhaps more significant, however, is the value of these sketches in helping us to locate another source of Marc's fascination with this motif, for the lead horses in Marc's 1912 and 1915 sketches are strikingly similar in position and facial expression to both Delacroix's *Tiger Attacking a Horse* of 1825–1828 and to George Stubb's series of works illustrating lions attacking horses which date from about 1762 to 1795.

As we move our eye downward into the left-hand corner of the painting we see two purple wild boars (a male and a sow), their heads streaked with blue and turned sharply away from the conflagration which is about to engulf them. Flames have already begun to lick at the shank of the boar on the extreme left, while the animal to the right of it is being struck by one of the deadly diagonal rays streaming downward from the upper right. The boars make no effort to run. Perhaps they are paralyzed; perhaps they sense that no escape is possible. In any case, their eyes betray a deep feeling of pathos, a look of hopelessness and helplessness that makes the boar and his mate perhaps the most sensitively depicted of all the animal groups in the entire painting.

The sensitivity toward this particular animal has appeared before in Marc's work. In the painting *Swine*, of 1912, we see a mother sow with her offspring appearing in a position not unlike that of the boars in *Fate of the Animals*, their eyes especially portrayed with the same kind of tenderness that is so evident in the later painting. In the following year, 1913, Marc painted *Wild Boars*, which again depicts two animals similar in both form and composition to those in *Fate of the Animals*. In *Wild Boars*, however, the two animals are more animated, showing a sense of weightless vitality as they run and leap through the forest. The most significant study of the boar prior to *Fate of the Animals* can be seen in the tempera *St. Julian Hospitator* [28] of 1913. In this study we see (rather prophetically as it turned out) a horseman wearing a blue tunic and spiked headgear suggesting a German officer's helmet (a blue rider) astride a rather ominous-looking blue steed, riding across a devastated landscape, where smoke and tree stumps are all that occupy the background. In the foreground appear two animals, a deer and a boar, both shrinking in ter-

28. *St. Julian Hospitator*, 1913, tempera.

ror, neither animal insensitive to or unaware of the danger facing it. Such is the type of animal we see depicted in the lower left-hand section of *Fate of the Animals.*

As we move toward the center of the composition we move not only into the scene of greatest drama, but into a scene that has provoked some of the greatest controversy surrounding this painting as well. As we unfold the drama, we must unfold the controversy along

with it. In the center of *Fate of the Animals* a blue deer with white markings on its tail, chest, neck, and throat has run as far as it can. Its long neck, exaggerated in length, is now raised high into the air; the animal is about to die. To its immediate right a large tree cuts a strong diagonal across the canvas, almost slicing the painting in two. At first glance, it may appear that the deer is about to be crushed as this huge tree falls upon it. Yet, calling to mind that the original title of this work was *The Trees Show Their Rings, The Animals Their Veins*, we should be prepared to observe the transparent nature of the objects painted on the surface of this canvas. That is, the trees actually do show their rings, and at least one of the animals its veins.[9]

We are not viewing a literal interpretation of nature in this painting. On the contrary, we are, in this instance, seeing through nature, fulfilling what Marc declared as his purpose when he said,

> Today we seek behind the veil of appearance the hidden things in nature that seem to us more important than the discoveries of the Impressionists. . . . We seek and paint this inner spiritual side of nature not out of caprice or desire to be different but because we see this side in the same way that earlier ones suddenly "saw" violet shadows and the atmosphere surrounding things.[10]

In seeking to locate this "spiritual" side of nature, we are, in *Fate of the Animals*, looking behind the "veil of appearance," "piercing the veneer," as it were, looking through standing trees and seeing their rings, their essence. If we look closely at the interior line of the massive, diagonally inclined tree, the line closest to the neck of the deer, and follow this line from the top of the painting to the bottom, we can find no evidence of a crack or even an area of stress that would indicate any movement on the part of the tree.

Further indication that the tree is standing can be supported by an analysis of this motif in previous works of the artist, for the motif of the diagonal tree is one of his most recurrent. It appears, for example, in such diverse works as: *Yellow Cow* (1911), *Stags* (1911), *The World Cow* (1913), *Two Foxes* (1913), *Sleeping Animals* (1913), *Sleeping Deer* (1913). The diagonal is even more strongly emphasized than in *Fate of the Animals* in such works as: *Lying Steer* (1913), *Blue Deer in the Landscape* (1914), *Horse and Hedgehog* (1913–woodcut), *Wild Horses* (1912–woodcut), and perhaps most dramatically in *Deer in the Woods II* [24] (1912). In the last-mentioned painting we are faced not

only with the same motif of the diagonal tree that occurs in *Fate of the Animals*, but an equally apparent "confrontation" between tree and deer. The tree in *Deer in the Woods I* is even more emphatically inclined than in *Fate of the Animals* (or indeed, than in any of the above-mentioned works), yet again, there is absolutely no indication or suggestion or the slightest intimation that we should perceive this tree as falling or even moving. The most conclusive evidence to support the view that the tree is standing can be found in the preliminary sketch for *Fate of the Animals* [29], where we are readily able to distinguish the presence of the rings, but can, again, find no indication of a falling tree. Thus, while it was used most repeatedly and most effectively around the year 1913, we can easily see that the diagonal-tree motif is, indeed, an element that appears in much of Marc's work, so much so in fact, that its appearance in *Fate of the Animals* should not be seen as exceptional.

The deer, then, is not being killed by the tree but rather by the very diagonal ray which pierces both the tree and the neck of the animal, enveloping the head of the latter. The death of the deer is thus, perhaps, somewhat less dramatic than previously imagined, and possibly, therefore, less sacrificial as well. It is not, in fact, offering itself in sacrifice to the "falling" tree, nor is it displaying any more nobility than the frightened horses or the doomed pigs. Its death is as mundane and yet as spectacular as all the rest.

Like the position of the tree, the position of the deer is not at all unusual in Marc's previous work. We can see the appearance of the deer with upraised neck as early as 1908. In a lithograph from that year entitled *Deer in the Woods*, we see a group of seven deer, each assuming a different posture; the third deer from the right has its neck raised in precisely the same fashion as the blue deer in *Fate of the Animals*. In another work of 1908, a drawing entitled simply *Study of a Deer*, we see the animal in the posture it would assume some five years later; one foreleg is raised, its weight is supported by its hind legs, its neck is raised almost vertically. In yet another drawing from 1908, *Dying Deer*, we see another deer, only this time appearing with its legs buckled and drawn in beneath its body, apparently suffering its end. Its neck is again raised, its mouth open in a scream. The deer is clearly dying in this drawing, but not from any visible external source. Yet we must bear in mind that this drawing was intended as a study for a lithograph which also appeared in 1908,

29. Preliminary Study for *Fate of the Animals*, 1913, mixed media.

a lithograph also entitled *Dying Deer* [30]. In the lithograph, the source of the deer's death is clearly indicated—it is being killed by arrows which pierce its body, arrows which, like the rays in *Fate of the Animals*, originate in the upper right section of the work. I believe it was this lithograph to which Marc referred when he conceived of his project for the later painting.

The drama of *Fate of the Animals* lies in the center of the canvas, in the area of tension between tree and deer, but the significance of the work lies elsewhere. The meaning of the painting occurs in the section on the right, somewhat ironically in that portion of the work that was destroyed in 1917. Here again, however, there is room for confusion and mistaken identification. For example, the four animals hunched together in the lower-to-middle-right-hand section of the canvas have been variously identified as wolves and as foxes.[11] Yet the four animals in this section of the painting are clearly deer. They carry the same markings as the blue deer to their left: white markings on their undersides beginning just below the nose, extending through the chest and underbelly and ending in the white tail at the rear (the tail is most readily observable in the first deer on the left, the deer with its hindquarters facing us). Further, when we glance at the foreshortened deer in the upper right of the group, and follow the

curve of its neck into its back and rump, we see an animal whose very proportions rule out its identification as anything but a deer. In order to add further support to this identification let us again look at the evidence presented in Marc's previous work.

In the *Large Deer Drawing* [11] of 1908 we see a deer in a position not unlike that of the deer at the upper right of the foursome in *Fate of the Animals;* its markings differ, but its posture is fully in keeping with that of the latter. The other deer in this drawing, the lower one, carries the white tail that we see reproduced in the deer of *Fate of the Animals.* In a painting of the following year, *Deer at Twilight*, we again see two deer whose postures and markings are similar to those of the group in the 1913 work, as are the head and throat markings of the *Red Deer* of 1912 and the *Deer in Monastery Garden* [22].

In following the evidence from the other direction, we can find no relationship between the group of four animals in *Fate of the Animals* and that of any of the wolves and foxes depicted by Marc in previous or contemporaneous works. Even if we choose a most extreme example, such as the watercolor entitled *Two Foxes* of 1913, where the throat and chest markings are indeed similar, the enormous bushy tail which characterizes these foxes is nowhere evident in the animals of *Fate of the Animals.* As for the designation of these animals as wolves, one need only look at the painting *Wolves: Balkan War* [31], painted at about the same time as *Fate of the Animals*, a painting in which three desperate wolves stalk across the canvas from left to right, to see immediately the dissimilarity between the two groups of animals.

The position these four deer occupy within the work is a curious one. They are located in an area that is protected from the ravaging destruction that covers the remainder of the canvas; in short, this group of deer is going to survive the holocaust. If we follow the path of destruction we can see that it moves on an upper-right to downward-left axis, the diagonal of the large tree in the center of the canvas directing our eye toward the carnage that occurs to the left of it. There are no destructive lines of force moving into the lower right-hand corner of the painting. Indeed, if we look into the dark blue night sky which is visible in the extreme upper right-hand section of the canvas, we notice immediately that there the sky is serene, that indeed nothing penetrates into that serenity. It is an area of refuge.

To specify the exact nature of this refuge we must again go back to the concept of transparency to which we referred earlier. Peter Selz

30. *Dying Deer*, 1907, lithograph.

31. *Wolves (Balkan War)*, 1913, oil.

has, quite correctly, identified this area as that of "the roots of a gigantic tree."[12] Immediately above the quartet of deer to the upper right we notice three rings that, according to the original title again, would designate this area as a tree. It is the most highly stylized object in the entire work, its branches or roots shooting upward in bold massive strokes. While other roots or branches occupy an immense triangular area to the right of the central, diagonal tree, extending as far left as the green horses, another arm of the tree descends into the earth. The stylized area may or may not be the roots of that central diagonal tree but, in any case, we are looking through the composition of this tree "network," again piercing the veneer, to locate four deer who find shelter within the network, safe from the holocaust raging outside.

The style of *Fate of the Animals* shows a complete assimilative understanding of the art currents of the time and indeed, encompasses Futurist/Rayonist lines of force, cubistic structure, and the simultaneity of contrasts and color harmonies that characterize the "Orphic" work of Delaunay. What concerns us here, however, is an understanding of the nature and extent of the destruction we witness on the surface of this canvas, for indeed, *Fate of the Animals* represents more than an image of the destruction of a group of seemingly unrelated animals. It is, in the final analysis, an image of world destruction, of cosmic cataclysm, an image of apocalypse, whose sources can and must be ascertained if we wish to arrive at a fuller understanding of this vitally significant work.

3.

The most directly discernible literary source that influenced Marc in the thematic construction of *Fate of the Animals,* the source whose effect is most readily indentifiable, is Gustave Flaubert's *La Légende de St. Julien l'hospitalier.* Flaubert was one of Marc's favorite authors,[13] and indeed *The Legend of St. Julian* is a story that would, by its nature, hold great appeal for the painter. It is a tale that strongly contrasts the base in man with his ability to do good, a tale that in contrasting the conflict between the nature of man-as-murderer and man-as-saint, holds forth the possibility of man's ultimate deliverance from evil. The catalysts for the action in Flaubert's story, the bearers of the suffering, are animals. It is they whom the young Julian slaugh-

ters indiscriminately; it is their innocence that is destroyed by Julian's lust for murder; and finally, it is they who prophesy Julian's fate. This becomes clear when we consult the story itself. Consider the following passages:

> Then he [Julian] went along an avenue of great trees, whose tops formed a kind of triumphal arch leading into a forest. A roe bounded out of a covert, a buck appeared at a cross-way, a badger came out of a hole, and a peacock spread its tail on the grass. And when he had killed them all, more roes came forward, more bucks, more badgers, more peacocks, together with blackbirds, jays, polecats, foxes, hedgehogs, and lynxes— an endless succession of birds and beasts growing more numerous at every step. They circled round him, all trembling and gazing at him with gentle, supplicating eyes. But Julian did not tire of killing, first drawing his cross-bow, then unsheathing his sword, and after that thrusting with his knife. He had no thought or recollection of anything at all. Only the fact of his being alive told him that he had been hunting for an indefinite time in some indeterminate place, for everything happened with dream-like ease. [14]

Julian then came upon a group of stags and the thought of killing them excited him tremendously. He began firing arrows in their direction, eventually killing the animals one by one.

> Then all was still.
> Night was drawing on, and behind the forest, through the spaces in the branches, the sky showed red like a sheet of blood.
> Julian leant back against a tree, considering with wide-eyed wonderment the magnitude of the slaughter, unable to understand how he could have carried it out.
> Then on the far side of the valley, at the edge of the forest, he saw a stag with its doe and its fawn. [15]

Julian's apparently insatiable appetite for killing was again stirred. He readied his cross-bow and then killed the fawn. The mother, screaming toward the sky, in grief, was killed by the next arrow. Julian then fired at the large stag:

> The great stag did not seem to feel it. Striding over the dead bodies, it came steadily nearer, apparently bent on attacking and disemboweling him. Julian fell back in unspeakable terror. The huge beast stopped; and with blazing eyes, solemn as a patriarch or a judge, and to the accompaniment of a bell tolling in the distance, it said three times:

"Accursed, accursed, accursed! One day cruel heart, you will kill your father and mother!"

The stag's knees gave way, its eyes gently closed and it died.[16]

The prophecy of the stag would later come true, and the thought of his parents' murder and the guilt he felt for the perpetration of the deed hounded Julian for the rest of his life. He began, slowly, to hate the person he was and little by little he changed that person into one of goodness and self-sacrifice. His sainthood is finally attained at the end of the story, when, having reached the lowest levels of desperation, Julian gives aid and comfort to a leper. The leper is later revealed as an incarnation of Jesus who then rewards Julian by carrying him off to heaven.

Marc was so impressed by this story of suffering and redemption that he chose to illustrate it. The result is a tempera dating from the early spring of 1913; the title, inscribed in the upper left-hand corner of the work, reads: *La Légende de St. Julien l'hospitalier.*

A glance at Marc's *St. Julian* reveals an image that is filled with terror and destruction. The background is a veritable transcription of Flaubert's sky that "showed red like a sheet of blood." The boar and the deer turn away from the horse and its rider in fear. While his horse glares menacingly at the two frightened animals, the grim-faced Julian rides by with "dreamlike ease," oblivious to either the terrified animals or the tree stumps and flames that occupy the distance. Indeed, the destruction has been wrought by Julian himself, but both in Flaubert's tale and in Marc's painting, this destruction does not exist as an end in itself; rather, it may be seen as a necessary preliminary cleansing, a clearing away of sin and corruption, a preparation for the emergence of purification and redemption.

The preliminary sketch for *The Legend of St. Julian Hospitator* was drawn on the reverse side of the preparatory drawing for *Fate of the Animals.* There can be no question that Marc had the former in mind when he began work on the latter. The elements of apocalyptic vision contained in Flaubert's tale seem naturally to have found their way into *Fate of the Animals.* We can notice this specifically in the form of the doe killed with its head raised in the air, an image that is common both to Flaubert's *St. Julien* and to Marc's *Fate of the Animals,* and in the death of the boars; in Flaubert they are killed with a spear, in Marc they are killed with spear-like rays.

While Flaubert's vision of sin and redemption was clearly in Marc's mind when he began work on *Fate of the Animals*, the further iconographical derivation of the work extends far beyond that of the French author; indeed, it extends back to images and symbols contained in the ancient Nordic myths. While the popularization of these myths gained impetus throughout the nineteenth century, the two figures most responsible for their widespread acceptance and influence toward the close of that century, during the period of Marc's youth, were Friedrich Nietzsche and Richard Wagner.

Nietzsche's *Birth of Tragedy from the Spirit of Music* (1872) had a most profound impact upon the consciousness of its age. It was, and remains, among Nietzsche's most frequently read, translated, and cited works, a book that was written to supply an aesthetics and to find a historical precedent for the Wagnerian conception of art.[17] In seeking to further this end, Nietzsche contrasted the Dionysiac, irrational spirit of Greek culture before Socrates with the Apollonian, rational temper of the culture that followed him—the latter, according to Nietzsche, consuming the former, to the disadvantage of both. Nietzsche saw his Germany as a civilization predicated upon the destructive rationality of the Socratic-Apollonian model, a civilization whose only hope for salvation lay in the return toward primitivism, toward the expression of passion, toward the understanding and appreciation of myth.[18] Nietzsche envisioned a return to the Dionysiac spirit that, for him as a German, would mark a return to the truth of Germanic culture that lay buried in the old legends and myths. The catalytic agent for this rebirth of the German myth, the man who would resurrect the sleeping Siegfried, was Richard Wagner.

Wagner's influence upon the Germany of the late nineteenth century (and, indeed, into the twentieth century as well) was simply enormous. While he left the world an indelible legacy of music and drama, he left to the German people, in particular, an estate of far-reaching consequence. All of Wagner's work embodied his protestation against nineteenth-century bourgeois complacency, and posited instead a vision of living myth, of passion, and of heroism. Wagner's thought was dominated by the concept of salvation, "salvation of the people by the hero, salvation of man by woman, salvation of life by death,"[19] and his vehicle for this salvation was, as Nietzsche had indicated, the "age-old Dionysiac myth."

During the 1840s Wagner had become more and more engrossed

in the study of Nordic mythology, and by the year 1847 he was able to disassociate himself completely from his previous absorption in the works of classical antiquity, "and fall back once more upon my old and trusty guide, Jakob Grimm, for the study of German antiquity." Wagner continues:

> In my efforts to master the myths of Germany more thoroughly . . . I was drawn irresistibly to the northern sagas; and I now tried to acquaint myself with the Edda(s). My conceptions as to the inner significance of these old world legends gradually gained strength and I now succeeded in building up for myself a new world of the future, which presented itself with ever-growing clearness to my mind as the refuge whither I might retreat from all the miseries of modern . . . life.[20]

Many Germans of the late nineteenth century would react and respond to Wagner in much the same way as Wagner, in this passage, reacted and responded to Grimm.

In 1848 Wagner began to work on his magnum opus, the composition that most closely reflected his personal philosophy, *The Ring of the Nibelung*. In writing *The Ring*, however, Wagner looked not to the original *Nibelungenlied*, but toward the older Norse sagas contained in the *Edda*s, back to the realm of primitive, pre-Christian myth.[21] Wagner worked on his enormous operatic tetralogy for almost thirty years. By 1857 he had finished *Rheingold*, *Valkyrie* and the first part of *Siegfried*. Then, following a long interruption, he completed both *Siegfried* and *Götterdämmerung* (*Twilight of the Gods*) in 1874.

During his work on the tetralogy Wagner began reading Schopenhauer, whose philosophy confirmed Wagner's ever-growing romantic conviction that "night and death redeem man from the turmoil and burden of daylight and life."[22] Indeed, there is a sense of peril, of omnipresent and inevitable doom that pervades the four operas of *The Ring*. This sense of destructive despair is sounded by Wotan in the second act of *Valkyrie*:

Dost thou, child, know my wrath?
* If ever its awful*
* Lightning struck thee*

Then quail wouldst thou indeed!
 Within my bosom
 Burns enough rage
 To lay waste
 In dread ruin a world
That once were nothing but smiles.
Woe to him whom it strikes!
Dear the price he would pay! 23

Only at the end of the tetralogy, in the flames that provide the conclusion for *Götterdämmerung*, is there any hope for the redemption of man. It is only in the finality of that holocaust that Brünnhilde can proclaim: "The fire by which I am burnt cleanses the ring of its curse." 24 In the final act of *Götterdämmerung*, indeed, the final act of the tetralogy, Wagner's desire for a cleansing is realized. In this act, the evils of the present world are consumed in an apocalyptic holocaust, thus preparing the way for a new world to emerge phoenix-like from the ashes of the old.

In a letter written during the fall of 1897 (when he was seventeen years old), a letter whose importance cannot be overstated, Franz Marc wrote to August Caselmann:

> Those men who have chosen to castigate our age have not done so superficially, I am becoming more and more certain of this conviction. More so in recent days, days in which I have become acquainted with the writings of Richard Wagner, and in which I have seen and heard his magnificent "Götterdämmerung." And next to Wagner, there is, above all others, Nietzsche, with whom I become better and better acquainted. 25

According to Klaus Lankheit, "the enthusiasm for Wagner and Nietzsche was characteristic not only of Marc, but of youth in general at the end of the nineteenth century." 26 It is plainly evident, then, that Marc both knew of Wagner and had seen at least one performance of *Götterdämmerung*.

Whether or not Marc's knowledge and enjoyment of Wagner led him to the study or perusal of Germanic mythology is not entirely clear. We should recall, however, that after receiving his *Abitur* in theology from Munich's Luitpold Gymnasium in 1899 (two years after the letter to Caselmann) Marc decided to enroll in the faculty of German philology, thus expressing a strong interest in the study of Ger-

man literature, an interest which, indeed, continued for the rest of his life. We cannot say with certainty that Marc actually read the *Eddas*, but it is hard to see how he could have avoided them; and, as we shall now see, elements included in the image of *Fate of the Animals* seem to show considerable familiarity with these ancient Norse myths.

The center of the Nordic cosmology is the giant world-ash tree known as Yggdrasill. Yggdrasill is a tree whose qualities are unique, symbolizing both the vastness of the universe and the concept of immortality. All living things on earth, and, contrary to Greek mythology, even the gods above it are susceptible to death. Yet, the Yggdrasill remains firm and unaltered from age to age.

The tree has three great aortal-type roots; one reaches toward heaven, one into hell, and one into the earth, while the tree draws its sustenance from the fountains of these three regions. Among the animals present about the tree the most noteworthy are the fearful dragon Nidhögg that constantly chews at its roots and four deer that wander about the tree, gnawing on its leaves. The Yggdrasill is cared for and looked after by three Norns: Urd, Verdanda, and Skuld, the three goddesses of fate who represent respectively, the present, the past, and the future.[27]

Before its destruction in 1945, the Neue Museum in Berlin contained a large mural of the Yggdrasill and its immediate community [32]. Painted about 1864 by Ernst Ewald, the mural shows the three Norns guarding and nurturing the giant tree, while Nidhögg chews at its roots and the four deer nibble at its leaves. While, again, it cannot

32. Ernst Ewald, *The Three Norns*, c. 1864, wall mural.

be said with absolute certainty that Marc was directly influenced by this mural, there are, nevertheless, certain similarities between it and *Fate of the Animals* that cannot be overlooked. The number and position of the deer in the two paintings are in accord, as is the size and leftward-diagonal inclination of the giant tree. Further, there is evidence that places Marc in Berlin at least once a year from 1907 to 1913, when a visit to the Neue Museum would have been possible. A mere glance at this mural may have been all that was necessary to rekindle the fires of enthusiasm for Wagner's *Götterdämmerung* that had preoccupied the youth of seventeen. Indeed, Wagner's opera opens upon a scene which is not dissimilar to that presented in the Berlin mural.

Yet, even if we were to assume that Marc had no knowledge of the Berlin painting, there are too many images in Marc's work that too closely parallel the images contained in the Yggdrasill myth to suggest that the ultimate derivation of *Fate of the Animals* should be traced to any other source. Even the most cursory glimpse reveals that there *is*, indeed, a giant tree in *Fate of the Animals* that is *not* destroyed by the conflagration that surrounds it. The branches or roots of this tree reach far into the sky, down into the earth, and apparently descend below the earth as well. There are *four deer* in Marc's painting acting as a group. Taking all these factors into account, we should not be surprised to learn that the mythical tree, Yggdrasill, is referred to by the Germans as *Schreckross*,[28] a word which may be translated as "horse of terror." As we look to the left of the great tree in *Fate of the Animals*, there we are faced with what can only be described as an image of terror, the green of the leftward, diagonal branch or root, indeed linking the horse to the tree.

The *Edda* that most completely describes the Yggdrasill and the activity that surrounds it is the *Volüpsa*. It is also the *Volüpsa Edda* that describes the period of Ragnarok or the "Twilight of the Gods." This *Edda* provided the source material for Wagner's *Götterdämmerung*. A short analysis of the apocalyptic content of this *Edda* will provide significant insight into the meaning and import of Franz Marc's largest and most significant painting.

In the *Volüpsa Edda* the period of "Götterdämmerung" (Ragnarok) is preceded by a period of degeneracy, a period of "cold," when "snow will fall from the far corners of the world," a period when "war

and discord will spread over the whole earth." It is a time when, as the *Edda* tells us:

> *Brothers slay brothers;*
> *Sisters' children*
> *Shed each other's blood.*
> *Hard is the world;*
> *Sensual sin grows huge.*
> *There are sword-ages, ax-ages;*
> *Shields are cleft in twain;*
> *Storm-ages, murder-ages;*
> *Till the world falls dead,*
> *And men no longer spare*
> *Or pity one another.*[29]

This period of degeneracy is the signal upon which the dissolution of the world is to begin. It is at this time that one wolf, Fenris, devours the sun, while another wolf, Maanegarm, devours the moon. When this occurs, the stars are hurled from the heavens and the earth trembles with such violence "that trees will be torn up by the roots, the tottering mountains will tumble headlong from their foundations, and all bonds and fetters will be shivered to pieces."[30] The god of fire, Surt, then unleashes lightning flames upon the earth. The *Volüpsa* continues:

> *Quivers then Yggdrasill,*
> *The strong rooted ash;*
> *Rustles the old tree*
> *When the giant gives way.*
> *All things tremble*
> *In the realms of Hel*
> *Till Surt's son*
> *Swallows up Odin.*[31]

The gods and the giants are then locked in a battle to the death, a battle in which there will be no victor. Then,

> *All men*
> *Abandon the earth.*

The sky darkens,
The earth sinks into the ocean;
The lucid stars
From heaven vanish;
Fire and vapor
Rage toward heaven;
High flames
Involve the skies. [32]

It is a time when fire, water, darkness, and death work together to destroy the earth, the gods, the humans, and the animals.

The evils of the world are thus destroyed in the great cataclysm that engulfs the universe. But this is not by any means the end of things. A new earth and an entirely new species of gods and men emerge from the ruins of what had been a corrupt and degenerate world. In short, the earth has by this act been cleansed, evil has been eradicated, and the new, "pure" inhabitants of this new, "pure" earth are now free to construct an entirely fresh, hopefully "more perfect" existence.

But the question should naturally arise, that if all the inhabitants of the earth are consumed by this act, then how can there be such rapid renewal? While the answer can be found not only in the *Eddas* themselves, but also in critical analyses of the myth, the description provided by Carl Jung is by far the most perceptive: "In the wood of the world-ash Yggdrasill a human pair hide themselves at the end of the world, and from them will spring a new race of men. At the moment of universal destruction the world-ash becomes the guardian mother, the tree pregnant with death and life." [33] In turning once more to *Fate of the Animals*, we should again be reminded that we are looking through the veneer, peering inward, beyond the surface and into the interior of things. Thus, in designating the tree complex on the right-hand side of the painting as the boughs and roots of the mighty Yggdrasill, it must necessarily follow that the four deer are, at this moment of universal destruction, safely sheltered within the protected interior of the indestructible tree. Indeed, it is the deer who will survive the holocaust and live to form a new race. [34]

The ultimate meaning of *Fate of the Animals* can thus be fully understood only within the context of its sources. It is, in short, a plea for apocalypse; the expression of a longing for the destruction of the

present world of corruption, evil, and degeneration, and its replacement with a world of innocence, goodness, and purity. Indeed, *Fate of the Animals* is a specifically Germanic plea for redemption, drawn from the sources of centuries-old tradition that can be traced at least as far as the ancient Norse myths.

4.

As dramatic as Marc's depiction of apocalypse may be, it is a work that is not at all unique for its time. Indeed, the apocalyptic preoccupation of *Fate of the Animals* is typical of this period of German Expressionist painting. These themes occur, for example, in Kandinsky's *Improvisation #30 (Cannons)*; Meidner's *Burning City, Apocalypse,* and *Apocalyptic Landscape;* Pechstein's *Life Boat;* Nauen's *Battle of the Amazons;* Hofer's *Banner Carriers;* Kokoschka's *Tempest;* Beckmann's *Sinking of the Titanic;* and Rohlfs's *War,* to name but a few of the works painted between 1912 and 1914 that are clearly apocalyptic in outlook. This thought of imminent catastrophe seems also to have gripped artists throughout the country. It affected Marc and Kandinsky in Munich, Meidner and Pechstein in Berlin, Rohlfs in Hagen, Hofer in Paris, Nauen in Düren, Beckmann in Frankfurt, and Kokoschka in Vienna.

This outburst of premonitory production was due partly to the lingering possibility of a catastrophic European conflict. For example, Kandinsky attributed the unmistakable presence of two firing cannons in the lower right-hand corner of his *Improvisation #30* (1913) to "the constant war talk that had been going on throughout the year."[35] Yet, much of Kandinsky's literary output, published long before 1913, also has rather distinct affinities with later apocalyptic presentiments. Consider the following passage from Kandinsky's poem "Klänge" ("Sounds"), published in 1912:

> Great big houses suddenly collapsed. Little houses remained quietly in place. Suddenly a fat hard egg-shaped cloud-orange hung over the city. . . .
>
> A withered bare tree stretched its quivering trembling long branches heavenward. The tree was pitch black, like a hole in white paper. The four little leaves quivered a long while. But there was no wind.
>
> But when the storm came and many a thick-walled building toppled,

the thin branches remained motionless. The leaves grew stiff: as though cast in iron.

A flock of crows flew in a straight line over the city. And suddenly everything was still again.[36]

The year 1912 was also the year in which one of the most apocalyptic of the German Expressionist poets, Georg Heym, was drowned, and the year in which Ludwig Meidner began his series of Apocalyptic Landscapes. Thus, while the war-talk of 1913 no doubt influenced the flurry of prophetic images of doom that appeared in that year, the trend toward the representation of apocalyptic themes had clearly begun some years before, when war was first considered a real possibility.

In addition, the explosiveness of much of prewar Expressionist art and literature had its roots in the Expressionists' reaction to the society in which they lived, a society they saw as soulless, materialistic, hopelessly bourgeois, a society whose morals, mores, and institutions they despised as wholly corrupt, the same society from which they felt rejected and by which they felt ignored. The driving ambition of prewar Expressionism may be characterized as a messianic ultimatum: either the Wilhelmine "society of externality" must change radically, or it must be destroyed totally. There could be no middle ground.

In their desperate attempt to overcome their overwhelming loss of hope and social alienation, the Expressionists were led "to the belief that only through the destruction and rebirth of the world could a new and pure humanity arise."[37] In what is perhaps the most lucid enunciation of this belief, Hermann Hesse discussed its purpose and direction:

> The future is uncertain, but the path which is here indicated . . . is clear. It involves a spiritual reorientation. It means that we must think "magically," that we must welcome the chaos that is to come. We must return to the realms of disorder, of the unconscious, of formless existence, of brute life, and far beyond brute life to the beginning of all things. But we do it not in order to remain there, but to reorient ourselves, to rediscover the forgotten instincts and possibilities of development at the very roots of our existence, in order to bring about a new creation, valuation and distribution of life. No programme can show us the way, no revolution can throw open the gates. But each individual

must travel there unaccompanied. Each of us must for one hour of his life stand . . . at that parting of the ways where old truths end and new truths begin.[38]

The road that led toward salvation had to begin with destruction. Thus, when the war finally did begin, most of the Expressionist artists, poets, and authors greeted it in the belief that the hour of judgment was finally at hand. In August of 1914, Stefan Zweig could proclaim that "each individual experienced an exaltation of his ego,"[39] and Franz Marc could write from the front "that the war was nothing if not a moral experience . . . a preparation for a breakthrough to a higher spiritual existence,"[40] just the kind of event that was needed for "sweeping dirt and decay away to give us the future today."[41]

Fate of the Animals is but one representation of this apocalyptic current. Needless to say, however, each Expressionist artist represented his vision of apocalypse and redemption in his own, largely individual way, through the use of his own vocabulary of symbols. Kandinsky expressed himself through the depiction of "inner moods and tensions," his vocabulary consisting of the vagaries of line and color. Meidner and Heym, on the other hand, chose a somewhat more specific point of departure, that of the city as a symbol of the repository of the world's evils. Franz Marc (along with many other Expressionists) expressed himself through the symbolic use of the animal.

In a most revealing letter to his wife, written from the front, and dated April 12, 1915, he explained the reasons why:

On the whole my instincts have not, so far, guided me too badly, even though my works are not, as yet, pure; especially those instincts that led me away from my sense of feeling for man and towards a feeling for the animalistic, for the "pure animals." Those un-spirited impious people who surrounded me (especially the males) never inspired my true feelings. While the animals with their untouched, innocent sense of life allowed all that was good in me to resound. . . .

Very early in life I found man to be "ugly"; the animals appeared more beautiful, more pure. But then I discovered in them, too, so much that was repulsive and ugly. . . . Trees, flowers, the earth, all showed me more of their ugly and repulsive sides with each passing year, until now when I have suddenly become fully conscious of the ugliness of nature, its *impurity*. Perhaps it is our European view of the world that has so

poisoned and distorted it. It is, indeed, for that reason that I dream of a new Europe.[42]

Despite this apparent revulsion against nature late in his life, Marc returned to the depiction of animals and their environment later in that very same year, as we can see from his *Field Sketchbooks*.

The purpose of animal symbolism in the art of Franz Marc is fully in keeping with a tradition that extends at least as far back as the artists of prehistory. In the next chapter we will examine the use of this symbolism in the literature and thought of the late eighteenth and nineteenth centuries, in works of which Marc was fully aware. We will then briefly analyze both the use of animal symbolism and the representation of the theme of apocalypse in the literature of German Expressionism, exploring also the relationship of the symbol to the theme.

Signs
in the Sky

1.

THE PURPOSE behind the type of animal symbolism em-
ployed by Marc and the Expressionists has its most immediate roots
in the literature and philosophy of the nineteenth century. As we
trace some of the sources, we should begin to see the development of
a pattern—that is, we should begin to notice that, as the century
progresses, the employment of animal symbols in literature and phi-
losophy gradually develops into a more and more rigid mold, being
more and more restricted to the symbolizing of one aspect of being.
By the early twentieth century, the use of this symbol becomes al-
most fixed in its application: the animal will almost exclusively repre-
sent the stage of primitive, irrational, precognitive being, a state of
being that will be viewed with an increasingly positive outlook as the
negativism and despair of the late nineteenth century broaden. In
surveying this development we will begin first with the work of Jean-
Jacques Rousseau.

It has been said that Voltaire referred to Jean-Jacques Rousseau's
Discourse on the Origins and Foundations of Inequality among Men
(1755) as "Rousseau's book against the human race." [1] Indeed, Rous-
seau's work is the first in the modern period which so effectively
called into question the achievements of civilization and the very
course of its direction.

The further man is separated from the state of nature, Rousseau believed, the further he is separated from his true essence. The only men on earth who, according to Rousseau, exhibit the true, inherent qualities of humankind are the "savages," those closest to the "animal" state of being. Through his intellect, his logic, and emphasis on rationality, modern man has become a "degenerate" animal. Imprisoned in his "poisoned" culture, the bourgeois citizen, according to Rousseau, either works himself to death or renounces life itself in a delusive bid for immortality. He lives a lie paying obeisance to the rich and great while inwardly he envies and loathes them. He is a slave proud of his servitude and scornful of those who choose not to share it. Rousseau believed that the man of instinct, the precultural "savage" on the other hand, breathes the pure air of freedom and leisure. He seeks nothing but life itself and is profoundly indifferent to even the idea of acquiring material possessions. Rousseau's "savage" is internal, self-contained, living within himself, while the man of society is a dependent creature living in a world of externals. Rousseau compared the internal world of the "savage" to that of a stallion pawing at the earth and instinctively resisting any attempt to rein him, while he viewed the man of civilization as a trained horse unruffled by the crack of the whip or the bite of the spur.[2]

Whatever the merits of Rousseau's philosophical assumptions (and they certainly had a strong appeal to the Expressionists' concept of "real" versus "unreal," "true" versus "false," and the "world within" versus the "world without"), he did help to establish the precedent for the use of animal symbolism that would gain many adherents throughout the century that followed. Henceforth, the symbol of the animal (or the state of animality) would be used with increasing frequency to represent the unity with nature enjoyed by prelogical, instinctive being, in contrast to modern man's loss of that unity.

The reaction to reason and the return to nature advocated by Rousseau saw fulfillment during the period of Romanticism. It was during this period, in 1819, that Arthur Schopenhauer's *The World as Will and Idea* was first published. Our helpless subjection to the Will, declared Schopenhauer, was the cause of our suffering. The Will, or the will to live, is a blind endless striving that can find neither attainment nor satisfaction. Man's search for happiness is thus never-ending, for pleasure or enjoyment is always a temporary cessation of the

pain of desire. Implicit in Schopenhauer's conception of human life is the unlimited potential for suffering, a potential increased in direct proportion to the intellectual ability of the individual.

Schopenhauer contrasts this world of man, this hell in which one person is the devil of another, with that of the irrational unreasoning animal. Living in the present alone, the animal is neither haunted by the past nor hopeful of the future and, as such, its suffering is considerably lessened. Acting solely by its instincts the animal has no understanding of the concept of death; it does not know that it must die at some future time and thus cannot make itself miserable by contemplating what will happen or what might have happened. In addition to its present-consciousness the animal is a being that cannot lie or make erroneous judgments, for it is simply not able to reason abstractly. According to Schopenhauer, the animal cannot be insincere, cannot perform trickery or fraud, nor use the faculty of reason to inflict pain and torture on its companions.[3]

In the thought of Schopenhauer, then, the animal is again employed to symbolize a unity with nature that man has forsaken. But Schopenhauer has also added another dimension to the use of animal symbolism; the animal will now also represent a being that lives in innocence and goodness, qualities relinquished by man long ago.

In *The Origin of Species* (1859) and *The Descent of Man* (1871), Charles Darwin announced his theories of natural selection and evolution. One of the first major effects of these works was to contradict the time-honored Christian belief in special creation, and to hold in its place that man was and is a part of nature and subject to its laws. In *The Descent of Man*, Darwin concluded inescapably that man himself had evolved from lower, less highly developed forms of life.[4]

The implications of Darwin's theory of evolution for every aspect of life during the remainder of the nineteenth century were so widespread as to be incalculable. What is clear, however, is that the concept of an unalterable rational order, the nature of absolute standards or absolute thought, had been seriously undermined. The stamp of science had now given further credence to the already existing conviction that man was, indeed, an animal, was a part of nature engaged in the same struggle for survival that preoccupied his fellow creatures. There now existed a direct proven link between man and the animals, a relationship that some were able to project as familial: the

animal assuming the position of a distant cousin whose "innocence" and whose "purity," whose existence at the "heart of nature," were to be envied.

The immediate impact of Darwin's ideas can, perhaps, best be appreciated as we look at the use to which animal symbolism was directed in the thought of Friedrich Nietzsche. In the work of Nietzsche, the animal continues its representative function as a symbol of prelogical being, free of the consciousness of history, existing in a state of timelessness, a state of being in balance with nature. Nietzsche begins his *The Use and Abuse of History* (1874) with the following words:

> Consider the herds that are feeding yonder; they know not the meaning of yesterday or today; they graze and ruminate, move or rest, from morning to night, from day to day, taken up with their little loves and hates, at the mercy of the moment, feeling neither melancholy nor satiety. Man cannot see them without regret, for even in the pride of his humanity he looks enviously on the beast's happiness.[5]

For Nietzsche, as for Schopenhauer, the animal is an instinctual being, concealing nothing, living in the present, it cannot strive to be something it is not. Man, on the other hand, is continually oppressed by the burden of the past and thus looks with envy upon the lost paradise of animality. Here, Nietzsche uses the animal as a symbol of unhistorical consciousness, as a being that leads a pure vital life, as a functional ideal toward which man might aspire.[6]

A decade later in *The Antichrist* (1888), Nietzsche interpreted Darwin's findings in a way that would have significant influence upon the thought of the Expressionists. Attacking the time-worn concept of man's derivation from "the spirit" or "the deity," Nietzsche not only placed him back among the animals but derided the very thought of human life having been the great hidden purpose of creation. On the contrary, Nietzsche found man to be "the most bungled of the animals, the sickliest, and not one has strayed more dangerously from its instincts."[7] Man, says Nietzsche, by seeking to disown his innate instinctual heritage has adopted a false set of values, thereby corrupting himself and his society as well. He says, in *The Antichrist:* "Understand corruption, as you will guess, in the sense of decadence; it is my contention that all the values in which mankind now sums up its supreme desiderata are *decadence-values*. I call an animal, a species,

or an individual corrupt when it loses its instincts, when it chooses, when it prefers, what is disadvantageous to it."[8]

Nietzsche's attack on the "false values" of the rational and the intel- lectual,[9] and his depiction of the "happiness" of the instinctual ani- mal, its joyous union with nature, its habitation in an innocent state of being had the most profound effect upon the art and literature of his day. It served to give support to similar developments in thought that had begun to appear in French literature at about this time. As early as 1861, for example, Baudelaire had written in *Les Fleurs du Mal*, "I envy the fortune of the meanest animal/Who is able to plunge himself into stunned sleep,"[10] while eight years later, in his *Chants de Mal- doror*, Lautréamont plunged his hero into the forms of the animals themselves, "forms which, to him, represented a greater 'likeness to the divine' than his own human existence."[11]

Further, Nietzsche's defense of instinct ignited the imagination of the succeeding generation of artists and writers throughout Europe. Writing of the period 1880–1914 in England, a period contempo- raneous with that of prewar Expressionism in Germany, John Lester has said: "It was a reunion . . . with the senses and instincts of the animal kingdom, senses fresher and keener than our own. Perhaps in animal instinct, in the unconscious, there might be faculties of know- ing which are superior to man's weary march of mind.[12] D. H. Lawrence, in what is almost a paraphrase of Nietzsche, wrote in 1913: "My great religion is a belief in the blood, the flesh, as being wiser than the intellect. We can go wrong in our minds. But what our blood feels and believes and says, is always true."[13] It was in Germany, however, that the fullest impact of Nietzsche's thought was felt.

2.

The historical, psychological, and sociological conditions of Wilhel- mine society, against which Nietzsche had railed so vehemently, were now, during the period of prewar Expressionism, deteriorating even further. As his existential situation grew more and more desper- ate, the Expressionist artist tended to view the ideal of primitive, prelogical, instinctual life as a correspondingly more positive and at- tainable end. To achieve such a goal would, in actuality, require nothing less than a complete destruction of the corrupt and decadent bourgeois society he saw surrounding him. In a brief survey of works

by various Expressionist authors and poets, we find examples that are by no means extraordinary to the movement but which reflect the pervasiveness with which these themes were represented.

While Frank Wedekind did not, for the most part, directly employ animal symbolism in his work, the desire for the animalistic and the instinctual is consistently pronounced in his plays. As we have seen, he sought an end to the sham, the pomposity, and insincerity of middle-class life and a return to the primitive, the vitalistic, to what he viewed as a freer and more honest life.

In his two most influential plays, *Erdgeist* (*Spirit of the Earth*, 1895) and *Büchse der Pandora* (*Pandora's Box*, 1904), Wedekind utilized the figure of Lulu, a woman of rather liberated morals, as his symbol for the "true" spirit of mankind. Lulu represents the antithesis of a civilized society, a person totally alien to the everyday world of bourgeois reality. She symbolizes the human race in its precivilized state, innocent, instinctive, and charged with a primitivism which has become sublimated in the modern world. But Wilhelmine society, indeed present society as well, must defend itself against Lulu, against the lure of instinct, of gratification, in order to preserve and extend itself.

In *Erdgeist*, instinct is locked in an intense confrontation with bourgeois morality, a confrontation that can only end with the victory of the one over the other. Wedekind here sets the stage for the battle of wills that would preoccupy the next decade.

While specific reference to instinctual primitivism is less apparent in the work of Jakob van Hoddis, his revolutionary poem "Weltende" ("End of the World") set the tone for the representation of the theme of apocalypse in Expressionism. This influential work, first published in 1911, is credited with initiating "that abuse of the cosmic and chiliastic that led to the gradual inflation of the verbal currency of Expressionism. Soon it ceased to matter greatly whether a writer predicted the end of the world or a new humanity; both became the stock-in-trade of every poetaster."[14] Van Hoddis's poem is quoted in its entirety:

The bourgeois' hat flies off his pointed head,
The air re-echoes with a screaming sound.
Tiles plunge from roofs and hit the ground,
And seas are rising from the coasts (you read).

The storm is here, crushed dams no longer hold,
The savage seas come inland with a hop.
The greater part of people have a cold.
Off bridges everywhere the railroads drop. [15]

The form of the poem assumes a mixture of sarcasm aimed at the bourgeoisie and a deadly seriousness at the premonition of the coming world catastrophe. Johannes Becher, an Expressionist poet and a friend of van Hoddis, referred to "Weltende" as "the *Marseillaise* of the Expressionist rebellion," [16] a poem whose "eight lines carried us away. We continuously discovered new beauty in these eight lines, we sang them, we hummed them, we murmured them, we whistled them, we . . . whispered them, we took them to the cycle races. We shouted them up and down the street. . . ." [17]

For Gottfried Benn, the general regression to the instincts desired by the Expressionists could not go far enough. He sought a complete escape from consciousness, from any kind of reason or rationality and, like Nietzsche, he too could envy "the animal [that] lives only for the day/and in its udder has no memory." [18] Benn's poetry speaks of a longing for inclusion back into primitive nature, a longing for suffering, rational, intellectual man to return quite literally to his "senses." We can readily see the expression of this belief as we look at the following lines, excerpted from Benn's "Gesänge I" ("Cantos I"), published in 1913:

Oh that we were like our ancestors,
A lump of slime in a warm swamp.
Life and death, fertilization and birth
Our silent fluids gliding before us.

An alga leaf or hillock in the dunes,
Shaped by the wind and weighted towards earth.
A dragonfly's small head, a seagull's wing
Would be too far advanced in suffering. [19]

The other side of Benn was revealed in his first volume of poetry, *Morgue*, which appeared in 1912. In these poems the world is described as a heap of corpses, a world filled with sickness, depravity, suffering, and death. Else Lasker-Schüler described the poems of *Morgue* as a climate in which "suffering breaks open in vengeance and then becomes silent, hospital rooms are turned into graveyards,

and plants are placed before the beds of the suffering. As [this] world ends, a child-bearing woman is heard screaming from the operating room."[20] Benn's escape into an ideal world in which life is no more advanced than a microscopic organism was extreme in its regressive intensity. Nevertheless, it was a goal toward which his Expressionist contemporaries could also aspire, with the realization that the sickness of the existing society had to be destroyed.

The image of destruction in Expressionism is nowhere more powerfully expressed than in the work of Georg Heym. His is a poetry obsessed with death and war, apocalypse and doom. But coupled with his images of omnipresent destruction is Heym's reason for its necessity: the loss of Being, the loss of substance by modern man, which the poet regards with horror. In the approaching apocalypse, Heym does not foresee much hope for the urban world. Consider the following lines from "Umbra Vitae," one of his most widely read poems, first published in 1912:

The people on the streets draw up and stare,
While overhead huge portents cross the sky;
Round fanglike towers threatening comets flare,
Death-bearing, fiery snouted where they fly. . . .

Through night great hordes of suicides are hurled,
Men seeking on their way the selves they've lost. . . .

The dying man sits up as if to stand,
Just one more word a moment since he cries,
All at once he's gone. Can life so end?
And crushed to fragments are his glassy eyes. . . .[21]

While it is man's helplessness in the face of this approaching catastrophe that Heym stresses in "Umbra Vitae," the image of a cleansing, purgatorial act which will sweep evil from the world and allow man to be reborn in his true essence is most forcefully expressed in what is, perhaps, his most influential work, "Der Krieg" ("War"), published in 1911:

He has arisen, who has long been asleep,
Arisen from the depths of the cellars deep.
In the twilight he stands, huge and unknown,
And he crushes the moon in his black hand.

In the evening noise of cities everywhere,
Frost and shadows of a strange darkness fall.
And the whirlpool of the market turns to ice.
Silence descends. They look around and no one knows.

In the alleys it lightly grasps their shoulders.
A question. No answer. A face turns pale.
In the distance a thin chime wails.
And their beards tremble on their pointed chins.

On the mountains he begins to dance,
And he shouts: All you warriors, to arms!
And it resounds, when he turns his black head,
For a thousand skulls ring loudly on his chain.
. .
In the night he drives the fire across the fields,
A red dog howling with wildy gaping jaws.
. .
And with a thousand high-capped peaks,
The dark plains are everywhere in flames,
. .
And the flames devour forest after forest,
. .
A great city sank down in yellow smoke,
Threw itself without a sound into the belly of the abyss,
. .
On the reflection of storm-shredded clouds,
In the dark, cold barrenness of death
The night withered away while he with the flames
Trickles pitch and fire down upon Gomorrah. [22]

Heym's "war" is not a combat between opposing armies or societies
or ideologies, but rather a great cosmic cataclysm in which unhuman,
supernatural forces unleash themselves in fury upon the hapless vic-
tims of a decadent urban culture. Man's "nobility" is swept away in
the cosmic disorders over which he can never have any control. He is
reduced to the role of eternal victim, now dominated and exploited
by the very nature he once sought to subdue.

For Georg Trakl, nature and the animal within nature represent
the true state of Being. In his poetry we find the most immediately
recognizable relationship between regression and apocalypse in all of

Expressionist literature. Trakl's words speak profoundly of the necessity for man to return to his lost innocence, represented in the symbol of the animal, and the need for an apocalyptic cleansing of the world so that the return to innocence may be successfully realized. His poems are filled with the contrast between the images of true Being, of life lived in its most primitive state, and the decay, corruption, and callousness of modern urban life. This contrast becomes all too clear in the following lines from the poem, "Kaspar Hauser Lied" ("The Song of Caspar Hauser"), which first appeared in 1913:

He truly adored the sun, as crimson it sank from the hill-top
The paths of the forest, the blackbird singing
And the joy of green.

Serious was his habitation in the tree-shade
And pure his face.
God spoke a gentle flame into his heart:
O man!

His silent footsteps found the city at evening
. .
House and pallid garden of pallid men
And his murderer sought him. . . .

Beautifully the spring and summer of the autumn
Of the righteous man, his soft footfall
Beside the dark rooms of dreamers.
By night he stayed alone with his star;
Saw snow falling through bare branches
And in the dusking hall his murderer's shadow

Silver it fell, the head of the not-yet-born.[23]

Here, the life of innocence, the life that was lived to its fullest in the primitiveness of nature, is destroyed by the "murderous" city. Trakl's image is not the depiction of a "noble savage," however, murdered by a single killer in the dark evils of the metropolis. On the contrary, one way of life, a life of simplicity and of "joy of green," is destroyed by the overwhelming powers of evil and spiritual corruption which, according to Trakl, are characteristic of the society in which he lived.

In the poem "Abendland" ("The West"), which was first published in 1914, and was dedicated to his friend Else Lasker-Schüler, Trakl

drew further the dichotomy between these two modes of existence.
In this work, however, Trakl provides an answer to his dilemma; the
answer is apocalypse:

II

So quiet are the green woods
Of our homeland,
The crystal wave
That dies against a perished wall
And we have wept in our sleep;
Wander with hesitant steps
Along the thorny hedge
Singers in the evening summer
In holy peace
Of the vineyards distantly gleaming;
Shadows now in the cool lap
Of night, eagles that mourn.
So quietly does a moonbeam close
The purple wounds of sadness.

III

You mighty cities
stone on stone raised up
in the plain!
So quietly
with darkened forehead
the outcast follows the wind,
bare trees on the hillside.
You rivers distantly fading!
Gruesome sunset red
is breeding fear
in the thunder clouds.
You dying peoples!
Pallid below
that breaks on the beaches of Night,
stars that are falling.[24]

The "homeland" of which Trakl spoke in the first line of this poem,
"the green woods," can be redeemed as the home for a rejuvenated
and regenerated race of men. But, if the "new man" is to escape the

fate of Caspar Hauser, then the "mighty cities," symbolic of the whole of prewar degenerate society, must first be swept away.

The vision of destruction and renewal is a constant element in Trakl's work, but it is the image of the animal, an image that appears again and again throughout his poetry, that represents to Trakl the ideal type of inhabitant for this "new world." His would be the kind of a world in which, "At the forest edge a shy deer shows itself, at peace."[25] First, however, as we can see in the poem "Untergang" ("Decline"), the world of the present must meet its destiny:

Over the white pond
The wild birds have travelled on.
In the evening an icy wind blows from our stars.

Over our graves
The broken brow of the night inclines
Under oak-trees we sway in a silver boat.

Always the town's white walls resound
Under arches of thorns,
O my brother, blind minute-hands,
We climb towards midnight.[26]

In the belief of Trakl and in the belief of Heym and Benn, van Hoddis and Wedekind, and indeed in the belief of the Expressionist movement as a whole, the fervent hope for man's renewal, the longing for his return to a kind of innocent, primitive, instinctual state of Being, could be envisioned only upon the condition that the present world, the world in which they lived and struggled and suffered, be obliterated beyond recognition.[27] The powers of evil, the Expressionists felt, the powers represented by materialistic, spiritless, bourgeois Wilhelmine society, had to be destroyed before the powers of righteousness, the powers of the spirit, of instinct, of animalism, could ever be allowed to reign. Such were the beliefs held by Franz Marc as well.

3.

The form of life desired by the Expressionists, a life in which the free play of instincts would be secure, could not be guaranteed without the elimination of the instinct-repressing society in which they lived.

An apocalypse, they believed, could provide the necessary cleansing, following which their goal might somehow be attained. The theme of apocalypse is thus an integral part of the art and literature of the Expressionist movement.

The most frequently recurring symbolic image employed by the Expressionists to represent the heralding of the apocalypse was that of the moon, particularly the crescent or sickle moon. The cyclical pattern of the moon's appearance—its phases and regular alterations—has historically provided a convenient symbol for the cyclical pattern of life, especially as enunciated in ancient apocalypses. As the moon wanes and disappears so may a sinful humanity dissolve and vanish and, as the new moon reappears, so may a new mankind emerge as well. In short, the moon in mythology refers to the cyclical nature of the world, a world that is born, that disintegrates into chaos, that perishes, and is reborn.[28]

The particular image of the crescent phase of the moon is even more closely associated with the imminence of apocalypse. In this phase the moon strongly resembles the shape of the ancient instrument used for cutting the grain at harvest, the sickle or scythe. The longing for the sickle moon that we see voiced in Expressionist poetry does indeed represent this desire for a harvest. It becomes a yearning for the scythe with which the grain or the grass, representing humanity, is harvested. "Surely," says Isaiah (40:6, 8), "the people is grass." As the grass or grain is replenished or renewed in the months that follow, so too may humanity be renewed. But first the harvest must be completed.

We can see a reference to this lunar symbolism in Trakl's "Abend" ("Evening") of 1913:

With dead figures of heroes
The moon is filling
The silent forest,
O sickle moon!
And the mouldering rocks all round
With the soft embraces
Of lovers,
The phantoms of famous ages;
This blue light shines
Toward the city

Where a decaying race
Lives coldly and evilly,
Preparing the dark future
Of their white descendants.
O moon-wrapped shadows
Sighing in the empty crystal
Of the mountain lake.[29]

The moon, in Trakl's poem, refers to a plea for deliverance. Its "blue light shines/toward the city" as a premonition of the destruction which the city (i.e., civilization) will undergo. The "decaying race" that occupies this city has no future (it prepares only for a "dark future"). Nor will this city have any descendants, for the color "white," in Trakl's symbolism, refers to death.[30]

Trakl, however, was by no means the only Expressionist poet to refer to the moon in this way. Theodor Däubler, in his poem "Der Stumme Freund" ("The Mute Friend"), wrote, "The moon disseminates the pale seeds of death."[31] In his poem "Der Krieg" ("War"), Georg Heym spoke of some unnamed demonic force who, "In the twilight . . . stands, huge and unknown/ And . . . crushes the moon in his black hand"; while in the poem "Mondlegende" ("Moon-legend"), Paul Zech wrote, "Now raging, the moon travels from the roof of the clouds/ the moon which freezes all things."[32] In his work "D-Zug" ("D-Train"), Gottfried Benn wrote, "In longing for the sickle: how long the summer is!/ the next to the last day of the ninth month already,"[33] thus anticipating with excitement the "harvest" of the fall. Perhaps the most vivid use of the moon as a symbol of the approaching apocalypse appears in Yvan Goll's poem "Mond" ("Moon").

I

But how unrelentingly you swelled
The solitary hearts of little dressmakers
And blustering pianos' sky-desires.

How unrelentingly you shed your brightness
Into the dark and shivering alcoves
And behind iron bars of prisoners.

Out of the blazing hell of their hearts
Men cried aloud and came into despair
And tore their breasts wide open in their madness
And died of it, you had been so beautiful.

II

And when abruptly, like a wounded bird,
You fluttered down from heaven and your flames
Were falling in red feathers everywhere:

How cruelly your ray drove over the earth!
The animals had eyes of phosphorus,
The houses burned to ash like funeral pyres.

. .

IV

And one night drops of blood fell on our faces:
Your blood with blood of our war interfused
Ran round the earth, an all-encircling ring.

There was no help in heaven or on earth:
We had to hide our heads deep under ground,
Our loves we had to bury in deep graves,
And we lamented not to have rather died.

V

But even then as painted mask and dancer
You set the graves all free. The columns crumbled,
Marble came rattling down, wreaths fell apart.

You who have ransomed all that died, O dancer,
While deep in filth and torment, fast asleep,
We went on snoring, blind to a little gladness:
Ourselves it was had died; the dead, they lived.[34]

Goll's poem was written in 1916, and thus speaks, in a very real sense, as something of a capsule summary of the use of the moon by the Expressionists as a symbol of their desire for apocalypse. The last four lines of the first verse denote the ecstasy with which the moon (i.e., the apocalypse) in the form of the war was greeted. Indeed, it "had been so beautiful" to the Expressionists that the time for cleansing was now to be so close at hand. But the war had turned out to be

less apocalyptic and yet far more murderous than the Expressionists had ever believed possible: "How cruelly your ray drove over the earth." Indeed, it was the Expressionists themselves who were being killed in the war, while the ones they sought to destroy remained safely at home. In full realization of what has occurred, Goll, in words of painful, pathetic desperation, concludes his poem: "Ourselves it was had died; the dead, they lived."

One of those who died in the false apocalypse was Franz Marc, killed in the same year in which Goll's poem was written. Marc shared the beliefs of those Expressionist poets and writers we have discussed in this chapter. He, too, longed for a regression to primitive instinctual life, and a concomitant apocalyptic cleansing.

In looking at what is perhaps the most popular of Marc's paintings, *The Tower of Blue Horses,* we can notice quite clearly something the painter obviously intended for our eyes. On the chest of the horse in the foreground of *The Tower of Blue Horses* we can easily see a rather large and distinct sickle moon.

4.

The Tower of Blue Horses is one of Franz Marc's larger paintings, measuring approximately 6½ feet by 4⅓ feet (200 centimeters by 130 centimeters). Like *Fate of the Animals,* its history was not without adventure. Painted a few months before *Fate of the Animals,* in the winter of 1913, *The Tower of Blue Horses* was also first exhibited at the First German Herbstsalon in the fall of that year. In 1919 it was purchased by Ludwig Justi for the National Gallery in Berlin, where it remained for the next eighteen years. It was declared "degenerate" by the Nazis in 1937, removed from its position in the National Gallery, and exhibited (along with five other of Marc's works) in the "Entartete Kunst" exhibition held in Munich that same year. Considerable protest, however, was voiced throughout Germany at Marc's inclusion in the exhibition. Apparently, the protest was successful for Hitler himself ordered the immediate removal of Marc's paintings from the show.[35] Oddly enough, it was the last opportunity for the public to view *The Tower of Blue Horses,* for, since its removal from that notorious 1937 extravaganza, the location of the work has continued to remain a mystery.

On its surface, *The Tower of Blue Horses* [33] presents a far less

33. *The Tower of Blue Horses*, 1913, oil.

dramatic image than *Fate of the Animals*. There are no streaking diagonals, no screaming helpless animals, no forest in flames, that give the latter painting such an overwhelming sense of action, and indeed, such an omnipresent aura of disaster. There is nothing rushed, nothing frantic, nothing desperate about *The Tower of Blue Horses*. At first glance, the two paintings may appear totally dissimilar in their imagery and thematic representation. Upon closer examination of the second of these major works, *The Tower of Blue Horses*, we shall see that this is not, in fact, the case.

Whereas *Fate of the Animals* is a work constructed primarily upon diagonals, *The Tower of Blue Horses* is built predominantly upon verticals. The most immediately observable feature of this construction lies in the configuration of the animals themselves. Ignoring linear perspective, Marc has arranged four blue horses, one above the other, on either an ascending or descending plane. The body of the lowest horse, its lines clear and precise, is echoed in the bodies of the two horses immediately above it, and, in seeking to solidify this construction, the artist has traced a vertical line which leads from the right foreleg of the lower foreground horse, into the body of the horse occupying what would appear to be the middleground, and which culminates in the shank of the third and most elevated horse in the background. The line is continued from the tail of this horse into the sky, above and behind it, where we can quite readily see a distinct separation into yellow and blue segments.

Another significant aspect of this verticality can be noticed in Marc's depiction of the landscape. Here we see three massive, boulder-like objects piled one on top of the other, and culminating in the triangular mountainous form of the highest of the three. Above this mountainous form, a somewhat modified rainbow, composed only of red, orange, yellow, and green, forms an arc across the top left-center of the painting, sweeping behind the most elevated of the horses and ending at the head of the seemingly transparent, red-faced horse at the upper right.

The central focus of *The Tower of Blue Horses* is, as one might reasonably anticipate, on the horses themselves. Neither the depiction of a group of horses nor the position which the horses of this painting occupy represents an entirely novel departure for Marc. As we have seen, his preoccupation with the representation of horses goes back at least as early as 1905, and his first attempt to realize a

34. *Two Horses in a Mountain Landscape*, 1910–11, pencil.

harmonious grouping of these animals is dated one year later.[36] Initially, however, his preference seems to have been for a horizontal emphasis.

The first vertically constructed study of a horse group appeared between 1910–1911, in a pencil sketch entitled *Two Horses in a Mountain Landscape* [34]. It was this sketch that seems to have provided him with the inspiration to develop the "tower concept," consisting of a group of horses (or, indeed, any animal) arranged in varying degrees of height within a mountainous setting. We should be able to see this arrangement quite readily in the 1910–1911 sketch, where two horses are placed in a mountainous environment. The lower of the two horses, the one with its tail facing us, is wrapping its body around a tree in the left-center of the page, while its neck and head are turned sharply to the left. Immediately above this horse, standing at the top of an elevation in the landscape we see another horse, whose posture is not at all dissimilar to that of the animal in the foreground of *The Tower of Blue Horses*. The weight of this horse is placed on its right foreleg, its neck is shifted sharply to the right. This horse appears in much the same form in a 1912 tempera entitled *Two Horses* [35]. Here, one animal assumes the precise posture it will later bear in the finished 1913 work. But *Two Horses* may be considered a highly significant work for yet another reason.

In this tempera we can rather easily notice the appearance of the crescent moon, a symbol that will later appear on the chest of the foreground horse in *The Tower of Blue Horses*. While this image does not appear in the rather hurried 1912 sketch for *The Tower of Blue Horses*, this lapse is only momentary, for, as we can see in the tempera postcard which Marc sent to his friend Else Lasker-Schüler early in 1913 [36], the crescent reappears, not once but twice. The one which appears on the neck of the foreground horse will be discarded in the final version, the one on its chest will remain. As we have already seen in our brief examination of Expressionist poetry, the crescent moon was, for the Expressionists, symbolic of their premonition of, and longing for, the apocalypse. As we shall now discover, this symbol serves a similar function in the work of Franz Marc.

35. *Two Horses,* 1912, tempera.

36. *The Tower of Blue Horses*, 1912, mixed media.

5.

The purpose of the crescent on the foreground horse of *The Tower of Blue Horses* can only be fully understood within light of the position this motif occupies in the context of the artist's work from 1912 to 1914. Beginning in late 1912, the crescent or sickle motif plays a seemingly innocent, almost decorative role in Marc's paintings and drawings. It can be seen quite readily in the tempera entitled *Two Horses* of 1912, which we have already discussed, as well as in a watercolor from that same year, *Blue Horses*. Here, the crescent is suspended in the sky between two steep mountain peaks. There is nothing extraordinary about the placement of this symbol, nothing that would suggest its inclusion in this work to be other than that of a moon appearing above a landscape. There *is* something disconcerting, however, about the appearance of the crescent in Marc's works of the following year.

In the paintings and drawings of 1913, the motif of the crescent moon appears more and more to correspond with images of chaos and destruction. At the same time, the crescent or sickle can be seen to forgo its immediate surface indentification as an aspect of the moon, and must increasingly be viewed as an independent symbol, existing in its own right. This is quite clear as we look at a tempera from 1913 entitled *Mythical Green Animal* [37]. In this work, the mythical animal of the title, most probably a horse, is seated atop a red hill, which contrasts sharply with the blue of the night sky in the background. These heavens are not at all peaceful, however, for in the midst of this sky we see a huge, triangular, burning mass, rising above the head of the animal and reaching far back into the upper right-hand section of the work. In this section we can begin to notice flames and smoke rising from an unidentified source somewhere beneath the slope of the hill. In what is already a scene of ominous portent, Marc has added, beneath the "mythical green animal," the symbol of the sickle moon.

Among the postcards Marc sent to Else Lasker-Schüler during 1912 and 1913, four carry the symbol of the crescent. We have already seen one of these watercolor postcards, *The Tower of Blue Horses*, in which two crescents appear on the foreground horse. In *The Three Panthers of King Joseph* [38], a large green crescent is suspended in the middle of a scene in which one of the panthers is attacking an un-

37. *Mythical Green Animal*, 1913, tempera.

identifiable red object in the foreground, while another stares directly
out at the viewer, and yet another is seen climbing a black and red
mountain, stopping long enough to turn its head and snarl at the
menacing, mysterious symbol. Above the mountain, in the sky, Marc
has depicted a full moon and yet even here he has emphasized the
shape of the crescent by drawing a thick black curve along its right-
hand surface. The postcard entitled *On the Hunting Grounds of King
Joseph* is notable not for any depiction of the crescent within the body
of the composition, but for the appearance of this symbol beneath the
inscription in the lower right-hand corner of the work. The remaining
postcard from this series in which the symbol of the crescent is used
so often is entitled, simply, *Elephant* [39]. This image is perhaps the
most destructive-appearing of the entire series. Amidst a landscape of
utter ruin and devastation, one in which the stumps of trees jut out
from the background (not unlike the image of *St. Julian Hospitator*), a
large, violet and black elephant stands unmoving and perhaps im-
mobilized upon a group of boulders. A violet crescent moon is obser-

38. *The Three Panthers of King Joseph*, 1913, mixed media.

39. *Elephant*, 1913, tempera.

vable in the smoke-filled sky, to the right of the blackened trees, while immediately below it, the tusks of the large animal again reproduce the sickle motif.

While the sickle moon is present in many of Marc's drawing from the year 1913, among them: *Sitting Wolf, Two Blue Horses, Red Bull*, it is in the sketch entitled *Plunging Mountain* [40] that we see the full consequences of this symbol's function. In this sketch, the crescent assumes its natural position (i.e., as an aspect of the moon) high in the sky, above a rather steep rectangular mountain. This mountain, however, is apparently in the process of disintegration, raining rocks and boulders upon the earth below. The figures in the foreground of this sketch are rather hastily and inconclusively drawn, but they nevertheless assume enough of the characteristics of the human figure for us to designate them as such. The world and its inhabitants are thus in the process of being destroyed while the image of the sickle moon occupies the heavens, a symbol of the very destruction it witnesses.

6.

In seeking to understand Marc's use of the sickle motif more fully, we must turn toward the past, toward works which Marc may or may not have seen, but which nevertheless present themselves as precedents for the subsequent employment of this symbol. Actually, we need look no further than the apocalyptic motifs of late fifteenth century German art, particularly that of Albrecht Dürer.

In a letter to his wife dated March 27, 1915, Franz Marc wrote the following words: "Most of Dürer's works are, apart from the educated observer, dead things. Not all, however, not, for example, the woodcuts."[37] It is not surprising that Marc exempted the woodcuts from his otherwise general dismissal of Dürer's work, for it is in these woodcuts, especially in the series entitled *Apocalypse* of 1498, that the full implications of the sickle motif are most clearly revealed.

In the *Frontispiece* of Dürer's *Apocalypse* [41], we see St. John the Evangelist on the island of Patmos. "Accompanied by his eagle and seated by a grassy ledge on which he has deposited his inkpot and pen box, he sees and describes the 'Apocalyptic Woman,'"[38] the vision which inspires his writing of the Apocalypse. The "Apocalyptic Woman" is the Madonna; appearing in this woodcut she is crowned the queen of the heavens holding the infant Jesus in her arms. She

40. *Plunging Mountain*, 1913, pencil.

41. Albrecht Durer, title page from *The Apocalypse*, 1498, woodcut.

appears to St. John as a half-length figure atop a rather large and imposing crescent. An engraving of the same year, 1498, also by Dürer, entitled *Mary with Apocalyptic Attributes*, shows the Madonna without her crown, but with loose flowing hair, standing full-length upon an equally impressive crescent.

Dürer, however, was not the only artist of his time to employ such a motif. In a woodcut from the year 1492, Michael Wolgemut's *Mary Crowned Queen of the Heavens*, we can again see the Madonna standing full-length atop a crescent, this time guarded by two angels, while being crowned by two others. On the title page of the *Liber Fraternitatis Rosaceae Coronae*, dating from about 1500, we can see this motif once again, as the Madonna, crowned and haloed, holds a scepter in one hand and her Infant in the other. Again, she is standing upon the crescent.

The full implications of this motif for the art of Franz Marc can best be seen in one of his last oil paintings, *Tirol* [42], painted in 1913 and retouched in 1914. The overall image of this painting is, as in *Fate of the Animals*, one of cataclysmic destruction. The heavens have broken asunder and mountains are crumbling and depositing rocks and ruin upon the village below. In the lower part of the painting two small cottages appear on a hilly bluff, and to the left of them stand two dead trees. But our attention is consistently drawn to the dominant motifs of the foreground, the thin, diagonally inclined tree which sweeps across the canvas from the lower right-hand corner to the left-center of the composition. The branches of this tree culminate in what can best be described as a sickle shape. The tree, in fact, assumes the form of some giant scythe. The painting remained in this state throughout the year 1913, for it, too, along with *Fate of the Animals* and *The Tower of Blue Horses*, was exhibited at the First German Herbstsalon. After the exhibition closed, however, Marc asked to have the painting returned to him and later in 1914 he added, immediately above the diagonal tree, the same motif of the "Apocalyptic Woman" (Madonna and child atop a crescent) that had fascinated artists of the late fifteenth century, the motif which indicated that a rebirth of man would follow the destruction of the evil society of the present, the motif which spoke of the coming "Age of Righteousness."

Marc's *Tirol* presents us with two apocalyptic images—the "Apocalyptic Woman" and the scythe. The symbol of the scythe is also ap-

42. *Tirol*, 1913, oil.

parent in Dürer's *Apocalypse*. In looking at the eleventh woodcut of Dürer's series entitled *The Two Animals Enticing Humanity* [43], we can notice quite readily that the Lord of the Apocalypse is holding a scythe or sickle in his right hand. The scythe is apparently used here as that symbol of the harvest about which we spoke earlier. In this case, the harvest is about to begin, the earth will be cleansed of its wickedness and sin, and thus prepared for its assumption by the righteous. To the right of the throne an angel, carrying a scythe in his right hand, descends to the earth below. It is he who will do the actual "cutting," while the Lord, seated on a throne of clouds, clothed in ornate robes, and crowned in radiance delivers his judgment upon the world. The symbol of that judgment is in his right hand.[39]

There may, of course, be some legitimate question as to whether or not Marc ever actually saw Dürer's *Apocalypse* series. The question

43. Albrecht Durer, *Two Animals Enticing Humanity* from *The Apocalypse*, 1498, woodcut.

becomes largely irrelevant, however, when we look into the sources of Dürer's great work. According to Erwin Panofsky, "What may be called the 'raw material' of his compositions was largely furnished by the illustrations of the Quentell Bible of 1479 and its derivatives, the Koberger Bible of 1483 and the Grüninger Bible of 1485."[40] One illustration from the Koberger Bible (published in Nuremberg in 1483) that had considerable effect upon Dürer, Panofsky mentions, was that of the *Babylonian Whore*. In the illustration [44], we see her entering the scene from the left of the page, astride her seven-headed beast, towers toppling behind her, while in front of her, four supplicants kneel in homage. In the right-hand portion of the illustration we see a scene with which we should not be unfamiliar. Here, the Lord reaches through his *mandorla*, a large scythe held in both of his outstretched arms, cutting the grain on the earth below. The angel we saw en route to his task in the Dürer woodcut has, in the Koberger illustration, arrived on the earth and is himself busily engaged both in the cutting of the grain with his scythe and in restraining the newly enchained devil from "polluting" the freshly harvested fields. This illustration from the Koberger Bible appears on page 121 of the 1912 edition of *Der Blaue Reiter Almanach*.[41] The coeditors of *Der Blaue Reiter Almanach*, the persons who chose the articles and illustrations that went into this, one of the most significant documents in all of twentieth century art history were, as we have seen, Wassily Kandinsky and Franz Marc.[42]

Considering the evidence we have before us, we would not, I believe, be wrong in suggesting that the symbol of the sickle moon or the scythe carried on the chest of the foreground horse in *The Tower of Blue Horses* represents an impending apocalypse.[43] We can give this conclusion further support by analyzing the thematic pattern of Marc's work during this period. If we take *Fate of the Animals* as the focus, as the climax (but not necessarily the culmination) of Marc's concern with the presentation of themes of apocalypse, then the central motif of his most significant work during the years 1912 to 1914 falls readily into place. A mere glance at the titles of some of these works will tell us much of the tale. Immediately prior to *Fate of the Animals*, we see the appearance of such paintings as: *Foxes*, *Wolves (Balkan War)*, *The Tower of Blue Horses*, *The Poor Land Tirol*, *St. Julian Hospitator*, *Springing Wolves*, the woodcuts with such titles as: *Lion Hunt* (after Delacroix) and *Riding School* (a title which perhaps

44. Anton Koberger, *The Babylonian Whore* from the *Nurnberger Bible*, 1483, woodcut.

refers to the repression of instinct). After *Fate of the Animals* we see such paintings as: *The First Animals*, *The World Cow*, and perhaps most revealing of all, woodcuts entitled: *Birth of the Wolves*, *Birth of the Horses*, *Story of Creation I*, and *Story of Creation II*. The pattern of Marc's work during this period shows a clear development from images which present a premonition of apocalypse, to at least one image which presents an apocalypse in progress (*Fate of the Animals*), to images that depict a new beginning, a resurrection and reestablishment of life.

The Apocalypse
Realized

1.

I N F E B R U A R Y of 1914, in what was to have been the preface for the second volume of the *Blaue Reiter Almanach*,[1] Marc wrote the following words: "The world gives birth to a new age: there is only one question: has the time yet arrived today in which the old world will be dissolved? Are we ready for the *vita nuova?* This is the most anxious question of our day."[2] The implications inherent in this statement will serve us well in attempting to illuminate and to decipher the meaning of the apparent ambivalences and ambiguities of the artist's final period.

Toward the close of 1913 and throughout the year 1914 Marc was engaged in the production of works that seem to maintain little thematic order; that is, sensitive images which appear to depict the creation of a new world tend to alternate quite freely with radically violent images enunciating the destruction of the old. These works are expressive of a dramatic conflict of the will, a conflict that would deepen perceptibly as the inevitability of the war became more and more pronounced.

As we have seen in the preceding chapter, Marc's work throughout the year 1913 followed a fairly systematic pattern of thematic development. The range of his imagery during this period extended from premonitory scenes of violence to the actualization of the apocalyptic holocaust itself and finally to the depiction of a world in the midst of a

miraculous creation, a world bursting forth with life and energy. The woodcuts *Birth of the Horses, Birth of the Wolves, Story of Creation I,* and *Story of Creation II* (the first two completed toward the end of 1913, the last two in the winter and spring of 1914) represent the first steps toward the realization of a project that Marc had initially conceived the preceding spring. The plan originally called for a series of illustrations depicting different books of the Bible, each to be undertaken by an individual artist. Among the participants in the project were Kandinsky, Klee, Heckel, Kubin, and Kokoschka, but, most significantly, Marc chose for himself the depiction of scenes from Genesis, the story of creation.[3] The resulting woodcuts are among the most powerful of Marc's graphic works, revealing a new dynamic concept of form and a highly charged, indeed explosive, means of expression.

Story of Creation I and *Story of Creation II* [45 and 46] are the most vital plates in the series, showing a lessening of the crystalline structure that had characterized much of the artist's work during the preceding year. In these woodcuts we see a new concern for the expressive potential of smoother, more flowing forms. Rendered in terms of arabesques, spheres, and circles and energized with a mobility and volatility, Marc's line becomes fully kinetic, and seeks to record the pulsations and explosions of life emerging from the void, finding definition in being. Most of the animal and plant forms in these two woodcuts are generally embryonic and tend to represent the dimension of possibility or potentiality rather than conclusion. Thus, we seem to be witnessing the precise biblical moment that occurs immediately *after* the issuance of the commandment by God, but immediately *before* the actualization of his word: "And God said, Let the earth bring forth living creatures. . . ."[4]

Whether Marc actually intended to continue work on this series is purely speculative, but it is significant that his "Story of Creation" excludes the presence of man. If we turn to Genesis we must therefore bear in mind that the artist has chosen to terminate the process of creation with the verse that reads: "And God made the beasts of the earth after their kind, cattle and creeping things, and beasts of the earth after their kind, and everything that creepeth upon the ground after its kind: and God saw that it was good."[5] The concept of primeval goodness that is enunciated in this passage, the purity and freshness and innocence that characterize the emergence of newly formed things, is something that lies at the very core of Marc's per-

45. *Story of Creation I*, 1914, woodcut.

sonal philosophy. As his wife would later recall, "The path upon which he travelled and to which he constantly and at all times felt bound [was] the striving toward purity—toward pure being."[6] Here, in these two scenes from the "Story of Creation," he has, in fact, both visualized and conceptualized the dynamic potential of the "promised land," the post-apocalyptic world, a revitalized earth forever free of the "impure" presence of man.

46. *Story of Creation II*, 1914, woodcut.

The final plate of the series, *Story of Creation II*, is perhaps the most successful in terms of rendering the explosiveness and volatility of forms in the process of creation. In this woodcut the whole complex of emergence seems to be issuing forth at a single moment. While the sky and the heavens appear to burst downward from the upper center of the composition, the sun finds its place in the upper right, directly above the embryonic shape of what seems to be a large

cat (possibly a lion or tiger). To the immediate left of this image we
see what can best be described as the faint suggestion of another
animal form (possibly a horse or deer), while in the lower center of
the plate a totally undefinable creature begins to blossom forth with
life. On the earth below, plants, represented as free-flowing ara-
besques, are taking root and germinating. The world is thus being
formed in a chaotic instant; the paradise of purity, the natural realm
of instinctual being is seen at its most innocent moment, as the
throbbing potential of life itself begins to unfold.

Comparatively more concrete in its construction, and therefore
more readily decipherable in terms of its symbolic imagery, is the
earlier *Story of Creation I*. In this woodcut the plant and animal
forms become more definable and the sensation engendered is that of
being present at the moment which immediately follows the dramatic
convulsions we viewed in the later plate. In *Story of Creation I* the
air seems to be settling somewhat, although the process of creation is
still far from completion. This inconclusiveness can be seen in the
emergent form in the lower center of the composition; it is clearly an
animal but it has not yet arrived at its final state of definition (indeed,
it seems to possess the head of a horse, the body of a bear, and the tail
of a fox).

Directly above this form of the emerging animal and to the left of
the plant that blossoms behind it, we see the more readily identifia-
ble image of a monkey, its head curved to the right and staring with
blank eyes toward an unknown object outside the frame of the work.
The position this monkey occupies within the work is a curious one.
It stands on its own plateau (formed by the triangular shape that ap-
pears to the left of its legs) in the center of the work between two
levels of being, levels represented by the formless animal we see
below it and the white bird perched upon an orb which is seen di-
rectly above. In the purely ecological sense the monkey, of course,
does indeed inhabit a middle region between that of its two com-
panions. The monkey is not entirely bound to the earth but can oc-
cupy the trees as well, "flying," in a limited sense, from one limb to
the next.

Whether or not Marc actually intended to portray this scene as one
indicative of the structuring of different levels of existence is uncer-
tain, but beyond this lies the symbolic function of the monkey itself,
as a representative of instinctive, unconscious activity.[7] This activity

is embodied in an animal that occupies the center of the composition, indeed, an animal that maintains a posture of haughtiness and pride, a position of dominance within his environment.[8] In this context, then, we may interpret the inclusion of the ape as representative of the triumph of the instinctual forces, the sovereignty of unconscious existence in the newly emergent world.

The third realm of the woodcut, the highest realm, is occupied by the aforementioned white bird, its body pointing sharply to the left, its legs perched upon a white sphere. At first glance the position of this figure appears to be perfectly natural, but upon closer inspection we can begin to notice that, quite unlike the animals below it, the bird and the sphere are floating or hovering independently, above the ground. Yet, quite surprisingly in view of its position, the bird makes no effort to fly, indeed, the wings of the animal remain tightly furled against its body. Considering the fact that we are, in this composition, present at the creation of the world, we would not be venturing too far to suggest that, in terms of its symbolic imagery, "the bird probably signifies the renewed ascent of the sun . . . and is at the same time one of those 'helpful animals' who render supernatural aid during the birth," and, as Jung goes on to say, that "this ascent signifies rebirth, the bringing forth of life . . . and the ultimate conquest of death."[9]

If we can interpret the sphere upon which the bird stands as symbolic of the sun, the same sun that is attaining definition in the later plate, then we can view the image of the bird as possessing the phoenix-like properties of "periodic destruction and recreation . . . the triumph of eternal life over death."[10] In this sense, the bird becomes the hero who is "assimilated to the sun; like the sun he fights darkness, descends into the realm of death and emerges victorious,"[11] while in Christian terminology, the bird could further represent the universal presence of the Holy Spirit, the promise of life everlasting, or the ascension of the soul. If we recall to mind that Marc envisioned no possibility of a "breakthrough to a higher spiritual existence" without an apocalyptic cleansing, then it should be readily understood that what we are witnessing in this plate (as well as in the companion plates of this series) is not so much a *creation* as it is a *recreation*, not the primary establishment of life so much as its renewal in a purer, more perfect world.

While the "creation woodcuts" are highly significant images in

terms of Marc's aesthetic and thematic development, they also provide us with a focus upon the conflict that would plague the artist for the next two years of his life. In this series, for the first time, Marc permits himself to cast a glimpse into the immediate post-apocalyptic world; here for the first time, Marc sees beyond destruction and imagines a revitalized being in the process of its own emergence. During this same period a new sense of urgency also becomes apparent in his work, an urgency reflected in the premonition of an imminent combat between hostile and opposing forces. This feeling of conflict is reflected in a significant number of Marc's watercolors, temperas, and drawings dating from 1914, and is quite readily observable in the so-called abstract works of this same period.

Perhaps the most violent of the drawings are the two small pencil sketches entitled *Abstract Forms* [47] and *Abstract Drawing* [48]. *Abstract Forms* is a work filled with the tension of disparate forces pictured on an irreversible course of collision. In the lower left center of the work we notice a large solid rectangular object, its sides shaded rather heavily in black. This solid rectangle, and the corresponding linear and rectangular forms that appear to emerge from it or blend with it, provides a strong gravitational pull to the entire left-hand side of the drawing. There is an unmistakable feeling of heaviness, of great weight, indeed of being drawn downward as we concentrate upon this section of the work. We are gripped by the sensation of looking down upon a scene that unfolds below, as though we were standing on a mountain or looking through the window of a tall building and seeing the city reduced in scale below us. From the right-hand side of the work a series of crescent forms, accompanied by several sharply vertical lightning-like strokes, appears to be moving in a leftward direction, ready to confront the rectangular area. This sense of leftward motion is reinforced by the appearance of a jagged form with three sharp angles at its head, positioned to the left of the leading crescent. The purpose of this form seems to be directional, to indicate the momentum and propulsion for the forces that follow. A confrontation is thus initiated between the more elevated, the smoother forms to the right and the more gravitational, more sharply angular forms to the left.

Immediately above this collision of abstract shapes in the upper center of the composition several curved forms appear. These forms are less readily definable than those below but can, in any case, be

47. *Abstract Forms*, 1914, pencil.

described as more lyrical, more flowing, indeed less discordant than the others. There is a distinct feeling of weightlessness about this flock of curves and arabesques, a sense of elevation, an intimation of hovering that sharply distinguishes them from the forms that constitute the remainder of the composition.

In *Abstract Drawing* we are presented with a somewhat less disso-

48. *Abstract Drawing*, 1914, pencil.

nant work, but one that nevertheless continues to depict a con-
vergence or confrontation of disparate elements. Here, in sharp con-
trast to *Abstract Forms*, our eye appears to be looking upward, but
the focus of concentration remains the same; the large, shaded rectan-
gular forms that constitute the lower half of the drawing seem once
again to undergo bombardment from the arabesques and curves that
stream downward as a group from the upper left. As we have sug-
gested earlier, the large rectangular forms could be viewed as the ab-
stract representations of the buildings that constitute a large city.
Concrete in their formation, massive, and darkly shaded in appear-
ance these forms would, for Marc, prove an ideal representation for
the very forces he wished to overcome, the forces of materialism, "of
the greed and impurity of the masses." [12] Once again, these same
forces seem under attack by the more flowing, the more buoyant
forms which, in their descent, receive support from the larger ara-
besques that swarm throughout the work.

The floating forms of both *Abstract Drawing* and *Abstract Forms* may be interpreted ideographically as representing the forces of light, of transcendence and of spiritual elevation that have here joined to do battle with the forces of greed and materialism. Marc had recognized the necessity for just such a battle almost two years before, when he wrote in *Der Blaue Reiter Almanach:*

> Furthermore, the hour is right for such a confrontation since we believe we are now at the juncture of two long ages. . . . But everywhere ruins remain, old ideas and old forms which refuse to vanish even though they now belong to the past. They linger on like ghosts and a Herculean task faces us—how can we dispel them and make room for the new which is already waiting? [13]

Actually, he had answered his own question earlier in the same text, in a statement that helps us immeasurably in our seeking to understand the meaning of the drawings of 1914. He ended the article "Geistige Güter" with the following words: "The spirit," he said, "can tear down citadels." [14]

Abstract Forms and *Abstract Drawing* are indeed "abstractions" in the sense that they represent the summary of the qualities or characteristics of a conception that has a more substantial foundation in fact. The key to this conception and to the actual identity of the buoyant, hovering forms that appear in the two drawings can perhaps be ascertained by considering two earlier works from the same year, *Abstract Composition* and *Abstract Watercolor I.*

Abstract Composition [49] is an extraordinarily free and fluid work which appears, at first glance, to be almost entirely without objective forms. This small tempera, rendered solely in the palest tones of blue, red, green, and yellow, is striking both for its simplicity and for its harmony. Beginning in the upper left-hand side of the composition we notice three circular forms shaded in green. Joined together most gently, as though they possessed the consistency of soap bubbles, these forms tend to rise very slowly, touching and impelling into motion the three red spheres that are located above them and to the right. In their own ascent these red spheres in turn activate the three yellow forms that appear immediately to the right of them; the yellow forms themselves begin to dissipate into the insubstantiality of the top center of the composition and then emerge back into form in the

49. *Abstract Composition*, 1913–14, tempera.

upper right-hand portion of the work. Immediately below this canopy we see the true focus of this small but significant tempera.

In the center of *Abstract Composition* we can notice at least five

50. *Abstract Watercolor I*, 1913–14, mixed media.

major arabesques that both intersect and yet appear to dominate the more sharply geometric lines that cross in the right-hand section of the work. Interspersed with the arabesques are what appear to be musical notes, establishing both a very real sense of lyricism and providing a substantive rhythm to the overall tone of the composition. The arabesques in this work seem to assume a less active position and appearance than the more horizontally inclined, more mobile arabesques we have already identified in *Abstract Forms* and *Abstract Drawing*. There is, however, a rather distinct relationship among all three of these compositions, a relationship whose true nature is revealed within the imagery of *Abstract Watercolor I*.

In *Abstract Watercolor I* [50] we are immediately presented with what appears to be yet another nonobjective work, a composition predicated primarily upon converging arcs and suspended spherical forms. Here, however, unlike the other abstract works we have so far discussed, the composition is less congested, the shapes more freely spatial and, indeed, more buoyant. This dramatic sensation of buoyancy, this feeling of loftiness and of soaring, is due partly to the fact

that the forms themselves exhibit little solidity or weight. The construction of these shapes is primarily linear and the direction in which they move tends to point upward, a sensation that is graphically illustrated by the dynamic inclination of the small arrow-like form visible at the base of the work. Our attention is consistently drawn, however, toward the center of the composition, for there an image crystallizes into something approaching natural form. In this area of the work we can notice a form that draws its consistency from that which surrounds it, a form that can best be defined as the image of a bird soaring in flight, its head and neck bisecting the vertical line that divides the composition. The bird's wings are raised in flight while its tail emerges from behind the ring that encircles its body.

It is this image, the image of the bird, that links all four of these compositions and indeed provides us with the visual evidence necessary for approaching an understanding of the complex thematic issues which these works in fact serve to enunciate. What we are witnessing in *Abstract Composition, Abstract Forms, Abstract Drawing,* and *Abstract Watercolor I* is the refinement of a symbol, the purification of an object into its most basic and elemental structural form. This becomes most readily apparent when we compare *Abstract Composition* with its "rough" predecessor dating from the previous year, the tempera entitled *Birds I* of 1913.

Within the crystalline foundation of *Birds I* [51], four birds are arranged together as a group, each perched upon what appears to be the limb of a tree and guarding two younger birds curled asleep in the nest below. It is extremely significant to note that each of these birds is of a long-necked species (whether they are geese, storks, or even flamingos is difficult to say with any degree of certainty) and that, in representing them, Marc has chosen to stress their most prominent and most rhythmic feature. Each of these birds is rendered primarily upon the structure of the arabesque formed by the highly lyrical curving line that begins at their beak, continues through the head, and then descends sharply down the curvature of the throat, blossoming forth at the chest and sweeping outward at the tail. When we shift our attention to the later *Abstract Composition,* what we are seeing is a remarkably fluid transcription of these same arabesques; indeed, the lines themselves seem directly to echo the very positions occupied by the inhabitants of *Birds I.* Furthermore, this same process of purification, this same abstraction of recognizable

51. *Birds I*, 1913, tempera.

52. *Birds II*, 1913–14, tempera.

elements can be seen in the reduction of the birds in *Birds II* [52] and *Birds over the City* [53] (both dating from early 1914) into the lyrical flowing arabesques that either hover or descend from the skies of the later *Abstract Forms* and *Abstract Drawing*.

As we have so often seen, Marc did not choose his forms solely for decorative purposes. Each animal, each symbol represents the employment of a specific motif, which, when fully investigated, provides us with an indication of the temper of his thought and a focus upon the direction of his art.

By the late winter and early spring of 1914 Marc's refinement of the bird motif into a personal ideographic script was almost complete. While the use of this motif would reach what is perhaps its most successful realization in one of the artist's final paintings, it is time now that we begin to consider the larger and more comprehensive issues involved in the use of bird symbolism, especially as it relates to the thematic content of Marc's work.

2.

As we have seen in our investigation into the meaning and application of the sickle motif, much of Marc's symbolic imagery has its precedent in the art of earlier periods. Indeed, he seems to have been not

only aware of late medieval and early Renaissance art but a strong admirer of both its "pure" intentions and its communal virtues. In a letter written from the front on the seventh of April, 1915, he told his wife: "The nameless Gothic masters—they are the most pure. . . . Art has been ruined by the poisoning sickness of the cult of individualism, by the emphasis on the personal, by vanity. One must liberate oneself completely from all of that. Then one is free." [15] In seeking a fuller meaning of Marc's use of bird imagery we must, once again, turn back to these Gothic masters and to the apocalyptic imagery of the past.

As Francis Klingender has observed, during the thirteenth and fourteenth centuries birds appear in almost all English apocalypse manuscripts as the main actors in the scene described in verses 17 to

53. *Birds Over the City*, 1913, watercolor.

21 of the nineteenth chapter of Revelation.[16] These verses, remarkable for the violence of their imagery, read as follows:

> And I saw an angel standing in the sun; and he cried with a loud voice, saying to all the birds that fly in mid heaven, Come *and* be gathered together unto the great supper of God; that ye may eat the flesh of kings, and the flesh of captains, and the flesh of mighty men, and the flesh of horses and of them that sit thereon, and the flesh of all men, both free and bond, and small and great. And I saw the beast, and the kings of the earth, and their armies, gathered together to make war against him that sat upon the horse, and against his army. And the beast was taken, and with him the false prophet. . . . They were two cast alive into the lake of fire that burneth with brimstone: and the rest were killed by the sword of him that sat upon the horse . . . and all the birds were filled with their flesh.[17]

Most illustrations of this passage are based upon one or more of the following images: the gathering of the birds at the angel's call, the casting of the beast and the false prophet into the bottomless pit, and the birds filled with the flesh of their victims. These images may be combined into one scene, and, in most cases, the birds do not simply lounge or peck quietly at the bodies but dive in a dramatic and vigorous assault from the skies. This image appealed so strongly to these medieval illuminators that they frequently included it in other scenes from Revelation, most notably the Fall of Babylon, which occurs in the eighteenth chapter:

> After these things I saw another angel coming down out of heaven, having great authority; and the earth was lighted with his glory. And he cried with a mighty voice saying: Fallen, fallen is Babylon the great; and is become a habitation of demons and a hold of every unclean spirit and a hold of every unclean and hateful bird.[18]

While most illuminators interpreted this passage as describing only birds of prey, others sought to create the impression of a great diversity of species.[19]

In the following illustration from the Trinity College Apocalypse of about 1230, we can view just such a presentation. Folio 23v. [54] shows the results of this contest where, as the angel plunges the beast into the mouth of Hell, to the right of the scene the birds engage in the great supper and feast upon the flesh of the captains and the kings. In both instances the lightness, airiness, and grace of the birds

54. *Birds Feeding on Corpses* from *The Apocalypse*, c. 1230.

is rendered in sharp contrast to the weightiness and heaviness of their opponents. In each case, whether alighting upon branches or corpses or flying in mid-air, the predominant form of each of these birds is that of an arabesque.

This is equally true of the next illustration depicting the Fall of Babylon. Folio 36 of the early fourteenth century British Museum Add. MS. 17333 [55] depicts a scene of far greater ferocity and violence, as birds dive forcefully and dramatically from the sky and prey with relentless vigor upon the demons and unclean spirits of the doomed Babylon. Curiously, however, neither of these illustrations seems to conform literally to the text of Revelation. Rather than seen as "caged, unclean, or hateful," these birds are depicted as the aggressors, indeed, the victors in this epic struggle. They are shown not as a part of Babylon, but rather as a force that signals or determines its destruction.

While Marc may or may not have seen any concrete examples of the apocalyptic tradition of these medieval illuminators (he had, however, visited England in 1911), there can be little doubt that the birds in his compositions are seen either gathering (as in *Abstract Composition*), or indeed, descending upon the scene below (*Abstract Forms, Abstract Drawing*). We should also recall that Marc had been a theology student in his youth, and that as late as 1915 could still write;

55. *Birds Descending on the Fallen Babylon,* early 14th century.

"You must not think that I read the Bible 'poetically,' I read it as *truth* as I hear Bach as *truth* and see pure art as *truth*. Can you understand me? Oh, if you only could!"[20]

With this in mind, it is not at all unlikely that, as the days of the Great War drew ever closer, Marc, along with August Bebel, could have foreseen that "there will be a catastrophe. Then the tocsin will be sounded in Europe and sixteen to eighteen million men will march against each other, equipped with lethal weapons," and that "this great march will be followed by the great collapse."[21] Indeed, it is not difficult to imagine that, as the political situation grew more dim, Marc could clearly see the hour of judgment at hand, the time when the "seed of the spiritual" would "survive, refined and hardened by the purifying fire of [the] war."[22] Along with the author of Revelation, Marc too could envision the time when "the beast and the kings of the earth, and their armies gathered together to make war against him that sat upon the horse and against his army";[23] he too could foresee "an eagle flying in mid heaven, saying with a great voice, Woe, woe, woe, for them that dwell on earth."[24] In one of the last paintings completed by the artist before the outbreak of the war, this very imagery reaches its most expressive, its most explosive fulfillment.

Fighting Forms [56], painted during the late spring and early summer of 1914, is one of the most emotionally convulsive compositions the artist ever completed. It is a work in which the entire canvas becomes a battleground of disparate forces as two huge and vividly contrasting forms meet in a violent and climactic struggle. Streaming downward from the upper left, we see that a large mass of intense fiery red has arrived at the center of the painting. With streaks of intense, pulsating, prismatic colors trailing in its wake, this immense red form has crashed headlong into an equally large curving black mass which dominates the entire right side of the composition. The initial shock of this contact has sent the black form recoiling back even farther to the right, into an area dominated by dark, heavy tones. On even the most elementary visual level we can immediately notice that a sharp and vivid contrast has been accentuated between two distinct and opposing forces; a force of light and elevation on the left, a force of darkness and weight on the right.

Within the imagery of *Fighting Forms* we can see that a dramatic conflict has been joined, that a momentous struggle is under way. In Marc's own terminology, we may identify these combatants as the forces of the spiritual engaging the forces of the material world, and while the result is still to be determined, we may be assured that there can be but one victor. To give this interpretation a less abstract and more concrete foundation, however, we need only look closely at the outline of the apparently formless area of red pigment. As this fiery mass arrives at its target, we can clearly notice the profile of a bird's head and beak, and indeed, as we move our eye downward and to the left we see what can best be described as the legs and talons of an eagle. While the black mass to the right is somewhat less distinguishable, there should be little doubt as to the identity of the figure to its left.

As we have seen, Marc's forms in his later period were certainly "abstract," but they were by no means completely nonobjective. If we consider the artist's preoccupation with the bird motif during these past several months, it is fitting that, in a conflict of this magnitude, he should turn to the symbolic imagery of the eagle, the bird that, more than any other, signifies the struggle between spiritual and celestial principles and those of the lower world.[25]

Beyond this, however, the combatants of *Fighting Forms* depict an

56. *Fighting Forms*, 1914, oil.

image of chaotic fury, one whose very texture resounds with the blasts and trumpet calls of the Apocalypse itself. In seeking the deeper meaning of this canvas, this painted premonition of judgment bursting with the drama of opposites in collision, we need only recall the imagery of Revelation and the Opening of the Seventh Seal:

> And the angel taketh the censer; and he filled it with the fire of the altar, and cast it upon the earth: and there followed thunders and voices and lightnings and an earthquake.
>
> And the seven angels that had the seven trumpets prepared themselves to sound.
>
> And the first sounded, and there followed hail and fire, mingled with blood, and they were cast upon the earth: and the third part of the earth was burnt up. . . .
>
> And the second angel sounded, and as it were a great mountain burning with fire was cast into the sea. . . .
>
> And the third angel sounded and there fell from heaven a great star, burning as a torch and it fell upon the third part of the rivers. . . .
>
> And the fourth angel sounded, and the third part of the sun was smitten, and the third part of the moon, and the third part of the stars; that the third part of them should be darkened, and the day should not shine for the third part of it. . . .
>
> And I saw and I heard an eagle, flying in mid heaven, saying with a great voice, Woe, woe, woe, for them that dwell on earth. . . .
>
> And the fifth angel sounded and I saw a star from heaven fallen unto the earth. . . . And he opened the pit of the abyss; and there went up a smoke out of the pit, as the smoke of a great furnace; and the sun and the air were darkened by reason of the smoke of the pit. . . .
>
> And in those days men shall seek death and shall in no wise find it; and they shall desire to die, and death fleeth from them.[26]

Soon after his completion of *Fighting Forms*, Marc added the final touches to a painting he had thought finished more than six months before. In what were perhaps the last strokes of paint he ever committed to canvas, the artist completed *Tirol* by painting in the image of "a great sign seen in heaven: a woman arrayed with the sun and the moon under her feet . . . and she was with child . . . a man child who is to rule all the nations."[27] This depiction of the rebirth, of the coming of the Messiah, this expression of the artist's faith and conviction that the coming Age of Righteousness was at hand, preceded by days the actualization of the cataclysm that had so long been antici-

pated: on the third of August, 1914, Germany declared war on France. "Down plunged the avalanche," wrote Alistair Horne, "sweeping away alike the midgets that had been preparing its descent, as well as those that had tried feebly to prevent it. The wind of its passage snuffed out the age. . . ."[28]

3.

Immediately upon receiving news that his country was at war, indeed even before he had received his orders for mobilization, Franz Marc volunteered for military service.[29] More than twenty years later, Kandinsky would recall the painful realities of those days, especially of the days immediately preceding Marc's departure.

> Shortly before the outbreak of the war Marc realized one of his oldest dreams, to own a small piece of property in Upper Bavaria. . . On the land (at Ried) stood a not-too-small house with a garden, a meadow, and a bit of woods.[30] It was the surroundings that he especially loved—at Benediktbeuern—a few kilometers from Kochel—the true Bavarian foothills with all its wonders.
>
> The war erupted. I still had just enough time to travel from Murnau to Ried. There Marc showed me his deer, whom he loved as if they were his own children, his entire property, coming finally to his peaceful and pleasant house. Marc was a "royal artillery gunner" and I foolishly imagined that he would spend a few months in a Bavarian castle (at beautiful Augsburg, e.g.) and that our separation would not be for long. I told him this as he accompanied me to my omnibus. "No," he replied, "we will never see each other again."[31]

On the seventh of August Marc left Ried to join his unit, the First Division of the Royal Bavarian Reserve Field Artillery Regiment. Less than three weeks later the artist was in the field, an eyewitness to the madness and the slaughter. From Sales, on the afternoon of September 2, 1914, he wrote to his wife:

> Today I have made my first extensive dispatch-ride (30 kilometers). . . . We rode toward France, from here to Remomeix (near Dié). Ahead of us was a vast front line of German infantry who were firing over a hill to the west, and who, in turn, were being fired upon by a French battery positioned behind the hill.[32]

Only a few days later the true tenor of the war became painfully obvious to him. He wrote home from Laveline that "the Germans advance only very slowly and with frightful casualties. . . . For many kilometers in this vicinity, the smell of decaying corpses is most horrifying. I can bear it less than seeing dead men and dead horses."[33]

As emotionally rending as these events had been for the artist, the worst news he would receive that year was yet to come. Less than three weeks later, on September 26, 1914, Marc's closest friend, August Macke, was killed in action at Champagne. Marc did not learn of this tragedy for almost a month, but when notification finally reached him on the twenty-third of October, he was irrevocably shaken. He tried to express his sense of loss in a letter written to his wife.

August's death is so frightful to me. . . . The naked fact will simply not register in my mind. I have actually trembled lately in fear for him. . . . I have felt in these days as if my nerves have been under assault—and today, when I received the definitive news from you, my consciousness went entirely mute. I will write at least a few words to Lisbeth (Macke's widow); I don't believe that I'm able to write an obituary just now; I will certainly do it at some future time.[34]

Two days later he added:

I feel the same, indeed uniformly stricken with grief. I cannot overcome August's death. How much is lost for all of us; it is like a murder, I cannot accept that familiar soldierly idea of death before the enemy and for the whole. I suffer horribly about that.[35]

Macke's death had an enormous impact upon Marc's psyche. A new fatalism becomes evident in his letters home, a feeling of being overwhelmed, of being surrounded by events that had got completely out of control. From Hagéville, on the eleventh of November, he wrote to his mother,

This world conflagration is indeed the most horrible moment in the history of the world. I often think of how I, as a boy, lamented the fact that I had not been witness to a great historical epoch—now it is here and it is more frightful than I could ever have dreamed. One is diminished before the magnitude of this event and submits oneself patiently to the place assigned by destiny.[36]

From the guard room, on Christmas eve of 1914, the artist noted the changes that had overtaken him during the course of the year. He wrote to his wife: "You would perhaps find me a little more silent, a little more melancholic—you would be also. The cleverness and the bright thoughts are not the same as they were before."[37] Two days and one battle later, the reason for his change of mood became clearly understandable:

> The combat of the infantrymen which I witnessed yesterday was incredibly hideous, more horrifying than anything I have ever seen. I was totally shaken last night. The courage with which they advance, and the indifference, indeed, the enthusiasm for death and for wounds has something mystical about it. Naturally, it is a mood of reconciliation, the clarification of something that was previously uncertain.[38]

By the eleventh of February, 1915, Marc could find some reconciliation of his own in the expression of his belief that "the spiritual realm will remain, perhaps (even certainly) grow stronger. Of this future I am never frightened—but what we will experience in the *external* realm, indeed, that we can hardly even conceive of today. What times these are!!"[39]

For the next several months, Marc began to redirect his interest increasingly toward matters of "the spiritual," and by March of 1915 he was once again at work. "My major thought now," he said, is to "design for a new world."[40]

The *Sketchbook from the Field* is a series of thirty-six drawings Marc compiled at the front between March and June of 1915 and it represents his final project.[41] In it we find a microcosm of the ambivalences and ambiguities that characterized his work during the previous year. In several of the sketches Marc seems preoccupied with images of cosmic birth, of primal becoming as evidenced by such titles as *Plant Life in Genesis, From the Days of Creation,* or *Arsenal for a Creation* [57]. There is, however, a distinct alteration in mood midway into the *Sketchbook* that is, in substance, anything but creative or optimistic.

As early as page 10 of the *Sketchbook,* in the drawing entitled *The Greedy Mouth* [58], we can notice the head of a serpent, its eyes bulging, its mouth open. The animal is fully absorbed in the process of devouring the "preorganic" crystalline foundations of this new world even before it has had a chance to form. Just a few pages later,

57. *Arsenal for a Creation*, page 12 from *Sketchbook from the Field*, 1915, pencil.

58. *The Greedy Mouth*, page 10 from *Sketchbook from the Field*, 1915, pencil.

the reality of battle, of violent conflict, becomes readily apparent in the drawing that Marc himself entitled *Strife*. By page 20, in an untitled work [59], we can see that the artist has returned to the depiction of clearly recognizable animal forms, while almost simultaneously writing in his letters home that "animals seemed more beautiful, more pure. But then I discovered in them too, so much that was ugly and unfeeling . . . until now, suddenly I have become fully conscious of nature's ugliness and impurity." [42]

Despite the tone of the artist's words, despite his declaration of revulsion at "nature's ugliness," we are nevertheless struck by the obvious regression in terms of style that characterizes a work like that seen on page 20 of the *Sketchbook*, a composition that clearly indicates a move backward toward the kind of depiction of forms that was evidenced in the imagery of 1913. In this small drawing we can vividly observe six deer coming to a halt at a mountain pass. While the crescent moon reigns in the sky to the upper right, two of the deer below are standing completely still, their necks raised in a position that clearly recalls that of the blue deer in *Fate of the Animals*. This same apocalyptic imagery is also evidenced in a drawing just two pages later, in the work entitled *Fragment*. Here we see two deer running and leaping, attempting to escape the cataclysmic explosions

59. *Untitled*, page 20 from *Sketchbook from the Field*, 1915, pencil.

rending the landscape in the background. At the base of the drawing a crescent is prominently in evidence.

Seen in light of the imagery contained in the two drawings that surround it, *Magical Moment* [60], page 21 of the *Sketchbook*, appears to be a work depicting not the sensitivity of creation, but rather the random violence of destruction. Here, in the midst of a cosmic storm, presided over by multitudes of crescents and arabesques, mountains collapse, cities tumble, and the world is yet again brought to an end. In supporting this view we need only recall a drawing Marc composed two years earlier, a work we have already discussed in terms of its destructive imagery, the sketch entitled *Plunging Mountain*. In *Plunging Mountain* [40] we saw a world in the process of disintegration, more specifically in the form of a rather steep, precariously inclined mountain breaking apart under the weight of cosmic forces and rocks and boulders raining down upon the earth below. We need only glance toward the left-center of *Magical Moment* in order to recognize what can only be described as an almost identical form, differing only in the inclination of its collapse.

As we have seen, for much of his life Marc had longed for the presence of a new world, a world of innocence, a world of purity and primal goodness that could take the place of the corruption, the decadence, the very loathsomeness of the society he was compelled to endure daily. He had sought a cleansing, a *tabula rasa* upon which the earth could begin again, fresh, vibrant, filled with the intensity, the vitality and exuberance of newness, of becoming. He had dedicated his art and his life toward this purpose and yet, here, on the field of battle, in the midst of the cataclysm itself, he came to the painful realization of his own failure. In March of 1914, just a year earlier, he had written:

> We know that everything can be destroyed if the germination of a spiritual race does not endure the test of the greed and impurity of the masses. We struggle for pure ideas, for a world in which pure ideas can be thought and can be expressed without becoming impure. Then only will we, or those more qualified than we, be able to show the other face of the Janus-head that today remains hidden and turned away from the view of our age. [43]

By the middle of 1915, everything, for Marc, had indeed been destroyed; the germination of the spiritual could not meet the test, and

60. *Magical Moment*, page 21 from *Sketchbook from the Field*, 1915, pencil.

the artist began to realize how lost and alone he really was. In October of 1914, after hearing of Macke's death, Marc could still envision the continuation of the struggle to redeem mankind. He was convinced that he would carry these ideals forward, by himself if necessary, no matter how arduous or overwhelming the task: "To think of *everything*," he wrote at that time, "for which I must now struggle alone! Truly *completely* alone.[44]

Less than a year later, in a letter written on the twenty-third of June, 1915, his concept of salvation had diminished considerably in its scope, and his words were now filled with the premonitions and presentiments of a man who had to reconcile himself to his own growing disillusionment, to the onrush of fate, and to the almost inescapable conclusion of his own death. As in his art during the preceding months, Marc's words now tend to reveal a reacceptance and reaffirmation of the religious convictions of his early years.

> What is war other than the prevailing condition of peace in another, more truly actual form; instead of concurrence there is now war. Whether men die on the battlefield or in the stifling atmosphere of the mine pits, there is no *essential* difference. Death and its wounds do not corrupt the soul. I do not really envision death as *destruction* . . . perhaps you can remember how I had earlier spoken about death; it is absolute deliverance. . . . "Death where is thy sting?"[45]

Marc went on to provide further support for this belief by saying, "There is yet another life that no death, no murder, no killing, no wounding, no sickness can vanquish and that can be influenced as little by the corruption of the world as by its bettering."[46] Finally, he concluded this no doubt painful letter home with the following words: "There is only one blessing and salvation: death, the destruction of form. With that, the soul becomes free."[47]

Of one of the final works in the *Sketchbook*, an untitled drawing appearing on page 34 [61], Klaus Lankheit has offered the following brief but most sensitive description:

> The stillness of death lies over the . . . sketch of partridges in a field. The delicacy of the pencil lines brings to mind India-ink drawings by Chinese artists. Once again the curved forms of the animals blend with the purely expressive forms of the natural setting. The resignation of the forsaken creature is echoed by the sorrowfully bending stalks. As though accidentally, two thin lines at the center form a cross.[48]

61. *Untitled*, page 34 from *Sketchbook from the Field*, 1915, pencil.

The drawing, which so beautifully, so sensitively evokes the sadness, the loneliness, and the quiet of death was rendered at the very same time as the letter we have just been considering, the letter dated June 23, 1915. In this serene but moody drawing, the apocalypse becomes personalized; here, Marc has pictured the certainty of his own death.

Conclusion

WHILE his work was now complete, Franz Marc still had eight months in which to live. As the month of June ended, he received his first official leave from the front, and while he naturally spent most of this short respite at Ried, he nevertheless found time to visit old friends in Munich. Paul Klee remembered that at that time Marc

> was very tired and visibly thinner . . . never ceasing to relate his experiences. The continuous pressure and loss of freedom clearly weighed on him. I now began to hate the cursed costume, a poorly fitting noncommissioned officer's uniform, with a tassled saber at the side. To speak more seriously with him, when he had time to recover I visited him in Ried. . . . When he had to leave again, his wife accompanied him to Munich, and they came to eat with us. I cooked risotto and he brought some raw ham. We were gay, leave-taking did not seem unbearable to him. He promised to duck assiduously whenever something dangerous came flying through the air. The fellow ought to paint again, then his quiet smile would appear, the smile that is simply part of him, simple and stupefying.[1]

By the seventeenth of July, however, Marc had returned to the war, and two days later he could report that he had "readjusted" to his location.[2]

Events touched the artist relatively little for the next several

months, and he employed every free moment to catch up on his reading.[3] On October 1 he was proud to report that "I have suddenly and unexpectedly been promoted to deputy officer which in a few months will be followed by a commission to the rank of lieutenant."[4] Yet, later in this letter, the specter of war drew ever closer:

> I believe and hope that we have slowly gained the upper hand in the west. One actually feels a general sense of relief that the offensive has finally begun—the hope that it will bring the war to a decisive climax has again become very active here. The immensity of the carnage is frightful on both sides, but nobody can see any other way.[5]

The artist spent the remainder of October in and around the city of Metz, and at the beginning of the following month he received another short leave. Once again Klee had the opportunity to see his old friend, and while he could not have known that it would be for the last time, Klee nevertheless had the impression that things were far from normal.

> In November Marc came home on leave as a lieutenant. This time he looked well; being an officer, he was able to take care of his appearance, and he had also assumed the bearing of an officer. His new dress fitted him well—I almost felt like saying "unfortunately." I am not certain whether he was still the same old Marc. I had with me a few variations by Jawlensky and was almost afraid to show them to him. The last evening he spent with us in Ainmillerstrasse he was without his wife. She was ill, and he had already taken leave of her. Deep seriousness emanated from him, and he spoke little.[6]

When Marc returned to the front this time, after two weeks at home, the situation grew steadily worse and the horrors of the war became a burning nightmare from which he could find little escape.

> The days of leave that brought back in me that close feeling with the living, with wife, and with friends, and with art, have only served to increase this dreadful yearning. I feel like a spectre here. The war has lasted too long and has become senseless. The sacrifice that it demands has also become senseless. Something more unprincipled, more mournful than the needless blood that was wasted at Isonzo would not permit a human mind to function any longer.[7]

On the very same day he wrote to his wife: "Today I understand for the first time why suicide would be proper in this wasteland."[8] Two months later he clearly warned her to expect the worst:

Don't take it too tragically if I represent Lisbeth [Macke's widow] to you as a model of bravery. I am smart enough to also notice the discrepancies, the difference in your situations. But I do not thoughtlessly stress the idea of a courageous cheerfulness despite all suffering. . . . *Pride* must triumph in man above everything else, not *grief.* [9]

On February 21, 1916, the German army launched what was perhaps the most massive assault since the start of the war. Hoping to catch the French off guard, and to seize the initiative in the fighting, nine German divisions began an assault upon what had been a small provincial village named Verdun. By the twenty-fourth, the Germans had broken through the French lines along a two-mile front and thus commenced "the longest battle of all time . . . with the highest density of dead per square yard that has probably ever been known." [10]

Within three days, the fury of the fighting had caught up with Marc, and his reaction was one of stunned disbelief.

We are now in the midst of the most monstrous, the most horrifying of all the days of this war. The entire French line has been broken. No man has any idea of the maddening rage, the power of the German advance. We have become essentially pursuit troops. The poor horses! [11]

On the second of March he reported: "For days I have seen nothing but the most horrifying things that a human mind could imagine. . . . The war ends this year." [12]

Indeed, for the artist, the war came to an abrupt end just two days later. Major Hans Schilling, Marc's commanding officer, recalled the events of March 4, 1916:

It was a radiant early-spring afternoon, as we got ourselves ready. At the foot of a hill Marc mounted his horse, a tall chestnut bay, and as long-legged as he himself. We rode together for some length along a path that the day before had been subject to some very severe fire, but on this day the fire was relatively light. In Braquis (20 kilometers east of Verdun) we separated. Marc was supposed to reconnoiter the woods for a path for a munitions convoy. Barely twenty minutes later his horse-attendant, H., returned, covered with blood and slightly wounded. His eyes filled with tears, he pointed toward the woods where, just a few minutes earlier, his superior had been struck by a grenade fragment and had died in his arms. Whether it was an unfortunate accident or whether it was the French . . . will forever remain a mystery. Franz Marc was dead! [13]

The following morning, Marc was buried by his comrades under a large oak tree in the park of the château of Gussainville, not far from where he had fallen. A year later his body was transferred to Kochel, not far from his "dream house" at Ried.

In the words of a letter written to his mother only two weeks before his death, Marc offered what was in a very real sense his final testament. Beneath the surface imagery of consolation we can, in this letter, recognize the substance of his personal philosophy, the resolution of those sincere convictions that found such dynamic expression in his art.

Dear Mama, 17 Feb 1916

I understand quite well why you speak so quietly about death, as if it were something you do not shout about. I feel exactly the same way. In this war one has indeed been able to see that for oneself—an opportunity that is seldom offered in life. In daily life, people generally never see deadly perils and don't believe in them in the least. But it has never occurred to me in this war to seek out danger and death as I had done so often in earlier years—at that time death avoided me, not I it; but that is long past! Today I would greet it very sadly and very bitterly, not out of fear or anxiety about it—nothing is more soothing than the prospect of the *stillness of death*—but because I have half-finished work to be done that, when completed, will convey the entirety of my feeling. The whole purpose of my life lies hidden in my unpainted pictures. Aside from that, death is not frightening; it is the mutuality of *everything* and leads us back to a normal state of being. The space between life and death is a state of exception in which there is much to fear and much suffering. The only real, constant philosophical comfort lies in the knowledge that this state of exception passes on and that the ever-troubled, constantly annoyed, most solemn and completely inadequate "Ego-Consciousness" lapses back once more into that wonderful stillness before birth. . . .

The *substance* of thought about life and death continually remains the same. The idea that people can, through poor management of their biblical burden in daily life, disturb the sweet peace of eternal life is indeed an all-too-human, all-too-inhuman invention. Those who do evil, and those who do nothing—they already have punishment in life, in their conscience and in their fear of death. These people cannot enjoy the purity of life (although they try to make it appear that way) because they have too much fear about their death, which, according to them, takes "everything." For those who strive after purity and knowledge, however, for them, death always comes as deliverance.[14]

Notes

All translations are those of the author unless otherwise indicated.

Introduction: The Themes of Expressionism

1. *Webster's Seventh New Collegiate Dictionary* (Springfield, Mass.: G. and C. Merriam Company, 1963), p. 294.

2. Donald E. Gordon, "On the Origin of the Word 'Expressionism,'" *Journal of the Warburg and Courtauld Institutes,* vol. 29 (1966), p. 381.

3. For the most complete history of the term "Expressionism" in relation to German art and its application in the early twentieth century see ibid., pp. 368–85.

4. See Franz Marc, "Zwei Bilder," in Wassily Kandinsky and Franz Marc (eds.), *Der Blaue Reiter* (a reprint of the original 1912 edition with documentation by Klaus Lankheit; Munich: R. Piper, 1965), p. 36.

5. Victor Miesel, *Voices of German Expressionism* (Englewood Cliffs, N.J.: Prentice Hall, 1970), p. 1.

6. Erich Fromm, *The Heart of Man* (New York: Harper & Row, 1964), p. 117.

7. Ibid.

8. C. G. Jung, *Symbols of Transformation,* 2 vols. (New York: Harper, 1962), vol. 1, pp. 235–36. It should be noted here that Jung as well as Freud may themselves be considered "Expressionist" psychologists in that they were involved in and influenced by the same cultural phenomena that affected the art under consideration. While many psychologists today can, and indeed do disagree with the positions advocated by Jung and Freud, we must remember that these two formidable figures existed contemporaneously with the period of Expressionism and, as such, tend to reflect a valuable assessment of psychological principles as advocated and disseminated at the time.

9. Ibid., vol. 2, p. 329.

10. Ibid., p. 330.

11. Sigmund Freud, "Beyond the Pleasure-Principle," in John Rickman (ed.), *A General Selection from the Works of Sigmund Freud* (New York: Doubleday, 1957), pp. 159–60.

12. Joost A. M. Meerloo, *Suicide and Mass Suicide* (New York: Grune & Stratton, 1962), p. 5.

13. Ibid., p. 68.

14. Ibid., p. 70.

15. Ibid.

16. That is, Freud's *Interpretation of Dreams*, Einstein's Theory of Relativity, Röntgen's discovery of the X-ray, and Planck's quantum theory. It is further worth noting that all of these remarkable discoveries of the "inner," or "hidden," world occurred in Germany and Austria.

17. Carlton J. H. Hayes, *A Generation of Materialism, 1871–1900* (New York: Harper & Row, 1963), p. 328.

18. Robert Musil, *The Man Without Qualities* (1930), trans. Eithne Wilkins and Ernst Kaiser (New York: Capricorn, 1965), p. 59.

19. Miesel, *Voices of German Expressionism*, p. 6.

20. This crisis of the late nineteenth century was not confined to Germany, but rather was an international phenomenon. The response of each nation, however, was largely dependent upon issues of purely national scope. Cf. Fritz Stern, *The Politics of Cultural Despair* (New York: Doubleday, 1965), p. 198.

21. Golo Mann, *The History of Germany Since 1789* (New York: Praeger, 1968), p. 201. As Mann notes: Total German industrial production overtook that of France in the seventies, caught up with the British around 1900 and surpassed it substantially by 1910; by this time it was second only to the Americans. Around 1830 four-fifths of the German population lived on the land and earned their living in agriculture; in 1860 the number had fallen to three-fifths, in 1882 to two-fifths and in 1895 it was barely one-fifth. The second greatest source of energy in the world was established within a period of forty years, in the state which had been thought incapable of possessing even the force of industrial organization shown by France. This is the essence of German history in that period.

22. For the most perceptive recent analyses of this crisis of national identity see George Mosse, *The Crisis of German Ideology* (New York: Grosset & Dunlap, 1971) and Stern, *The Politics of Cultural Despair*.

23. Paul de Lagarde in Stern, *The Politics of Cultural Despair*, p. 57.

24. Ibid., p. 131.

25. Ibid.

26. Ibid.

27. Ibid., p. 200.

28. Ibid., pp. 155–56. As Stern notes: "The temper of this criticism evinced a desire not so much for the reform as for the annihilation of modern society. . . . the book was dominated by a consistent aspiration toward a form of primitivism which, after the destruction of the existing society, aimed at the release of man's elemental passions and the creation of a new Germanic society based on Art, Genius, and Power."

29. Ibid., p. 160.

30. Jung, *Symbols of Transformation*, vol. 1, p. 260.

31. Sigmund Freud, "Dostoievsky and Parricide," in Philip Rieff (ed.), *Character and Culture* (New York: Collier, 1963), p. 281. Cf. also Sigmund Freud, *A General Introduction to Psychoanalysis* (New York: Simon & Schuster, 1969), pp. 294–96; Walter Sokel, *The Writer in Extremis* (New York: McGraw-Hill, 1964), pp. 97ff.; and Erich Fromm, *The Art of Loving* (New York: Bantam, 1963), pp. 34ff. See also Egbert Krispyn, *Style and Society in German Literary Expressionism*, p. 25.

32. Erich Fromm, *Escape from Freedom* (New York: Avon, 1965), p. 207.

33. Sokel, *The Writer in Extremis*, p. 83; Ernst Kris, "Art and Regression," *Transactions of the New York Academy of Sciences*, series II, vol. 4, no. 7 (1944), pp. 239–40.

34. Franz Marc in *Der Blaue Reiter* (1965), p. 325.

35. Franz Marc, "Die Wilden Deutschlands," in ibid., p. 30.

36. Significant exceptions are Klaus Lankheit and Alois Schardt. Their work will be discussed in some detail later.

37. Franz Marc, *Briefe, Aufzeichnungen, und Aphorismen* (Berlin: Cassirer, 1920), p. 126.

38. Ibid., p. 127.
39. Ibid., p. 124.

Chapter 1: Munich and the Formative Years

1. Eda Sagarra, *Tradition and Revolution, German Literature and Society, 1830–1890* (New York, Basic Books, 1971), p. 258.
2. Both of these artists would prove a strong influence on the work of the Expressionists. Marc, in particular, would later refer to Marées as one of the most important artists of the nineteenth century. Cf. Franz Marc, "Zwei Bilder," *Der Blaue Reiter* (1965), p. 35.
3. Barbara Tuchman, *The Proud Tower* (New York: Macmillan, 1966), p. 376.
4. Richard Dehmel, "Gleichnis," in Patrick Bridgwater (ed.), *Twentieth Century German Verse* (Baltimore: Penguin, 1963), p. 9.
5. Rainer Maria Rilke, "Ritter," in C. F. MacIntyre (ed. and trans.), *Rilke, Selected Poems* (Berkeley: University of California, 1968), p. 23.
6. Henry Hatfield, *Modern German Literature* (Bloomington: University of Indiana, 1968), pp. 36–37.
7. Alois Schardt, *Franz Marc* (Berlin: Rembrandt, 1936), p. 9.
8. Franz Marc, letter of 5 December 1915, in Franz Marc, *Briefe aus dem Felde* (Munich: List, 1966), p. 111.
9. Schardt, *Franz Marc*, pp. 10–11.
10. Franz Marc in Klaus Lankheit (ed.), *Franz Marc im Urteil Seiner Zeit* (Cologne: DuMont, 1960), pp. 23–24.
11. Franz Marc in ibid., p. 25.
12. That is, Julie Mark; for her relationship with E. T. A. Hoffmann, see Lankheit, *Franz Marc, Watercolors, Drawings, Writings*, p. 13.
13. Franz Marc in Lankheit, *Franz Marc in Urteil Seiner Zeit*, p. 25.
14. Ibid., p. 26.
15. Maria Marc in Klaus Lankheit, *Franz Marc* (Berlin: Konrad Lemmer, 1950), p. 71.
16. Friedrich Nietzsche, "The Genealogy of Morals" (1887), in Friedrich Nietzsche, *The Birth of Tragedy and the Genealogy of Morals*, trans. Francis Golffing (New York: Doubleday, 1956), p. 199.
17. Friedrich Nietzsche, "The Religious Nature" (1886), in Friedrich Nietzsche, *Beyond Good and Evil*, trans. R. J. Hollingdale (Baltimore: Penguin, 1973), p. 71.
18. Franz Marc, "Zwei Bilder," in *Der Blaue Reiter* (1965), p. 34.
19. See Schardt, *Franz Marc*, pp. 23–24.
20. Ibid., p. 24.
21. Franz Marc in Lankheit, *Franz Marc, Watercolors, Drawings, Writings*, p. 13.
22. Franz Marc in Schardt, *Franz Marc*, p. 26.
23. Lankheit, *Franz Marc, Watercolors, Drawings, Writings*, p. 13.
24. Schardt, *Franz Marc*, p. 28.
25. Ibid., p. 33.
26. Ibid., p. 29.
27. The series was entitled "Stella Peregrina," and was published posthumously in 1917.
28. Maria Marc in Lankheit, *Franz Marc*, p. 71.
29. Schardt, *Franz Marc*, p. 35. See also Marc's letter to Schnür, October 8, 1905, in Elisabeth Keimer-Dünkelsbühler, "Unbekannte Briefe von Franz Marc," in *Vossische Zeitung*, no. 155 (July 6, 1930).
30. Franz Marc's letter to Marie Schnür, October 20, 1905, in Keimer-Dünkelsbühler, "Unbekannte Briefe."
31. Ibid.
32. Lankheit, *Franz Marc*, p. 10.
33. Franz Marc's letter to Marie Schnür, June 17, 1906, in Keimer-Dünkelsbühler, "Unbekannte Briefe."

34. Franz Marc's letter to Marie Schnür, December 26, 1906, in ibid.
35. Klaus Lankheit, *Franz Marc. Katalog der Werke* (Cologne: DuMont, 1970), p. 94.
36. Schardt, *Franz Marc*, p. 43. Cf. Lothar G. Buchheim, *Der Blaue Reiter* (Feldafing: Buchheim, 1959), pp. 132–33.
37. James C. Coleman, *Abnormal Psychology and Modern Life* (Glenview, Ill.: Scott, Foresman, 1964), p. 229.
38. Ibid.
39. Lankheit, *Franz Marc, Watercolors, Drawings, Writings*, p. 15.
40. Aaron T. Beck, *Depression, Causes and Treatment* (Philadelphia: University of Pennsylvania, 1967), p. 6.
41. Marc, *Briefe aus dem Felde*, p. 67.
42. Ibid., p. 133.
43. Schardt, *Franz Marc*, p. 28.
44. Franz Marc in Lankheit, *Franz Marc, Watercolors, Drawings, Writings*, p. 14.
45. Ibid.
46. Karl Joël in Jung, *Symbols of Transformation*, vol. 2, p. 325.
47. Franz Marc in Lankheit, *Franz Marc*, p. 18.

Chapter 2: The Years of Transition

1. Maria Marc in Lankheit, *Franz Marc*, p. 75.
2. Marc, *Briefe aus dem Felde*, p. 57. (Letter of April 7, 1915.)
3. See Schardt, *Franz Marc*, p. 70.
4. Ibid., p. 71. Another impetus was the Islamic art exhibition of 1910. See Peter Selz, *German Expressionist Painting* (Berkeley: University of California Press, 1957), p. 185.
5. Jung, *Symbols of Transformation*, vol. 2, p. 326.
6. The basic meaning of this extremely widespread ritual was undoubtedly the maternity of the earth. Mircea Eliade, *Patterns in Comparative Religion* (New York: World, 1972), p. 248.
7. This bears a similarity to Alyosha's "mystical" contact with the earth as described by Dostoevsky in *The Brothers Karamazov* (1881), a book with which Marc was familiar:

> Alyosha stood, gazed out before him and then suddenly threw himself down on the earth. He did not know why he embraced it. . . . But with every instant he felt clearly and, as it were, tangibly, that something firm and unshakable as that vault of heaven had entered into his soul. . . . He had fallen on the earth a weak soul, but he rose up in strength.

Fyodor Dostoevsky, *The Brothers Karamazov* (New York: New American Library, 1957), p. 334.

8. Eliade, *Patterns in Comparative Religion*, p. 255.
9. Franz Marc in Schardt, *Franz Marc*, p. 78.
10. Selz, *German Expressionist Painting*, p. 202.
11. C. G. Jung, *Psyche and Symbol*, ed. Violet S. de Laszlo (New York: Doubleday, 1958), p. 105.
12. Jung, *Symbols of Transformation*, vol. 2, p. 277. See pp. 275–82 for a brief history of horse symbolism in legend and myth.
13. D. H. Lawrence, *Apocalypse* (1931; New York: Viking, 1960), pp. 97–98.
14. After 1910, Marc painted no more than a total of ten nudes, most of them combined with animals and usually designed as gifts for friends. See Lankheit, *Franz Marc, Katalog der Werke*.
15. Selz, *German Expressionist Painting*, p. 196.
16. Hugo von Tschudi, a supporter of the modern movements in art, was dismissed

as director of the German National Gallery in 1908, only to be hired by the Bavarian State Galleries in Munich the following year. From this position, Tschudi was an active and enthusiastic supporter of both the NKVM and the later *Blaue Reiter*.

17. Wassily Kandinsky in Lankheit, *Franz M ~rc im Urteil Seiner Zeit*, p. 46.

18. Franz Marc in Lankheit, *Der Blaue Reiter* (1965), p. 255.

19. Franz Marc in Will Grohmann, *Wassily Kandinsky, Life and Work* (New York: Harry N. Abrams, n.d.), p. 65.

20. Franz Marc, letter to August Macke, December 12, 1910, in August Macke and Franz Marc, *Briefwechsel* (Cologne: DuMont, 1964), p. 28.

21. Franz Marc, letter to August Macke, January 14, 1911, in ibid., pp. 39–40.

22. This horse appears to be more "spiritual" than "severe." An example of severity will be seen later in *The Tower of Blue Horses*.

23. Kandinsky in Lankheit, *Franz Marc im Urteil Seiner Zeit*, pp. 46–47.

24. Grohmann, *Kandinsky*, p. 65.

25. Franz Marc, letter to August Macke, August 10, 1911, in Macke and Marc, *Briefwechsel*, p. 65.

26. The work was ostensibly rejected because of its size. Cf. Selz, *German Expressionist Painting*, p. 197.

27. Franz Marc, letter to Paul Marc, December 3, 1911, in Klaus Lankheit, "Zur Geschichte des Blauen Reiters," *Cicerone* (1949), p. 112. See also Maria Marc, letter to August Macke, December 3, 1911, in Macke and Marc, *Briefwechsel*, pp. 83–86.

28. Wassily Kandinsky in Lankheit, *Der Blaue Reiter* (1965), p. 259.

29. Wassily Kandinsky in Hans Roethel, *The Blue Rider* (New York: Praeger, 1971), pp. 32–33.

30. Ibid., p. 33.

31. Ibid., pp. 32–33.

32. Somewhat ironically, the two shows (NKVM and *Blaue Reiter*) were held simultaneously in the same gallery. Cf. Lankheit, "Zur Geschichte des Blauen Reiters," (1949), p. 112.

33. Kandinsky in Roethel, *The Blue Rider*, p. 33.

34. Grohmann, *Kandinsky*, p. 67.

35. Selz, *German Expressionist Painting*, p. 221.

36. For a complete analysis and history of the Almanac, see Lankheit, *Der Blaue Reiter* (1965).

37. Franz Marc, "Geistige Güter," in *Der Blaue Reiter* (1965), p. 21.

38. Franz Marc, "Die Wilden Deutschlands," in ibid., pp. 29–31.

39. Marc's footnote, "In France, e.g., Cézanne and Gauguin to Picasso; in Germany, Marées and Hodler to Kandinsky; no evaluation of these artists is intended, merely a suggestion to the development of expression in France and Germany." Franz Marc, "Zwei Bilder," in ibid., p. 35.

40. Ibid.

41. Ibid., p. 36.

42. Cf. Marc's letter to Kandinsky concerning Delaunay in Lankheit, *Franz Marc, Watercolors, Drawings, Writings*, p. 18.

43. Mann, *The History of Germany Since 1789*, p. 289.

44. Franz Marc in *Der Blaue Reiter* (1965), p. 316.

Chapter 3: The Image of Apocalypse

1. Franz Marc, letter to August Macke, May 22, 1913, in Macke and Marc, *Briefwechsel*, p. 163.

2. Georg Schmidt, "Die Tierschicksale von Franz Marc," *Du*, vol. 4 (April, 1956), unpaged.

3. The reference is to Herwarth Walden's Sturm Gallery in Berlin, the site of the First German Herbstsalon.

4. Marc, *Briefe aus dem Felde*, p. 47.

5. Cf. Nell Walden, *Erinnerungsbuch an Herwarth Walden* (Wiesbaden: Klein, 1954), p. 49.

6. Schmidt, "Die Tierschicksale."

7. Lankheit, *Franz Marc im Urteil Seiner Zeit*, p. 15.

8. Schmidt, "Die Tierschicksale."

9. Peter Selz and Georg Schmidt have stated that the deer is being killed by a falling tree. See Selz, *German Expressionist Painting*, p. 267; Schmidt, "Die Tierschicksale." Bernard Myers has intimated that the deer is being killed by the tree. See Myers, *The German Expressionists* (New York: Praeger, 1957), p. 226. Alois Schardt and Klaus Lankheit view the confrontation between tree and deer as a sacrificial image in which we find the legacy, meaning, and import of the work. See Schardt, *Franz Marc*, p. 119; Lankheit, *Franz Marc*, p. 38.

10. Franz Marc, "Die Neue Malerei," *Pan II* (1912), p. 556.

11. Schardt (*Franz Marc*, p. 119) and Lankheit (*Franz Marc*, p. 38) identify the animals as wolves. Schmidt ("Tierschicksale") and Selz (*German Expressionist Painting*, p. 267) identify them as foxes.

12. Selz, *German Expressionist Painting*, p. 267. This stylized tree also appears a year earlier in Marc's painting entitled *Forest Interior with Bird* (1912).

13. Klaus Lankheit, *Franz Marc, Watercolors, Drawings, Writings*, p. 22.

14. Gustave Flaubert, "The Legend of St. Julian Hospitator," in *Three Tales*, trans. Robert Baldick (Baltimore: Penguin, 1961), p. 66.

15. Ibid., p. 67.

16. Ibid.

17. Arthur C. Danto, *Nietzsche as Philosopher* (New York: Macmillan, 1970), p. 61. The work's influence was in no way affected by Nietzsche's later disenchantment and subsequent break with Wagner.

18. Friedrich Neitzsche, "The Birth of Tragedy from the Spirit of Music," in *The Birth of Tragedy and the Genealogy of Morals*, pp. 136–37, 144.

19. Mann, *The History of Germany Since 1789*, p. 238.

20. Richard Wagner, *My Life* (New York: Dodd, Mead, 1924), p. 416. The first German edition of this work appeared in 1911.

21. Hans Kohn, *The Mind of Germany* (New York: Harper, 1965), p. 192.

22. Ibid., p. 200.

23. Richard Wagner, *The Ring of the Nibelung*, trans. Margaret Armour (Garden City: Doubleday, 1939), p. 118.

24. Ibid., p. 180.

25. Lankheit, *Franz Marc im Urteil Seiner Zeit*, p. 24.

26. Ibid., p. 23.

27. Donald A. Mackenzie, *Teutonic Myth and Legend* (London: Gresham, n.d.), p. 14.

28. Jung, *Symbols of Transformation*, vol. 1, p. 249. Yggdrasill, translated into English, means literally "horse of Ygg" or "horse of God."

29. R. B. Anderson, *Norse Mythology* (Chicago: S. C. Griggs, 1876), p. 417.

30. Ibid.

31. Ibid., p. 421.

32. Ibid., pp. 423–24.

33. Jung, *Symbols of Transformation*, vol. 1, p. 246. Cf. also De la Saussaye, *The Religion of the Teutons*, p. 352; and Anderson, *Norse Mythology*, p. 433.

34. The fact that deer inhabit this tree instead of human beings may be explained in two ways. First, after 1910, the appearance of humans in Marc's work is so rare as to be almost nonexistent. Second, Marc may have been attracted to the qualities which the deer represent, their proximity to nature, their sharp instinctive powers, and, indeed, their pacificity, thus earmarking these qualities for survival and regeneration in the post-apocalyptic world.

35. Myers, *The German Expressionists*, p. 214.

36. Wassily Kandinsky, *Concerning the Spiritual in Art* (New York: Wittenborn, 1970), p. 81. Much the same vision of destruction occurs in an earlier work of Kandinsky entitled *The Yellow Sound* of 1909. Cf. Miesel, *Voices of German Expressionism*, pp. 128ff.
37. Richard Samuel and R. Hinton Thomas, *Expressionism in German Life, Literature and the Theatre* (Cambridge, Eng.: Heffner, 1939), p. 121.
38. Hermann Hesse in ibid., p. 122. The question naturally arises as to whether the ascendancy of Nazism could perhaps have represented the culmination of this driving impulse toward regression and apocalypse as advocated by the Expressionists. While a number of interesting parallels can be drawn between the two movements, a full-scale discussion of the relationship between Expressionism and Nazism far exceeds the scope of this thesis.
39. Stefan Zweig in Miesel, *Voices of German Expressionism*, p. 7.
40. Franz Marc in ibid.
41. Franz Marc, "In War's Purifying Fire,"in ibid., p. 161.
42. Marc, *Briefe aus dem Felde*, p. 60. Compare this statement of Marc's with that of Nietzsche's *The Antichrist*, no. 38: "At this point I do not suppress a sigh. . . . I am afflicted with a feeling blacker than the blackest melancholy—*contempt of man*. And to leave no doubt concerning what I despise: it is the man of today, the man with whom I am fatefully contemporaneous. The man of today—I suffocate from his unclean breath."

Chapter 4: Signs in the Sky

1. Jean-Jacques Rousseau, *The First and Second Discourses*, ed. Roger D. Masters (New York: St. Martin's Press, 1964), p. 20.
2. Ibid., pp. 179, 164.
3. Frederick Copleston, *A History of Philosophy*, vol. 7, pt. II (New York: Doubleday, 1965), pp. 38–39, 54.
4. Philip Appleman (ed.), *Darwin* (New York: W. W. Norton, 1970), p. 264.
5. Friedrich Nietzsche, "The Use and Abuse of History," in *Thoughts Out of Season*, vol. 5, pt. II of *The Complete Works of Friedrich Nietzsche*, ed. Oscar Levy (New York: Russell & Russell, 1964), p. 6.
6. Ibid., p. 7.
7. Friedrich Nietzsche, *The Antichrist*, no. 14, in Walter Kaufmann (ed.), *The Portable Nietzsche* (New York: Viking, 1966), p. 580.
Dostoevsky offers a somewhat similar statement in a work that also had a great deal of influence on the thought of the Expressionists. In "Conversations and Exhortations of Father Zossima," from *The Brothers Karamazov*, we find these words:

Love animals: God has given them the rudiments of thought and joy untroubled. Do not trouble their joy, don't harass them, don't deprive them of their happiness, don't work against God's intent. Man, do not pride yourself on your superiority to animals; they are without sin, and you with your greatness, defile the earth by your appearance on it, and leave the traces of your foulness after you—alas, it is true of almost everyone of us.

Fyodor Dostoevsky, *The Brothers Karamazov*, trans. Constance Garnett (New York: Signet, 1960), p. 294.
8. Nietzsche, *The Antichrist*, no. 6, in *The Portable Nietzsche*, p. 572.
9. Nietzsche's attack was later given further support by the appearance of Henri Bergson's *Creative Evolution* which first appeared in 1907.
10. Karl Heinz Fingerhut, *Das Kreatürliche im Werke Rainer Maria Rilkés* (Bonn: Bouvier, 1970), p. 21.
11. Ibid.
12. John A. Lester, *Journey Through Despair 1880–1914: Transformations in British Literary Culture* (Princeton: Princeton University Press, 1968), p. 75.
13. D. H. Lawrence, letter to Ernest Hollings, in ibid., p. 75.

14. Michael Hamburger, *Contraries: Studies in German Literature* (New York: Dutton, 1970), pp. 275–76. Kurt Mautz referred to the theme of apocalypse as "one of the most fundamental motifs in all of Expressionist poetry." See Hansjörg Schneider, *Jakob van Hoddis* (Bern: Francke, 1967), p. 77.

15. Jakob van Hoddis, "Weltende," in Michael Hamburger and Christopher Middleton (trans. and eds.), *Modern German Poetry* (New York: Grove Press, 1962), pp. 48–49.

16. Johannes Becher in Schneider, *Jakob van Hoddis*.

17. Johannes Becher in Wolfgang Rothe (ed.), *Expressionismus als Literatur* (Bern: Francke, 1969), p. 346.

18. Gottfried Benn, from the poem "Icarus," in Hamburger and Middleton, *Modern German Poetry*, p. 69.

19. Gottfried Benn, "Gesänge I," in Friedrich Wilhelm Wodtke (ed.), *Gottfried Benn, Selected Poems* (London: Oxford University Press, 1970), p. 53.

20. Else Lasker-Schüler in Wodtke, *Gottfried Benn, Selected Poems*, pp. 14–15. Else Lasker-Schüler, an Expressionist poet in her own right, was, at the time of *Morgue*'s publication, living with Benn. Of her place in the Expressionist movement, however, I can only agree with John Willett's statement that it owed "more to her friendships . . . than to any specially Expressionist feature of her writing." (John Willett, *Expressionism* [New York: McGraw-Hill, 1970], pp. 93–94.) Her friendships are significant for our purposes here because they provide a likely link of communication between the Expressionist poets and painters.

From 1903 to 1911 she was married to Herwarth Walden, publisher of the Expressionist magazine *Der Sturm* and director of the *Sturm* Gallery in Berlin. Among her closest literary friends were Peter Hille, Alfred Döblin, Kurt Hiller, Franz Werfel, Karl Kraus, and most significantly Gottfried Benn, Georg Trakl, and Georg Heym. Her closest friend among the Expressionist painters from 1912 until his death in 1916 was none other than Franz Marc. See Heinz Politzer, "Else Lasker-Schüler," in Wolfgang Rothe (ed.), *Expressionismus als Literatur* (Bern: Franke Verlag, 1969), pp. 215–31; Walter Muschg, *Von Trakl zu Brecht* (Munich: Piper, 1963), pp. 124ff.; Hans Steffen (ed.), *Der Deutsche Expressionismus: Formen und Gestalten* (Göttingen: Vandenhoeck & Ruprecht, 1970), p. 10. The postcards Marc sent to Lasker-Schüler during the years of their friendship are included in *Franz Marc. Botschaften an den Prinzen Jussuf*, ed. Georg Schmidt (Munich: Piper, 1964). In this small volume there is also an introductory essay by Maria Marc documenting the friendship of the painter and poet. For a brief selection of Lasker's letters to Marc, see Ernst Ginsberg (ed.), *Else Lasker-Schüler, Dichtungen und Dokumente* (Munich: Kösel, 1951), pp. 521–25.

21. George Heym, "Umbra Vitae," in Hamburger and Middleton, *Modern German Poetry*, pp. 154–57.

22. Georg Heym, "Der Krieg," in William Rose (ed.), *Modern German Lyric Verse*, pp. 143–44.

23. Georg Trakl, "Kaspar Hauser Lied," in Hamburger and Middleton, *Modern German Poetry*, pp. 126–27.

24. Georg Trakl, "Abendland," in ibid., pp. 136–38.

25. Georg Trakl from "Kindheit," in ibid., pp. 118–19.

26. George Trakl, "Untergang," in ibid., pp. 113–15.

27. I have not discussed as many of the Expressionist writers as I may have wished. I chose to present a brief sampling of works by Wedekind, van Hoddis, Benn, Heym, and Trakl, not only because their output is considered among the finest of that produced during the prewar Expressionist period, but because it is also fully representative of the themes expressed by the movement as a whole. Indeed, the theme of regression can rather easily be perceived in the early work of Franz Kafka (*Die Verwandlung*), or the poetry of Paul Boldt ("Junge Pferde"), or Theodor Däubler ("Der Atem der Natur"), Rene Schickele ("Heilge Tiere. . . !" "Der Rote Stier Träumt), in the "crisis" poems of Rainer Maria Rilke, and in the work of Yvan Goll ("Wald"), and Franz Werfel ("Das Opfer").

The theme of apocalypse can also be seen in the poetry of Oskar Kenehl ("Sonnenuntergang"), or Heinrich Nowak ("Letzter Abend," "Der Krieg," "Das Schreien"); in Ernst Stadler's "Der Aufbruch," or in Alfred Lichtenstein's "Prophezeiung," or "Aschermittwoch"; in Else Lasker-Schüler's "Weltende," and in August Stramm's "Schwermut," to name but a few of the authors and works that prophesize the destruction of the world. There are, indeed, others—see Bibliography, *Expressionist Literature.*

28. Mircea Eliade, *The Myth of the Eternal Return* (New York: Pantheon, 1954), pp. 86–87.

29. Georg Trakl, "Abend," in Angel Flores (ed.), *An Anthology of German Poetry from Hölderlin to Rilke* (Gloucester, Mass.: Peter Smith, 1965), p. 365.

30. See Hamburger, *Contraries*, p. 311.

31. Theodor Däubler, from "Der Stumme Freund," in Kurt Pinthus (ed.), *Menscheitsdämmerung* (Berlin: Rowohlt, 1920), p. 275.

32. Paul Zech, from "Mondlegende," in Martin Reso (ed.), *Expressionismus Lyrik* (Berlin: Aufbau, 1969), p. 273.

33. Gottfried Benn, from "D-Zug," in Wodtke, *Gottfried Benn, Selected Poems*, p. 52. The ninth month might also be interpreted as referring to birth.

34. Yvan Goll, "Mond," in Hamburger and Middleton, *Modern German Poetry*, pp. 186–91.

35. Klaus Lankheit, *Franz Marc. Der Turm der blauen Pferde* (Stuttgart: Reclam, 1961), p. 27. Cf. also Wolfgang Hutt, *Deutsche Malerei und Graphik im 20. Jahrhundert* (Berlin: Henschelverlag, 1969), pp. 118–19. It is perhaps interesting to add in this context, that, according to Mosse,

After the First World War extreme racists—such as the Guesen, a youth group—regarded Expressionism as a religious experience that penetrated to the depths of the soul. Furthermore, in the 1920's the Völkish movement's emphasis on the mysticism of the soul seemed to provide a congenial climate for Expressionism, while the Nazis, both before and after attaining power, flirted with the idea of endorsing Expressionism as a valid means of depicting the "essence" of Germanic subjects—until Hitler summarily declared that the only authentic art was that based on the Völkish tradition.

See George L. Mosse, *The Crisis of German Ideology* (New York: Grosset & Dunlap, 1971), p. 187.

36. We see this in a crayon study entitled *Pferde auf Bergeshöhe gegen die Luft stehend (Horses atop a Mountain Peak Standing against the Sky)* of 1906. Schardt, *Franz Marc*, lists two small horse studies in oil dating from the year 1905, *Kleine Pferdestudie I* and *Kleine Pferdestudie II*. See Schardt, "Werkverzeichnis," p. 161.

37. Marc, *Briefe aus dem Felde*, p. 48.

38. Erwin Panofsky, *The Life and Art of Albrecht Dürer* (Princeton: Princeton University Press, 1955), p. 138.

39. See Revelation 14:14–20.

40. Panofsky, *The Life and Art of Albrecht Dürer*, p. 53.

41. In the original 1912 *Der Blaue Reiter Almanach*, edited by Wassily Kandinsky and Franz Marc, this illustration appeared on page 121. In the 1965 reprint, edited and with an introduction by Klaus Lankheit, the illustration appears on p. 215.

42. Also appearing in *Der Blaue Reiter Almanach* is a series of five Bavarian votive pictures, each dating from the eighteenth century, each depicting the Virgin atop a crescent, presiding over scenes of death and injury. See ibid., pp. 133, 150–53.

43. It is perhaps worth noting the already observable. There are four horses in *The Tower of Blue Horses*, four horses in the Revelation of St. John, and four horses in Dürer's *Four Riders of the Apocalypse*.

While there is no sickle or scythe present in the hands of the Rider of Death, in Dürer's print, there is an unmistakable one in *The Four Horsemen of the Apocalypse*,

Peter Cornelius's study of about 1850, which has been housed for more than a century in the National Gallery in Berlin.

Chapter 5: The Apocalypse Realized

1. The second volume never materialized. Cf. Lankheit, *Der Blaue Reiter* (1965), pp. 80–81.
2. Franz Marc in ibid., p. 325.
3. See Myers, *The German Expressionists*, p. 228; Lankheit, *Franz Marc im Urteil Seiner Zeit*, p. 40; Lankheit, *Der Blaue Reiter* (1965), note 18, p. 304. The project itself was abandoned after the outbreak of the war. Only Kubin was able to complete his series, *The Book of Daniel*.
4. Genesis 1:24.
5. Genesis 1:25.
6. Maria Marc in Lankheit, *Franz Marc*, p. 74.
7. J. E. Cirlot, *A Dictionary of Symbols* (New York: Philosophical Library, 1962), p. 202. Cf. Thedosius Dobzhansky, *Mankind Evolving* (New York: Bantam, 1970), p. 5.
8. The depiction of this animal differs considerably from Marc's earlier treatment of the same subject. Compare with the frightened, fleeing animals of *Frieze of Apes* (1911) or the playful creatures of *Apes* (1913). The monkey in *Story of Creation I* is, however, more readily comparable to the aggressive and dominant characteristics of *Mandrill* (1913).
9. Jung, *Symbols of Transformation*, vol. 2, p. 348.
10. Cirlot, *A Dictionary of Symbols*, p. 242. Cf. also Jung, *Symbols of Transformation*, vol. 1, p. 109.
11. Mircea Eliade, *The Sacred and the Profane* (New York: Harcourt, Brace & World, 1959), pp. 157–58. As we have already seen, the moon is generally symbolic of death, the sun of life. Cf. Cirlot, *A Dictionary of Symbols*, pp. 205, 303.
12. Franz Marc in Lankheit, *Der Blaue Reiter* (1965), p. 323.
13. Franz Marc, "Zwei Bilder," in ibid., pp. 33–34. Cf. Matthew 24:33 and Mark 13:29.
14. Franz Marc, "Geistige Güter," in ibid., p. 24.
15. Franz Marc, letter of April 7, 1915, in Marc, *Briefe aus dem Felde*, p. 57.
16. Francis Klingender, *Animals in Art and Thought to the End of the Middle Ages* (Cambridge, Mass.: M.I.T. Press, 1971), p. 403.
17. Revelation 19:17–21.
18. Ibid., 18:1–2.
19. Klingender, *Animals in Art and Thought*, p. 403.
20. Franz Marc, letter of June 23, 1915, in *Briefe*, p. 75.
21. August Bebel, in Mann, *The History of Germany Since 1789*, p. 290.
22. Franz Marc, "In War's Purifying Fire," in Miesel, *Voices of German Expressionism*, p. 163.
23. Revelation 19:19.
24. Ibid., 8:13.
25. Cirlot, *A Dictionary of Symbols*, pp. 87–88. Cf. Jung, *Symbols of Transformation*, vol. 1, p. 164n; vol. 2, p. 409.
26. Revelation 8:5–9:6.
27. Ibid., 12:1.
28. Alistair Horne, *The Price of Glory, Verdun 1916* (New York: Harper, 1962), p. 16.
29. Schardt, *Franz Marc*, p. 155.
30. According to Schardt, Marc moved into the house at Ried in May of 1914. See ibid.
31. Wassily Kandinsky, in Lankheit, *Franz Marc im Urteil Seiner Zeit*, p. 51.
32. Franz Marc, letter of September 2, 1914, in *Briefe*, p. 6.
33. Franz Marc, letter of September 6, 1914, in ibid., p. 7.

34. Franz Marc, letter of October 23, 1914, in ibid., p. 21.
35. Franz Marc, letter of October 25, 1914, in ibid., p. 22.
36. Franz Marc, letter of November 11, 1914, in ibid., p. 24.
37. Franz Marc, letter of December 24, 1914, in ibid., p. 38.
38. Franz Marc, letter of December 27, 1914, in ibid., p. 40.
39. Franz Marc, letter of February 11, 1915, in ibid., p. 44.
40. Franz Marc, letter of March 14, 1915, in ibid., p. 47.
41. Marc left the *Sketchbook* at home before returning to the front lines in July.
42. Franz Marc, letter of April 12, 1915, in *Briefe*, p. 60.
43. Franz Marc in Lankheit, *Der Blaue Reiter* (1965), pp. 323–24.
44. Franz Marc, letter of October 23, 1914, in *Briefe*, p. 21.
45. Franz Marc, letter of June 23, 1915, in ibid., pp. 74–75.
46. Ibid., p. 75.
47. Ibid.
48. Lankheit, *Franz Marc, Watercolors, Drawings, Writings*, p. 19.

Conclusion

1. Paul Klee, *The Diaries of Paul Klee*, ed. Felix Klee (Berkeley: University of California, 1968), pp. 319–20.
2. Franz Marc, letter of July 29, 1915, in *Briefe*, p. 78.
3. The book that had the most profound impact on Marc's thought was Gerhart Hauptmann's, *Der Narr in Christo: Emmanuel Quint.* See Maria Marc, in Lankheit, *Franz Marc*, p. 75.
4. Franz Marc, letter of October 1, 1915, in *Briefe*, pp. 86–87.
5. Ibid., p. 88.
6. Paul Klee, *The Diaries of Paul Klee*, p. 322.
7. Franz Marc, letter of December 1, 1915, in *Briefe*, p. 106.
8. Ibid., p. 105.
9. Franz Marc, letter of February 2, 1916, in ibid., pp. 125–26.
10. Horne, *The Price of Glory*, p. 1.
11. Franz Marc, letter of February 27, 1916, in *Briefe*, p. 137.
12. Franz Marc, letter of March 2, 1916, in ibid., p. 140.
13. Hans Schilling in Lankheit, *Franz Marc im Urteil Seiner Zeit*, pp. 71–72.
14. Franz Marc, letter of February 17, 1916, in *Briefe*, pp. 133–34.

Bibliography

Works on Franz Marc

Behne, Adolf. "Franz Marc." *Die Tat,* vol. 8, no. 2 (1916–1917), p. 1028.

Benninghoff, Ludwig. "Ehrenmal und Vermächtnis: in memoriam Franz Marc." *Kreis,* vol. 7 (1930), pp. 271–77.

Bünemann, Hermann. *Franz Marc. Zeichnungen, Aquarelle.* Munich: F. Bruckmann Verlag, 1948.

Däubler, Theodor. "Franz Marc." *Die Neue Rundschau,* vol. 27 (1916), pp. 564–67.

————. "Franz Marc und die Tiere." *Kunstwerk,* vol. 1, no. 7 (1946–1947), pp. 40–41.

Eberlein, Kurt Karl. "Franz Marc und die Kunst unserer Zeit." *Genius,* vol. 3 (1920), pp. 173–79.

Erdmann, Lothar. "Franz Marc und die Tiere." *Deutsche Allgemeine Zeitung,* vol. 65, no. 400 (August 29, 1926).

Erhart, Georg. *Franz Marc.* Stuttgart: Reclam Verlag, 1949.

Ernst, Harro. "Zu Frühen Bildern von Franz Marc." *Kunst und das Schöne Heim,* vol. 53, no. 12 (September 1945), pp. 441–43.

Francke, Gunther. "Wiederbegegnung mit Franz Marc." *Kunstwerk,* vol. 1, no. 7 (1946–1947), p. 42.

Hutton-Hutschnecker Gallery. *Kandinsky, Marc, Macke.* Exhibition Catalogue, April 16–May 28, 1968. New York, 1969.

Kandinsky, Wassily, and Marc, Franz (eds.). *Der Blaue Reiter.* Reprint of the original with documentation by Klaus Lankheit. Munich: Piper, 1965.

Keimer-Dünkelsbühler, Elisabeth. "Der Junge Franz Marc." *Vossische Zeitung* (August 2, 1930).

————. "Unbekannte Briefe von Franz Marc." *Vossische Zeitung,* no. 155 (July 6, 1930).

Kelleher, Patrick J. " 'Wolves' by Franz Marc." *Gallery Notes of the Albright-Knox Gallery, Buffalo,* vol. 15, no. 2 (May, 1951), pp. 7–8.

Lankheit, Klaus. *Franz Marc.* Berlin: Verlag Konrad Lemmer, 1950.

————. *Franz Marc. Katalog der Werke.* Cologne: DuMont, 1970.

————. *Franz Marc. Der Turm der blauen Pferde.* Stuttgart: Reclam, 1961.

————. *Franz Marc, Watercolors, Drawings, Writings.* New York: Abrams, 1959.

———— (ed.). *Franz Marc im Urteil Seiner Zeit.* Cologne: DuMont, 1960.

Linde, Franz. "Franz Marc." *Türmer,* vol. 39 (October, 1936), pp. 57–60.

Macke, August, and Marc, Franz. *Brief-wechsel*. Cologne: DuMont, 1964.

Marc, Franz. *Botschaften an den Prinzen Jussuff*. Intro. by Maria Marc with an essay by Georg Schmidt. Munich: Piper, 1954.

————. *Briefe, Aufzeichnungen, und Aphorismen*. 2 vols. Berlin: Cassirer, 1920.

————. *Briefe aus dem Felde*. Munich: List Verlag, 1966.

————. *Skizzenbuch aus dem Felde*. Berlin: Verlag Gebruder Mann, 1956.

————. *Tierstudien*. Edited by Klaus Lankheit. Wiesbaden: Insel-Verlag, 1953.

Schardt, Alois J. *Franz Marc*. Berlin: Rembrandt Verlag, 1936.

Schinagl, Helmut. *Der Blaue Kristall: Des Lebensroman des Malers Franz Marc*. Cologne: Styria Verlag, 1966.

Schmidt, Georg. *Franz Marc*. Berlin: Safari Verlag, 1957.

————. "Die 'Tierschicksale' von Franz Marc." *Du*, vol. 4 (April, 1956).

Seiler, Harald. *Franz Marc*. Munich: F. Bruckmann, 1956.

Tavel, H. C. von. *Franz Marc, das Graphische Werk*. Exhibition Catalogue. Bern, 1967.

Wingler, Hans Maris. "Franz Marc." *Ring*, vol. 10 (1947), pp. 16–19.

Zahn, Leopold. "Franz Marc und der Krieg." *Kunstwerk*, vol. 6, no. 5 (1953), p. 14.

Expressionist Painting

Buchheim, Lothar G. *Der Blaue Reiter*. Feldafing: Buchheim Verlag, 1959.

Dorra, Henri. *Years of Ferment; The Birth of Twentieth Century Art*. Los Angeles: UCLA Arts Council, 1965.

Goldwater, Robert. *Primitivism in Modern Art*. New York: Vintage, rev. ed., 1967.

Gordon, Donald E. "On the Origin of the Word 'Expressionism.'" *Journal of the Warburg and Courtauld Institutes*, vol. 29 (1966), pp. 368–85.

Grote, Ludwig. "Der Blaue Reiter." *Kunst und das Schöne Heim*, vol. 48, no. 1 (1950), pp. 4–7.

Haftmann, Werner. *German Art of the Twentieth Century*. New York: Museum of Modern Art, 1957.

————. *Painting in the Twentieth Century*. 2 vols. New York: Praeger, 1966.

Hoffman, Werner. *Expressionist Watercolors, 1905–1920*. New York: Abrams, 1967.

Hütt, Wolfgang. *Deutsche Malerei und Graphik in 20. Jahrhundert*. Berlin: Henschelverlag, 1969.

Kandinsky, Wassily. *Concerning the Spiritual in Art*. New York: George Wittenborn, 1970.

Kenedy, R. C. "On Expressionism." *Art International*, vol. 13, no. 8 (October 1969), pp. 19–23.

Klee, Paul. *The Diaries of Paul Klee, 1898–1918*. Edited by Felix Klee. Berkeley and Los Angeles: University of California Press, 1968.

Lankheit, Klaus. "Zur Geschichte des Blauen Reiters." *Cicerone* (1949), pp. 110–14.

Miesel, Victor (ed.). *Voices of German Expressionism*. Englewood Cliffs, N.J.: Prentice Hall, 1970.

Myers, Bernard. *The German Expressionists, A Generation in Revolt*. New York: Praeger, 1957.

Nemitz, Fritz. *Deutsche Malerei der Gegenwart*. Munich: Piper, 1948.

Rave, Paul Ortwin. *Kunst Diktatur im Dritten Reich*. Hamburg: Verlag Gebrüder Mann, 1949.

Ringbom, Sixten. "Art in the Epoch of the Great Spiritual; Occult Elements in the Early Theory of Abstract Painting." *Journal of the Warburg and Courtauld Institutes*, vol. 29 (1966), pp. 409–10.

Roh, Franz. *German Painting in the Twentieth Century*. Greenwich, Conn.: New York Graphic Society, 1968.

Scheffauer, Bertram. *The New Vision in German Art*. New York: Huebsch, 1924.

Schmidt, Georg. *Die Malerei in Deutschland, 1900–1918*. Königstein: Nachfolge, 1959.

Selz, Peter. *German Expressionist Painting*. Berkeley and Los Angeles: University of California Press, 1957.

Städtische Galerie im Lenbachlaus, München. *Der Blaue Reiter*. Exhibition Catalogue. Munich, 1966.

Sydow, Eckart von. *Die Deutsche Expres-*

sionistiche Kultur und Malerei. Berlin: Furche-Verlag, 1920.

Thoene, Peter. *Modern German Art.* London: Penguin, 1938.

Thwaites, J. A. "The Blue Rider: A Milestone in Europe." *Art Quarterly,* vol. 13, no. 1 (1950), pp. 13–20.

Willett, John. *Expressionism.* New York: McGraw-Hill, 1970.

Wingler, Hans Maria (ed.). *Wie sie einander sahen; Moderne Maler im Urteil ihrer Gefährten.* Munich: Albert Langen-Georg Muller, 1957.

Worringer, Wilhelm. *Abstraction and Empathy.* Cleveland: Meridian, 1967.

Wulf, Joseph (ed.). *Die Bildenden Künste im Dritten Reich.* Gütersloh: Sigbert Mohn Verlag, 1963.

Expressionist Literature

Benn, Gottfried. *Gottfried Benn, Selected Poems.* Edited by Friedrich Wilhelm Wodtke. London: Oxford University Press, 1970.

Bithell, Jethro. *Modern German Literature.* London: Methuen, 1959.

Casey, T. J. *Manshape that Shone: An Interpretation of Trakl.* Oxford, Eng.: Basil Blackwell, 1964.

Closs, August (ed.). *Twentieth Century German Literature.* London: Cresset Press, 1969.

Däubler, Theodor. *Theodor Däubler; Dichtungen und Schriften.* Edited by Friedhelm Kemp. Munich: Kosel Verlag, 1956.

Fingerhut, Karl-Heinz. *Die Funktion der Tierfiguren im Werke Franz Kafkas.* Bonn: H. Bouvier, 1969.

————. *Das Kreatürliche im Werke Rainer Maria Rilkes.* Bonn: H. Bouvier, 1970.

Flores, Angel (ed.). *An Anthology of German Poetry from Hölderlin to Rilke.* Gloucester, Mass.: Peter Smith, 1965.

Foltin, Lore B. (ed.). *Franz Werfel.* Pittsburgh: University of Pittsburgh Press, 1961.

Gittleman, Sol. *Frank Wedekind.* New York: Twayne, 1969.

Hatfield, Henry. *Modern German Literature.* London: Edward Arnold, 1966.

Hamburger, Michael. *Contraries: Studies in German Literature.* New York: Dutton, 1970.

————, and Middleton, Christopher (eds.). *Modern German Poetry.* New York: Grove Press, 1964.

Heselhaus, Clemens. *Deutsche Lyrik der Moderne von Nietzsche bis Yvan Goll.* Düsseldorf: August Bagel Verlag, 1962.

Hill, Claude, and Ley, Ralph. *The Drama of German Expressionism.* Chapel Hill: University of North Carolina Press, 1960.

Klarmann, A. D. "Expressionism in German Literature: Retrospect of a Half Century." *Modern Language Quarterly* (March, 1965).

Krispyn, Egbert. *Georg Heym, A Reluctant Rebel.* Gainesville: University of Florida Press, 1968.

————. *Style and Society in German Literary Expressionism.* Gainesville: University of Florida Press, 1964.

Lasker-Schüler, Else. *Dichtungen und Dokumente.* Edited by Ernst Ginsbeerg. Munich: Kosel Verlag, 1951.

Muschg, Walter. *Von Trakl zu Brecht.* Munich: Piper, 1963.

Raabe, Paul. *Expressionismus: Aufzeichnungen und Erinnerungen der Zeitgenossen.* Freiburg: Walter Verlag, 1965.

———— (ed.). *Expressionismus Literatur und Kunst.* Exhibition Catalogue, Schiller National Museum, Marbach, May 8–October 31, 1960 (1960).

Reinhardt, Kurt F. "The Expressionistic Movement in Recent German Literature." *Germanic Review,* vol. 6 (1931), pp. 256–65.

Reso, Martin (ed). *Expressionismus Lyrik.* Berlin: Aufbau Verlag, 1969.

Pinthus, Kurt (ed.). *Menscheitsdämmerung.* Berlin: Rowohlt Verlag, 1920.

Rilke, Rainer Maria. *Rilke; Selected Poems.* Edited and translated by C. F. MacIntyre. Berkeley and Los Angeles: University of California, 1968.

Rose, William (ed.). *Modern German Lyric Verse.* Oxford, Eng.: Clarendon Press, 1960.

Rothe, Wolfgang (ed.). *Expressionismus als Literatur.* Bern: Francke Verlag, 1969.

Samuel, Richard, and Thomas, R. Hinton. *Expressionism in German*

Life, Literature and the Theatre. Cambridge, Eng.: W. Heffner, 1939.

Schneider, Hansjörg. *Jakob van Hoddis.* Bern: Francke Verlag, 1967.

Schneider, Karl Ludwig. "Expressionism in Art and Literature." *American Germanic Review,* vol. 32, no. 3 (1966), pp. 18–23.

Seyppel, Joachim H. "The Animal Theme and Totemism in Franz Kafka." *American Imago,* vol. 13 (1956), pp. 69–93.

Sokel, Walter. "The Other Face of Expressionism." *Monatschefte für Deutschen Unterricht,* vol. 27 (1955), pp. 1–10.

————. *The Writer in Extremis; Expressionism in Twentieth-Century German Literature.* New York: McGraw-Hill, 1964.

———— (ed.). *An Anthology of German Expressionist Drama.* New York: Doubleday, 1963.

Steffen, Hans (ed.). *Der Deutsche Expressionismus: Formen und Gestalten.* Göttingen: Vanderhoeck & Ruprecht, 1970.

Trakl, Georg. *Selected Poems, Georg Trakl.* Edited by Christopher Middleton. London: Jonathan Cape, 1968.

Viviani, Annalisa. *Das Drama des Expressionismus.* Munich: Winkler, 1970.

Wallmann, Jurgen P. *Else Lasker-Schüler.* Muhlacker: Stieglite Verlag, 1966.

Literature and Philosophy

Appleman, Philip (ed.). *Darwin.* New York: W. W. Norton, 1970.

Bergson, Henri. *Creative Evolution.* Translated by Arthur Mitchell. London: Macmillan, 1960.

Camus, Albert. *The Rebel.* Translated by Anthony Bower. New York: Vintage, 1956.

Copleston, Frederick. *Arthur Schopenhauer.* London: Burns, Oates, and Washbourne, 1946.

————. *A History of Philosophy.* Part 2. New York: Doubleday, 1965.

Danto, Arthur C. *Nietzsche as Philosopher.* New York: Macmillan, 1968.

Dostoevsky, Fyodor. *The Brothers Karamazov.* Translated by Constance Garnett. New York: Signet, 1960.

Flaubert, Gustave. "The Legend of St. Julian Hospitator," in *Three Tales.* Translated by Robert Baldick. Baltimore: Penguin, 1961.

Heller, Erich. *The Artist's Journey into the Interior and Other Essays.* New York: Random House, 1965.

Hubben, William. *Dostoevsky, Kierkegaard, Nietzsche, Kafka.* New York: Collier, 1962.

Kaufmann, Walter (ed.). *The Portable Nietzsche.* New York: Viking, 1966.

Kermode, Frank. *The Sense of an Ending.* New York: Oxford University Press, 1968.

Kohn-Branstedt, Ernst. *Aristocracy and the Middle Classes in Germany, Social Types in German Literature, 1830–1900.* London: P. S. King, 1937.

Lawrence, D. H. *Apocalypse.* New York: Viking, 1932.

Lester, John A. *Journey Through Despair, 1800–1914: Transformations in British Literary Culture.* Princeton: Princeton University Press, 1968.

Lukács, Georg. *Essays on Thomas Mann.* Translated by Stanley Mitchell. New York: Grosset & Dunlap, 1965.

Mann, Thomas. *Buddenbrooks.* Translated by H. T. Lowe-Porter. New York: Vintage, 1961.

————. *Doctor Faustus.* Translated by H. T. Lowe-Porter. New York: Modern Library, 1948.

————. *Freud, Geothe, Wagner.* Translated by H. T. Lowe-Porter and Rita Matthias-Reil. New York: Knopf, 1939.

Marks, Elaine. *French Poetry from Baudelaire to the Present.* New York: Dell, 1962.

Musil, Robert. *The Man Without Qualities.* Translated by Eithne Wilkins and Ernst Kaiser. New York: Capricorn, 1965.

Nietzsche, Friedrich. *The Birth of Tragedy and the Genealogy of Morals.* Translated by Francis Golffing. New York: Doubleday, 1956.

————. *Thoughts Out of Season.* Parts I and II. Translated by Anthony M. Ludovici. Vol. 4 in *The Complete Works of Friedrich Nietzsche.* Edited by Oscar Levy. New York: Russell & Russell, 1964.

Rose, William. *Men, Myths, and Move-*

ments in German Literature. New York: Kennikat Press, 1962.

Rousseau, Jean-Jacques. The First and Second Discourses. Edited by Roger D. Masters. Translated by Roger D. Masters and Judith R. Masters. New York: St. Martin's Press, 1964.

Van Abbé, Derek Maurice. Image of a People. The Germans and Their Creative Writing Under and Since Bismarck. New York: Barnes and Noble, 1964.

Wagner, Richard. My Life. Authorized translation from the German. New York: Dodd, Mead, 1924.

———. The Ring of the Nibelung. Translated by Margaret Armour. Garden City: Doubleday, 1939.

Walzel, Oskar. German Romanticism. New York: Capricorn, 1966.

History and Art History

Bithell, Jethro. Germany. London: Methuen, 1947.

Butler, Rohan d'O. The Roots of National Socialism, 1783–1933. London: Faber & Faber, 1941.

Chadraba, Rudolf. Duerer's Apokalypse; Eine Ikonologische Deutung. Prague: Tschechoslowakian Akademie der Wissenschaften, 1964.

Gordon, Donald E. Metaphor, Metamorphosis and Meaning in Early Modern Art. A lecture given to the Art History Student Union, Columbia University, New York, December 8, 1972.

Hayes, Carlton J. H. A Generation of Materialism; 1871–1900. New York: Harper, 1963.

Horne, Alistair. The Price of Glory, Verdun 1916. New York: Harper & Row, 1962.

Klingender, Francis. Animals in Art and Thought to the End of the Middle Ages. Cambridge, Mass.: M.I.T. Press, 1971.

Kohn, Hans. The Mind of Germany. New York: Harper, 1965.

Laqueur, Walter. Young Germany. New York: Basic Books, 1962.

Mann, Golo. The History of Germany Since 1789. New York: Praeger, 1969.

Mönch, Walter. Deutsche Kultur von der Aufklarung bis zu Gegenwart. Berlin: Max Hueber Verlag, 1962.

Mohler, Armin. Die Konservative Revolution in Deutschland, 1918–1932. Stuttgart, 1950.

Mosse, George L. The Crisis of German Ideology. New York: Grosset & Dunlap, 1971.

Panofsky, Erwin. The Life and Art of Albrecht Dürer. Princeton: Princeton University Press, 1955.

———. Meaning in the Visual Arts. New York: Doubleday, 1965.

Samuel, R. H., and Thomas, R. Hinton. Education and Society in Modern Germany. London: Routledge and Kegan Paul, 1949.

Stern, Fritz. The Politics of Cultural Despair. New York: Anchor, 1965.

Tuchman, Barbara. The Proud Tower. New York: Macmillan, 1966.

Psychology

Allen, Robert M. Elements of Rorschach Interpretation. New York: International Universities Press, 1954.

Beck, Samuel, and Molish, Herman. Rorschach's Test. Vol. 2. A Variety of Personality Pictures. New York: Grune and Stratton, 1967.

Bergler, Edmund. The Writer and Psychoanalysis. New York: Doubleday, 1950.

Buss, Arnold H. Psychopathology. New York: Wiley, 1966.

Bychowski, Gustav. "Autismus und Regression in modernen Kunstbestrebungen." Allgemeine Zeitschrift für Psychiatrie, Vol. 78 (1922), pp. 116–21.

Ehrenzweig, Anton. "Unconscious Formation in Art." British Journal of Medical Psychology, Vols. 21 and 22 (1948–1949).

Freud, Sigmund. Character and Culture. Edited by Philip Rieff. New York: Collier, 1963.

———. Civilization and Its Discontents. Translated by James Strachey. New York: W. W. Norton, 1961.

———. On Creativity and the Unconscious. Translated under the supervision of Joan Riviere. New York: Harper, 1958.

———. A General Introduction to Psychoanalysis. Translated by Joan Riviere. New York: Clarion, 1969.

———. *The Interpretation of Dreams.* Edited and translated by James Strachey. New York: Avon, 1965.

———. "Mourning and Melancholia." *In Collected Papers.* Translated under the supervision of Joan Riviere, Vol. 4. New York: Basic Books, 1959.

———. *The Problem of Anxiety.* Translated by Henry Alden Bunker. New York: W. W. Norton, 1963.

———. *Three Case Histories.* Edited by Philip Rieff. New York: Collier, 1970.

Fromm, Erich. *The Art of Loving.* New York: Bantam, 1963.

———. *Escape from Freedom.* New York: Avon, 1965.

———. *The Forgotten Language.* New York: Grove Press, 1957.

———. *The Heart of Man.* New York: Harper & Row, 1964.

Goldfarb, William. "The Animal Symbol in the Rorschach Text and an Animal Association Test," *Rorschach Research Exchange,* Vol. 9 (1945), pp. 8–22.

Gurvitz, Milton S. "World Destruction Fantasies in Early Schizophrenia," *Journal of the Hillside Hospital,* Vol. 1 (1952), pp. 7–20.

Jung, Carl G. *The Archetypes and the Collective Unconscious.* Translated by R. F. C. Hull. New York: Pantheon, 1959.

———, and Kerenyi, C. *Essays on a Science of Mythology.* Translated by R. F. C. Hull. New York: Pantheon, 1949.

——— (ed.). *Man and His Symbols.* New York: Dell, 1968.

———. *Modern Man in Search of a Soul.* Translated by W. S. Dell and Cary F. Barnes. New York: Harcourt, Brace, 1933.

———. *Mysterium Coniunctionus.* Translated by R. F. C. Hull. New York: Pantheon, 1963.

———. *The Spirit in Man, Art and Literature.* Translated by R. F. C. Hull. New York: Pantheon, 1966.

———. *Symbols of Transformation.* Translated by R. F. C. Hull. 2 vols. New York: Harper, 1962.

Kris, Ernst. "Art and Regression," *Transactions of the New York Academy of Sciences.* Series II, Vol. 4, No. 7 (1944), pp. 236–50.

———. *Psychoanalytic Explorations in Art.* New York: Schocken, 1967.

Lafora, Gonzalo R. "A Psychological Study of Cubism and Expressionism." In *Don Juan and Other Psychological Studies.* London: Butterworth, 1930.

Laing, R. D. *The Divided Self.* Baltimore: Penguin, 1970.

———. *Self and Others.* New York: Pantheon, 1969.

Linton, Ralph. *The Cultural Background of Personality.* New York: Appleton-Century-Crofts, 1945.

May, Rollo. *Love and Will.* New York: W. W. Norton, 1969.

Meerloo, Joost A. M. *Suicide and Mass Suicide.* New York: Grune & Stratton, 1962.

Menninger, Karl. *Man Against Himself.* New York: Harcourt, Brace, 1939.

Panofsky, Erwin. *Totem and Taboo.* Translated by James Strachey. New York: W. W. Norton, 1952.

Pfister, Oskar. *Expressionism in Art: Its Psychological and Biological Basis.* London: Routledge & Kegan Paul, 1922.

Phillips, Leslie, and Smith, Joseph. *Rorschach Interpretation: Advanced Technique.* New York: Grune & Stratton, 1953.

Phillips, William (ed.). *Art and Psychoanalysis.* Cleveland and New York: Meridian, 1957.

Ranulf, Svend. *Moral Indignation and Middle Class Psychology: A Sociological Study.* Copenhagen, 1938.

Rickman, John (ed.). *A General Selection from the Works of Sigmund Freud.* New York: Doubleday, 1957.

Roe, Anne. "Artists and Their Work." *Journal of Personality,* Vol. 15 (1946), pp. 1–40.

Schaffner, Bertram. *Father Land: A Study of Authoritarianism in the German Family.* New York: Columbia University Press, 1949.

Schneider, Daniel E. *The Psychoanalyst and the Artist.* New York: Mentor, 1962.

Silberer, Herbert. *Problems of Mysticism and Its Symbolism.* New York: Moffat, Yard, 1917.

Smith, Andre, *Art and the Subconscious.* Maitland, Fla.: The Research Studio, 1937.

Mythology

Anderson, R. B. *Norse Mythology.* Chicago: S. C. Griggs, 1876.

Bertram, Johannes. *Mythos, Symbol, Idee.* In *Richard Wagners Musikdramen.* Hamburg: Hamburger Kulturverlag, 1957.

Cirlot, J. E. *A Dictionary of Symbols.* London: Routledge and Kegan Paul, 1962.

Eliade, Mircea. *Images and Symbols.* London: Harvill Press, 1961.

————. *The Myth of the Eternal Return.* New York: Pantheon, 1965.

————. *Patterns in Comparative Religion.* New York: Sheed and Ward, 1958.

Grimm, Jacob. *Teutonic Mythology.* 3 vols. Translated by James Steven Stallybrass. London: George Bell, 1883.

Howey, M. Oldfield. *The Horse in Magic and Myth.* London: William Rider, 1923.

Larousse Encyclopedia of Mythology. New York: Prometheus Press, 1959.

Lurker, Manfred. *Symbol, Mythos, und Legende in der Kunst.* Baden-Baden: Verlag Heitz, 1958.

Mackenzie, Donald. *Teutonic Myth and Legend.* London: Gresham, n.d.

May, Rollo (ed.). *Symbolism in Religion and Literature.* New York: George Braziller, 1960.

Rosteutscher, J. H. W. *Die Wiederkunft des Dionysos, Der Naturmystische Irrationalismus in Deutschland.* Bern: Francke, 1947.

Saussaye, P. Chantepie de la. *The Religion of the Teutons.* Boston: Athenaeum, 1902.

List of Illustrations

1. *Portrait of the Artist's Father*, 1902. Oil, 73 x 50.8 cm. Stadtische Galerie, Munich.
2. *Portrait of the Artist's Mother*, 1902. Oil, 98.5 x 70 cm. Stadtische Galerie, Munich.
3. *Woodland Path in the Snow*, 1902–03. Oil, 39.3 x 25.5 cm. Dr. Paul Marc, Ehemals, Hamburg.
4. *Cafe Chantant II*, 1903. India ink, 11 x 18 cm. Estate of the artist, Munich.
5. *Self Portrait*, 1904. Tempera, dimensions unknown. Destroyed.
6. *Small Mountain Study*, 1905. Oil, 16 x 25 cm. Nachals, Munich.
7. *The Dead Sparrow*, 1905. Oil, 13 x 16.5 cm. Private collection, Munich.
8. *Niestle with Birds (Portrait of the Painter Jean Bloe Niestle)*, 1906. Charcoal, 80 x 58.5 cm. Miss Deborah W. Dennis, Westport, Connecticut.
9. *Father on Sickbed II*, 1907. Oil, 36.7 x 46 cm. Dr. Paul Marc, Ehemals, Hamburg.
10. *Rider at the Sea*, 1907. Oil, 15.5 x 25 cm. Estate of the artist, Munich.
11. *Large Deer Drawing I*, 1908. Chalk and tempera, 79 x 58.8 cm. Hans Fries, Munich.
12. *Large Landscape I*, 1909. Oil, 170 x 215 cm. Collection George Schafer, Schweinfurt.
13. *Nude with Cat*, 1910. Oil, 86.5 x 80 cm. Stadtische Galerie, Munich.
14. *Nude Lying Among Flowers*, 1910. Oil, 72 x 100.5 cm. Collection George Schafer, Schwienfurt.
15. *Horse in the Landscape*, 1910. Oil, 85 x 112 cm. Folkwang Museum, Essen.
16. *The Red Horses*, 1911. Oil, 121 x 183 cm. Mr. and Mrs. Paul E. Geier, Rome.
17. *Blue Horse I*, 1911. Oil, 112.5 x 84.5 cm. Stadtische Galerie, Munich. Bernhard Koehler Bequest.
18. *The Yellow Cow*, 1911. Oil, 140 x 190 cm. Solomon R. Guggenheim Museum, New York.
19. *Tiger*, 1912. Oil, 110 x 101.5 cm. Stadtische Galerie, Munich. Bernhard Koehler Bequest.
20. *Two Cats, Blue and Yellow*, 1912. Oil, 74 x 98 cm. Kunstmuseum, Basel.
21. *In the Rain*, 1912. Oil, 81.5 x 106 cm. Stadtische Galerie, Munich. Bernhard Koehler Bequest.
22. *Deer in a Monastery Garden*, 1912. Oil, 76 x 110 cm. Stadtische Galerie,

Munich. Bernhard Koehler Bequest.

23. *Deer in the Woods I*, 1911. Oil, 129.5 x 100.5 cm. Estate of the artist, Munich.

24. *Deer in the Woods II*, 1912. Oil, 110.5 x 80.5. Stadtische Galerie, Munich. Bernhard Koehler Bequest.

25. *Fate of the Animals*, 1913. Oil, 196 x 266 cm. Kunstmuseum, Basel.

26. *Springing Horse*, 1912. Oil, 87.5 x 112 cm. Collection Otto Stangl, Munich.

27. *Horses Fleeing in Great Agitation*, 1915. Pen and ink, 9 x 14 cm. Nationalgalerie (Museumsinsel), Berlin.

28. *St. Julian Hospitator*, 1913. Tempera, 63 x 55 cm. Solomon R. Guggenheim Museum, New York.

29. Preliminary Study for *Fate of the Animals*, 1913. Mixed media, 16.4 x 26 cm. Bayerische Staatsgemaldesammlungen, Munich.

30. *Dying Deer*, 1907. Lithograph, 19 x 20.8 cm. Stadtische Galerie, Munich.

31. *Wolves (Balkan War)*, 1913. Oil, 70 x 140 cm. Formerly private collection, Berlin.

32. Ernst Ewald, *The Three Norns*, c. 1864. Wall mural. Destroyed. Formerly Neue Museum, Berlin.

33. *The Tower of Blue Horses*, 1913. Oil, 200 x 130 cm. Present whereabouts unknown. Formerly National Gallery, Berlin.

34. *Two Horses in a Mountain Landscape*, 1910–11. Pencil, 21 x 16.8 cm. Staatliche Graphische Sammlung, Munich.

35. *Two Horses*, 1912. Tempera, 44.5 x 36 cm. Rhode Island School of Design, Providence.

36. *The Tower of Blue Horses*, 1912. Postcard, mixed media, 14.3 x 9.4 cm. Bayerische Staatsgemaldesammlungen, Munich.

37. *Mythical Green Animal*, 1913. Tempera, 16.1 x 25.7 cm. Private collection, Munich.

38. *The Three Panthers of King Joseph*, 1913. Postcard, mixed media, 13.8 x 9 cm. Bayerische Staatsgemaldesammlungen, Munich.

39. *Elephant*, 1913. Tempera, 13.9 x 9.1 cm. Bayerische Staatsgemaldesammlungen, Munich. Bequest of Sofie and Emanuel Fohr.

40. *Plunging Mountain*, 1913. Pencil, 20 x 12.5 cm. Private collection, Munich.

41. Albrecht Durer, title page from *The Apocalypse*, 1498. Woodcut.

42. *Tirol*, 1913 (completed 1914). Oil, 135.7 x 144.5 cm. Bayerische Staatsgemaldesammlungen, Munich.

43. Albrecht Durer, *Two Animals Enticing Humanity* from *The Apocalypse*, 1498. Woodcut.

44. Anton Koberger, *The Babylonian Whore* from the *Nurnberger Bible*, 1483. Woodcut.

45. *Story of Creation I*, 1914. Woodcut, 23.8 x 20 cm.

46. *Story of Creation II*, 1914. Woodcut, 23.7 x 20 cm.

47. *Abstract Forms*, 1914. Pencil, 22 x 16.5 cm. Estate of the artist, Munich.

48. *Abstract Drawing*, 1914. Pencil, 16.9 x 22 cm. Staaliche Kunsthalle, Karlsruhe.

49. *Abstract Composition*, 1913–14. Tempera, 15 x 12.5 cm. Estate of the artist, Munich.

50. *Abstract Watercolor I*, 1913–14. Mixed media, 16.7 x 22 cm. Estate of the artist, Munich.

51. *Birds I*, 1913. Tempera, 16.8 x 10 cm. Dorothee Freifrau von Schrenck-notzing, Stuttgart.

52. *Birds II*, 1913–14. Tempera, 16.3 x 25 cm. Maria Marc, formerly Reid.

53. *Birds Over the City*, 1913. Watercolor, 37 x 44 cm. Werner v. Schnitzler, Munstereifel.

54. *Birds Feeding on Corpses* from *The Apocalypse*, c. 1230. Trinity College, Cambridge.

55. *Birds Descending on the Fallen Baylon*, early 14th century. British Museum.

56. *Fighting Forms*, 1914. Oil, 91 x 131.5 cm. Bayerische Staatsgemaldesammlungen, Munich.

57. *Arsenal for a Creation*, page 12 from *Sketchbook from the Field*, 1915. Pencil, 9.8 x 16 cm. Staatliche Graphische Sammlung, Munich.

58. *The Greedy Mouth*, page 10 from *Sketchbook from the Field*, 1915. Pencil, 9.8 x 16 cm. Staatliche Graphische Sammlung, Munich.

59. *Untitled*, page 20 from *Sketchbook*

from the Field, 1915. Pencil, 16 x 9.8 cm. Staatliche Graphische Sammlung, Munich.

60. *Magical Moment,* page 21 from *Sketchbook from the Field*, 1915. Pencil, 16 x 9.8 cm. Staatliche Graphische Sammlung, Munich.

61. *Untitled,* page 34 from *Sketchbook from the Field*, 1915. Pencil, 9.8 x 16 cm. Staatliche Graphische Sammlung, Munich.

Index

Page references in italic refer to illustrations.

"Abend" ("Evening") (Trakl), 116–117
"Abendland" ("The West") (Trakl), 113–114
Abstract Composition, 147–148, 148, 150, 155
Abstract Drawing, 144, 145–147, 146, 150, 152, 155
Abstract Forms, 144–145, 145, 147, 150, 152, 155
Abstract Watercolor I, 147, 148, 149, 150
Allard, Roger, 65
Amimals, first studies of, 33–34
Animal symbolism, 104, 106–108
The Antichrist (Nietzsche), 107–108
Apocalypse, as Expressionist theme, 3, 6–7, 100–103
Apocalypse (Dürer), 130, 132, 133, 134, 135–136
Apocalypse (Meidner), 100
Apocalyptic Landscape (Meidner), 100
"Apocalyptic Woman," 130, 133
Arsenal for a Creation from Sketchbook from the Field, 162, 163
Artists Association, Wiesbaden, 78
Authoritarianism, revolt against, 12
Avant-garde
 drama, 17–18
 literary, 17

Babylonian Whore, 136, 137
Baldung-Grien, Hans, 65
Banner Carriers (Hofer), 100
Basel Kunstmuseum, 79
Bathing Women, 51
Battle of the Amazons (Nauen), 100
Baudelaire, Charles, 108
Bayreuth festivals, 16
Bebel, August, 156
Becher, Johannes, 110

Benn, Gottfried, 110–111, 117
Beyond Good and Evil (Nietzsche), 19
Beyond the Pleasure Principle (Freud), 5
Bird symbolism, 150, 152–155
Birds I, 150, 151
Birds II, 152, 152
Birds Descending on the Fallen Babylon (early 14th century), 155, 156
Birds Feeding on Corpses. Apocalypse (c. 1230), 154–155, 155
Birds over the City, 152, 153
Birth of the Horses, 137, 139
The Birth of Tragedy from the Spirit of Music (Nietzsche), 19, 93
Birth of the Wolves, 137, 139
Bismarck, Prince Otto von, 15
Der Blaue Reiter, 63–64
Der Blaue Reiter Almanach, 64, 136, 138, 147
Bloch, Albert, 63
Blue Deer in the Landscape, 85
Blue Horse I, 58, 59, 60, 67
Blue Horses, 126
Bocklin, Arnold, 17
Brackl Gallery, Munich, 48
Brücke artists, Berlin, link with Munich artists, 64
Das Buch der Bilder (The Book of Pictures) (Rilke), 18
Büchse der Pandora (Pandora's Box) (Wedekind), 109
Burliuk, David, 63, 65
Burliuk, Vladimir, 63
Burning Bush, 50
Burning City (Meidner), 100
Busse, Erwin von, 65

Café Chantant II, 28, 29
Campendonck, Heinrich, 63
Carlyle, Thomas, 21
Caselmann, August, 95
 correspondence with Marc, 20–21
Cat Behind a Tree, 60
Chants de Maldoror (Baudelaire), 108
Chekhov, Anton, 17
Cheney, Sheldon, 1
Children in a Boat, 28–29
Color, principles and effects of, 57

Dancing Breton Fishermen, 28
Däubler, Theodor, 117
The Dead Sparrow, 36–37, 36
Decadence-values, 108
Deer at Twilight, 88
Deer in a Monastery Garden, 69, 70–71, 71, 88
Deer in the Reeds, 44
Deer in the Woods (1908 lithograph), 86
Deer in the Woods I, 60, 64, 71, 72
Deer in the Woods II, 71, 73, 74, 85–86
Degeneration (Nordau), 10
Dehmel, Richard, 18
Delaunay, Robert, 63, 65
 influence on Marc, 69
Depression, evidence of, 40–42
The Descent of Man (Darwin), 106
Didacticism, Expressionism as, 2–3
Diez, Wilhelm von, 15
Discourse on the Origins and Foundations of
 Inequality Among Men (Rousseau), 104
Drama, avant-garde, 17–18
Dürer, Albrecht, 130, 133
Dying Deer (drawing), 86
Dying Deer (lithograph), 86–87, 89
"D-Zug" ("D-Train") (Benn), 117

Ecce Homo (Cornith), 78
Eckardt, Annette von, 33, 35
Eddas, 94, 96, 97–99
Elephant, 127, 129, 130
Eliade, Mircea, 52
Erdgeist (Spirit of the Earth) (Wedekind), 109
Expressionists, 1–3
 alienation, 13
 and animal symbolism, 104
 and apocalypse, 3, 6–7, 100–103
 and moon symbolism, 116–119
 perception of society, 12–13
 primitivism in works of, 108–115
 and regression, 3–6
 and Wedekind, 18

Fate of the Animals, 76, 77, 78–81, 80, 83,
 84–85, 90, 92–93, 96–97, 99–100, 102, 121,
 133, 136, 137
 preliminary study, 86, 87–88, 87
Father on the Sick Bed I, 39
Father on the Sick Bed II, 39, 40
Fear of the Hare, 74
Fechter, Paul, 1, 2
The Fiddler of Death, 36
Field Sketchbooks, 103

Fighting Forms, 157, 158, 159
The First Animals, 76, 137
First Balkan War, 74
Flaubert, Gustave, 90
Les Fleurs du Mal (Baudelaire), 108
Foals in the Pasture, 44
Forest Interior with Deer, 44
Foxes, 136
Fragment, from Sketchbook in the Field, 164, 166
Freud, Sigmund, on regression, 5
' From the Days of Creation, from Sketchbook
 from the Field, 162
Fromm, Erich, on regression, 4
Frontispiece, from Apocalypse (Dürer), 130, 132,
 133
Futurists, influence on Marc, 69

Galerie Durand-Ruel, 28
Galerie Fischer, Lucerne, 78
"Geistige Güter," 147
The Genealogy of Morals (Nietzsche), 19
George, Stefan, 18–19
German Expressionism. See Expressionists
Germany, cultural crisis, late 1800s, 7–12
"Gesänge I" ("Cantos I") (Benn), 110
Goll, Yvan, 117, 118
Gorky, Maxim, 18
Götterdämmerung (Twilight of the Gods)
 (Wagner), 94, 95, 97
The Greedy Mouth, from Sketchbook from the
 Field, 162, 164
Grimm, Jakob, 94
Grüninger Bible, 136

Hackl, Gabriel, 22
Hans Goltz Gallery, Munich, 64
Hartmann, Thomas von, 65
Hauptmann, Gerhart, 18
Herbstsalon, First German, 77, 133
Hesse, Hermann, 101–102
Heym, Georg, 101, 111, 117
High Mountain Landscape with Shepherd, 26
Hoddis, Jakob van, 109–110
Hoffmann, E. T. A., 21
Horne, Alistair, 160
Horse and Hedgehog, 85
Horse in the Landscape, 52–53, 53
Horses, Marc's fascination with, 55
Horses and Panther, 81, 83
Horses Fleeing, 81, 82, 83

Ibsen, Henrik, 17
Identity crisis, German, late 1800s, 9–10
Improvisation #30 (Kandinsky), 100
Industrialization, Germany, late 1800s, 9
In the Rain, 69–70, 70
Intimes Theater, 17

Das Jahr der Seele (George), 19
Joël, Karl, 43
Jugend, 17
Jugendstil, 17
Jung, Carl, 99
 on regression, 5
Justi, Ludwig, 119

Kandinsky, Wassily, 17, 56, 61
 on Marc's property in Upper Bavaria, 160
 split from NKVM, 62–63
"Kaspar Hauser Lied" ("The Song of Caspar
 Hauser") (Trakl), 113
Kaulbach, Wilhelm von, 15
"Klange" ("Sounds") (Kandinsky), 100
Klee, Paul, 17, 77, 78
 on Marc's leaves, 170, 171
Kleines Theater, 17
Klingender, Francis, 153
Koberger Bible, 136, 137
Koehler, Bernhard, 48, 77
"Der Krieg" ("War") (Heym), 111–112, 117
Kühl, Gotthard, 16
Kulbin, N., 65

Lagarde, Paul de, 10
Langbehn, Julius, 11
Lankheit, Klaus, 95, 168
Large Blue Horses, 55
Large Deer Drawing I, 44, 45, 88
Large Landscape I, 44, 46, 46
Large Lenggries Horse Picture, 44
Lasker-Schüler, Else, 110, 113, 123, 126
Lawrence, D. H., 55, 108
La Légende de St. Julien l'hospitalier (The Legend
 of St. Julian) (Flaubert), 90–92
The Legend of St. Julian Hospitator, 92
Lenbach, Franz von (Malerfürst), 15–16
Lester, John, 108
Liber Fraternitatis Rosaceae Coronae, 133
Life Boat (Pechstein), 100
Lion Hunt, 136
Luitpold Gymnasium, 20
Lying Steer, 85

Macke, August, 57, 58, 65
 first meeting with, 46, 48
 killed in action, 161
Magical Moment, from Sketchbook in the Field,
 166, 167
The Man Without Qualities (Musil), 7
Marc, Franz
 articles in Der Blaue Reiter, 65–66
 artistic development, 29–34
 dies at Verdun, 172–173
 early years, 20–21
 France trip, 26, 28
 and German Expressionism, 13–14
 joins NKVM, 56
 military service, 160–169
 moon symbolism, 119–130
 and post-apocalyptic world, 139–144
 reaction to Macke's death, 161
 split from NKVM, 62–63
 stylistic development, 22–29
Marc, Maria Franck (wife), 22, 46, 76
Marc, Marie Schnür (wife), 34, 35, 37, 39, 40, 46,
 47
Marc, Paul (brother), 20, 37
Marc, Sophie Maurice (mother), 20
Marc, Wilhelm (father), 19–20
 illness and death, 30–31, 39, 40

Marées, Hans von, 17
Mary Crowned Queen of the Heavens
 (Wolgemut), 133
Mary with Apocalyptic Attributes (Dürer), 133
Matisse, Henri, 48
Meerloo, Joost, on regression, 5–6
Miesel, Victor, on Germany in 1890s, 8
Mist among Fir Trees, 34
"Mond" ("Moon") (Goll), 117–118
"Mondlegende" ("Moonlegend") (Heym), 117
Moon symbolism, 116–119
 and Dürer's Apocalypse, 130, 133
 in Marc's paintings, 119–130
Morgue (Benn), 110–111
Moritzburg Museum, Halle, 78
Mother Horse and Foal, 44
Munich Academy, 15, 16
Munich Secession, 16–17
Münter, Gabriele, 62, 63
Musil, Robert, 7–8
Mythical Green Animal, 126, 127

National Gallery, Berlin, 119
Nature symbolism, 105–106
Neue Künstlervereinigung München (NKVM),
 46, 47, 56
 Marc and Kandinsky split from, 62–63
Neue Museum, Berlin, 96, 97
Niestlé, Jean Bloé, 34–35, 37, 46
Niestlé with Birds (Portrait of the Painter Jean
 Bloé Niestlé), 37, 38
Nietzsche, Friederich, 11, 93
 animal symbolism, 107–108
 and German thought, 19
Nude Lying among Flowers, 51–52, 51, 60
Nude with Cat, 49–50, 49

On the Hunting Grounds of King Joseph, 127
The Origin of Species (Darwin), 106

Piloty, Karl von, 15
Piper, Reinhard, 44
Plant Life in Genesis, from Sketchbook from the
 Field, 162
Plunging Mountain, 130, 131, 166
Poets, Munich, 18–19
The Poor Land Tirol, 76, 136
Portrait of the Artist's Father, 22, 23, 25
Portrait of the Artist's Mother, 22, 24, 25
Primitivism, 108–115

Quentell Bible, 136

Ramberg, Arthur von, 15
Red Bull, 130
Red Deer, 88
The Red Horses, 52, 54–55, 54, 58
Regression, 3–6
Reinhardt, Max, 17
Rembrandt als Erzieher (Langbehn), 11
Das Rheingold (Wagner), 94
Rider at the Sea, 42–43, 43
Riding School, 136
Rilke, Rainer Maria, 18

The Ring of the Nibelung (Wagner), 94–95
Rousseau, Henri, 63
Rousseau, Jean-Jacques, 104–105
Royal Bavarian Reserve Field Artillery
 Regiment, 160

Sabanejew, Leonard, 65
St. Julian Hospitator, 83–84, *84*, 136
Salome (Strauss), 18
Sauerlandt, Max, 78
Schardt, Alois, 28, 30, 33, 50
Schilling, Hans, on Marc's death, 172
Schlier, Otto, 20
Schmidt, Georg, 78
"Scholle," 35
Schönberg, Arnold, 63, 65
Schönhausen Palace, 78
Schopenhauer, Arthur, 105–106
Scythe symbol, 133, 134
Second Balkan War, 74
Seele und Welt (Joël), 43
Self-Portrait, 31, *32*, 33
Selz, Peter, 1, 2, 55
Sickle symbolism. *See* Moon symbolism
Siegfried (Wagner), 94
Simplicissimus, 17
Sinking of the Titanic (Beckmann), 100
Sitting Wolf, 130
Sketchbook from the Field, 162–169, *163, 164,
 165, 167, 169*
Sleeping Animals, 85
Sleeping Deer, 85
Small Blue Horses, 55
Small Mountain Study, 34, *35*, 42
Small Yellow Horses, 55
Snow-Covered Branches, 36
Springing Horses (1910), 50, 81
Springing Horse (1912), 81, *82*
Springing Wolves, 136
Stags, 85
Stags in the Woods, 60
The Steer, 60
Story of Creation I, 137, 139–140, *140*, 142–143
Story of Creation II, 137, 139, 141–142, *141*
Strife, from *Sketchbook from the Field*, 164, *165*
Strindberg, August, 17
Stubbs, George, 83
Stuck, Franz von, 16
Study of a Deer, 86
"Der Stumme Freund" ("The Mute Friend")
 (Däubler), 117
Sturm Gallery, Berlin, 66, 78
Suicide, and apocalypse, 6
Sun symbolism, 143
Swine, 83

Tempest (Kokoschka), 78, 100
Der Teppich des Lebens (*The Tapestry of Life*)
 (George), 19
Thannhauser Gallery, Munich, 47, 56, 63
The Three Norns (Ewald), 96–97, *96*
The Three Panthers of King Joseph, 126, *128*

Thus Spake Zarathustra (Nietzsche), 19
Tiger, 66–68, *67*, 69
Tiger Attacking a Horse (Delacroix), 83
Tirol, 133
Tolstoy, Leo, 18
The Tower of Blue Horses (painting), 55, 76, 119,
 120, 121, 123, 133, 136
The Tower of Blue Horses (watercolor postcard),
 125, 126
Trakl, Georg, 112–115
*The Trees Show Their Rings, The Animals Their
 Veins. See Fate of the Animals*
Trinity College Apocalypse, 154–155
Tschudi, Hugo von, 64
Two Animals Enticing Humanity, from
 Apocalypse (Dürer), 134, *135*
Two Blue Horses, 130
Two Cats, Blue and Yellow, 68–69, *68*
Two Foxes, 85, 88
Two Horses, 123, *124*, 126
Two Horses in a Mountain Landscape, *122*, 123
Two Nudes in Red, 51
Two Springing Horses, 81
Two Women on a Mountain, 39

Uhde, Fritz von, 16
"Umbra Vitae" (Heym), 111
"Untergang" ("Decline") (Trakl), 115
Untitled, page 20 from *Sketchbook from the
 Field*, 164, *165*
Untitled, page 34 from *Sketchbook from the
 Field*, 168–169, *169*
The Use and Abuse of History (Nietzsche), 107

Die Valkyrie (Wagner), 94
Van Gogh, Vincent, 42
View of the Staffel Slopes, 26
Volüpsa Edda, 97–99

Wagner, Richard, 16, 21, 93–94
War (Rohlfs), 100
Weasels Playing, 60
Wedekind, Frank, 18, 109
"Weltende" ("End of the World") (Hoddis), 109
Wheat Shocks (Van Gogh), 42
Wild Boars, 83
Wild Horses, 85
Wilhelm I, Kaiser, 15
Wilhelm II, Kaiser, 15
Wolgemut, Michael, 133
Wolves (Balkan War), 76, 88, *89*, 90, 139
Wolzhogen, Ernst von, 17
Woodland Path in the Snow, 26, *27*
The World as Will and Idea (Schopenhauer), 105
The World Cow, 76, 77, 85, 137

The Yellow Cow, 60, *61*, 64, 67, 85
Yggdrasill, and *Fate of the Animals*, 96–97

Zech, Paul, 117
Zola, Emile, 17

DAT